AFRICA

Arts and Cultures

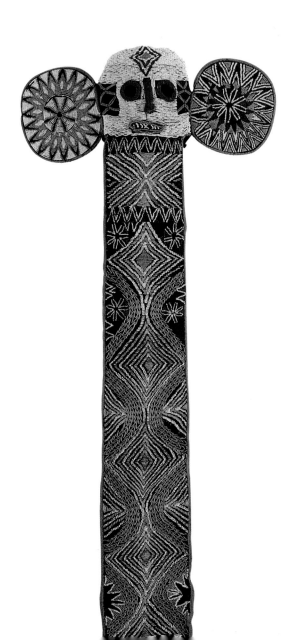

AFRICA

Arts and Cultures

Edited by John Mack

OXFORD

UNIVERSITY PRESS

DEDICATION

To the late Sir Robert and Lady Lisa Sainsbury

Published in the United States of America by
Oxford University Press, Inc.,
198 Madison Avenue
New York, NY 10016

Oxford is a registered trademark of Oxford University Press

Published in 2000 by British Museum Press
A division of The British Museum Company Ltd
46 Bloomsbury Street, London WC1B 3QQ

Library of Congress Cataloging-in-Publication Data
Data is available for this title

ISBN 0-19-521727-6

Designed by Andrew Shoolbred
Typeset by Rowland Phototypesetting Ltd,
Bury St Edmunds, Suffolk
Printed in Slovenia

HALF TITLE PAGE: Cameroon elephant mask (no. 28)
TITLE PAGE: Earplugs, Zulu, South Africa (no. 50)
CONTENTS PAGE: Beaded fan, Yoruba, Nigeria (no.3)

Contents

Preface

The occasion for the publication of this book is the opening of the Sainsbury African Galleries, part of the Great Court scheme, at the British Museum. The Court itself is a lively new space rediscovered at the very heart of the Museum with the move of the British Library to new premises. It provides the Museum with the opportunity to create for its visitors a vibrant cultural square to complement the illumination of world cultures in the many galleries that lead off it. The Sainsbury Galleries lie within the Court and offer a modern venue for an evolving exploration of African arts and cultures.

That the continent of Africa should hold this central position in the rearticulation of the Museum's galleries is appropriate. Firstly, the presentation of African culture has always been a major concern of the Museum of Mankind where the British Museum's Ethnography Department had been housed from 1970 to 1999. The return of this 'prodigal' Department offers us significant new opportunities. It should also be pointed out that all but one Department in the British Museum contain material relating to the continent and its broader influence (the exception being the Department of Japanese Antiquities). This in itself is a reflection of the historic influence of Africa on the development of culture worldwide. Africa is the home of traditional religions, of Christianity and of Islam. The Classical world had significant springs in antiquity to the south of the Mediterranean.

This book seeks to re-evaluate the significance of one of the world's leading collections of African art and material culture. It does so by looking across the range of African visual and cultural expression up to and including that of contemporary times. Individual commentaries seek to re-examine the collections and provide a background to what will be a changing African landscape as the Galleries respond to new cultural discoveries and artistic developments. These commentaries have largely been sought from younger researchers, not least from within Africa itself.

We are especially grateful to them for their assistance and contribution to the project of which this book is one outcome.

A collection of this importance has held the attention of a vast range of visitors, scholars, artists and collectors over the centuries of its display and development. It is a particular pleasure to the Trustees and staff of the Museum that the first Galleries to be a dedicated focus for the display of the African collections have been supported by some of the most prominent of these. Sir Robert and Lady Sainsbury and Henry Moore, the world-renowned sculptor, have been unswerving advocates of the unique opportunity that comes from being able to relate artistic achievement across cultures. Their joint support of the African Galleries is gratefully acknowledged. It is the foremost function of the few international museums that exist to facilitate the insight whose pursuit they have jointly shared. The book itself is dedicated to the late Sir Robert and to Lady Sainsbury.

Graham Greene CBE
Chairman of Trustees
British Museum

ACKNOWLEDGEMENTS

Many people have helped in the preparation of this book. Our first debt is to the numerous colleagues in Africa and elsewhere who have responded generously to the invitation to comment on objects in the collections of the British Museum, and whose observations are reprinted here. In-house we have been assisted by Maria Magro (editorial assistant), Hans Rashbrook (maps), Mike Row and David Agar (photography), Anna Gaudion (preparatory work), and at our publishers Carolyn Jones, Nicola Denny, Andrew Shoolbred and John Banks.

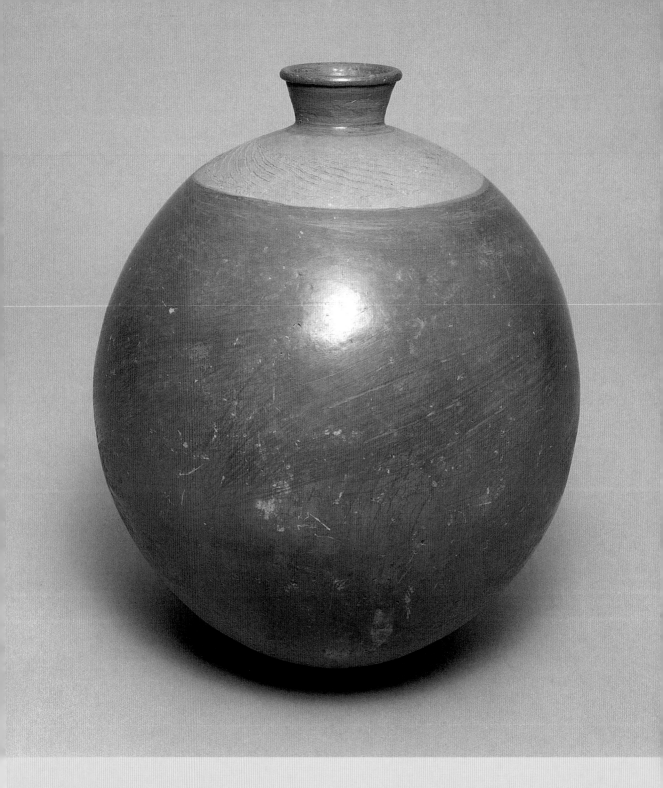

Fig. 1: Water jar of clay, Hausa, Sokoto, Nigeria. This classic African pot is totally practical. The lip applied to the body prevents leakage. The striations around the neck increase evaporation for cooling and provide a good grip. The round bottom allows the jar to be set at any angle without a flat surface, and it fits comfortably inside a head ring or against the curve of the human neck.
Ethno 1946, AF18.381

This is a book of many voices. It includes those of artists writing about their own works and about the works of others. But it also comprises art historians, anthropologists, museum curators and local experts; not surprisingly, some writers are more studiedly aesthetic than ethnographic or historical rather than cross-cultural. These different voices do not necessarily compete, since African objects impinge on many fields of experience, and this work deliberately seeks to link them together rather than keep them apart. Above all, there are African voices, reflecting the enormous recent growth in local interest in African material culture and the contribution of Africans to contemporary world scholarship (no. 1). At the same time, easy notions of 'Africanness' itself are dismantled by the inclusion of objects and writers who are both insiders and outsiders and form bridges between past and present.

In 1995, as part of a UK-wide festival devoted to the arts of the continent of Africa, the Museum of Mankind in London was given over entirely to exhibitions with African themes. One of these was entitled *Made in Africa*; it showed important works acquired by institutions in Britain with assistance from the National Art Collections Fund (fig. 2). The display proved to be revealing in terms of how many African objects had attracted support from an organization otherwise acknowledged mainly for its generosity to proposals for the acquisition of Western art. Equally startling to some of our visitors was the object selected as the centrepiece of the exhibition: a large cast bronze head with inlaid alabaster, glass and coloured stone eyes, which represents the Roman Emperor Augustus (fig. 3).

The portrait of Augustus dates from 27–25 BC, the period of the Roman occupation of North Africa. It was found during archaeological excavations near the so-called Temple of Victory at the site of Meroë in northern Sudan. The head appears to have come from a larger than life-size statue created and erected at Alexandria on Egypt's Mediterranean coast; the head seems to have been removed and carried off by raiders from further down the Nile Valley. At Meroë it was discovered placed

Introduction

1 Appliqué banner

Cotton
Fon, Republic of Benin
19th century?
L. 175cm, W. 109cm
Ethno 1982, AF23.1

The Fon people of the former kingdom of Dahomey are famous for their appliqué cloth through which they succeeded in immortalizing the past glory of their ancestors. Appliqué has been used for many purposes: to reiterate the king's strong names or the history of the kingdom, to celebrate friendship, to immortalize links with the gods and their active presence in our human world. Unlike the mud reliefs with which they share some figures rooted in oral traditions, the appliqué is a more supple medium which can be carried, rolled and stretched again, hence its quick development and expansion inside and outside the kingdom.

The present appliqué perpetuates such a tradition by evoking the martial accomplishments of King Glele (1858–98) who waged numerous wars and is said to have been kindly assisted by the gods and good fortune.

Although the banner is on a rectangular format, its real sense of construction and reading is circular, turning around the main central figure of Daghesu, a one-legged deity held to go before the king's army, leading it to success. Daghesu, as shown here, is holding both the sun and the moon in his hands, signifying his mastery over day and night. He is smoking a pipe, a royal attribute in the kingdom, showing its royal origin and the availability of tobacco brought from Brazil and exchanged for slaves. His hair is upright and his eyes and ears are wide open. He can see and hear in all directions and know what happens by day or night. A calabash gourd, used in various cults, which contains the powder of invincibility, is attached to his leg, and in his arms are two of the feet of people he helped to defeat.

The Yoruba and the Mahi people located in the east and the north of the kingdom were the main enemies of the Fon in the nineteenth century, and their defeat, after a long struggle, is remembered as often as possible. Here the ethnic marks of the figures above the deity portray them. They have been beheaded by Fon warriors recognizable through their war costumes. On this appliqué civilization and its opposite are again confronted. The Fon warrior is fully clad and holding a metal weapon, a cutlass, while the enemy is half-naked and uses a club. The scene depicted here clearly indicates the belief the Fon have in gods without whom nothing can happen. It illustrates the 'supernatural character' of those gods not quite resembling human beings although they share some features with them. No human has ever been able to walk on one leg unless as a joke.

Daghesu, then, shows the ability the Fon have to imagine their divinities in different forms and contexts. The best-known representation of Daghesu shows him as having the head of a male goat imposed on a human body. In the present form he is depicted as wholly human, but is still definitely Daghesu.

Joseph C. E. Adande
National University of Benin
Republic of Benin

BIBLIOGRAPHY

Blier, S. P., 1990, 'King Glele of Danhome', *African Arts*, vol. XXIII, 4: 42–53

Blier, S. P., 1991, 'King Glele of Danhome', *African Arts*, vol. XXIV, 1: 44–55

Herskovits, M. J., 1938, *Dahomey: An Ancient West African Kingdom*, 2 vols, New York: J. J. Augustin

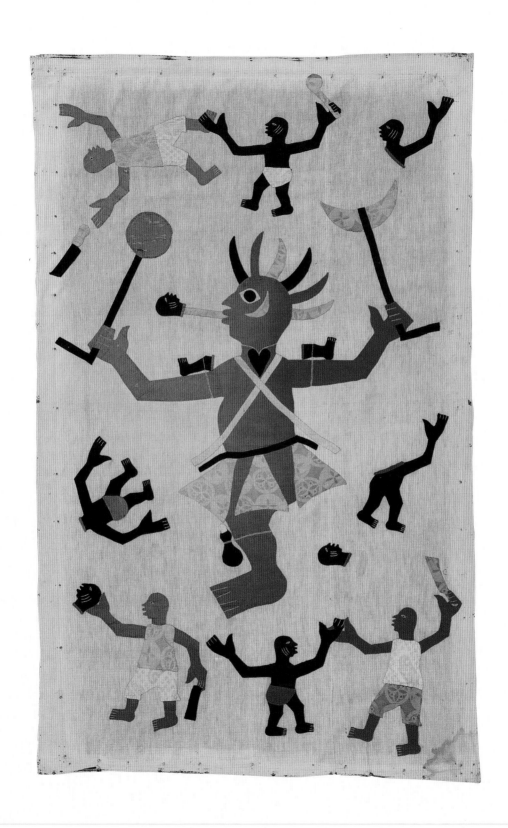

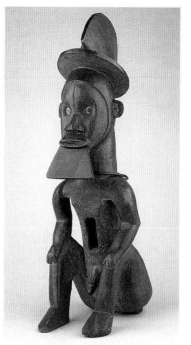

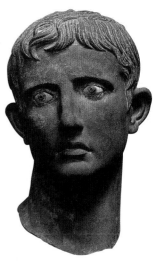

Fig. 2: RIGHT Teke figure from the Democratic Republic of the Congo collected by the French traveller Robert Hottot in the early twentieth century. It was made for use in a magical or medicinal context; the abdomen cavity would have contained appropriate substances.
Ethno 1995, AF6.1; National Art Collections Fund

Fig. 3: FAR RIGHT Bronze head of the Roman Emperor Augustus from an over-life-size figure probably originating in Alexandria but discovered at Meroë, Sudan, 27–25 BC.
Given by the Sudan Excavation Committee aided by the National Art Collections Fund
GR 1911, 9–1.1

beneath the threshold of a building so that those passing through the doorway literally had to step over it, an apt gesture in celebration of Meroitic resistance to Roman incursions.

The inclusion of the head of Augustus in an African exhibition – indeed the highlighting of it in the display – makes several important points. The first might seem a somewhat inward-looking issue. As in many Western institutions of its longevity (it was founded in 1753) the structure of the British Museum's current curatorial Departments and their associated galleries is itself an artefact of a particular intellectual history. Attention to the Graeco-Roman world preceded the development of interest in North Africa as a region, so material relating to Roman North Africa resides with other Greek and Roman artefacts. Interest in Ancient Egypt preceded that in the rest of African antiquity and it too has its separate curatorial home. Similar concerns have the result that material from the African continent is distributed across eight different curatorial clusters including the Prehistoric and Early European, Egyptian, Greek and Roman, Ancient Near Eastern, Coins and Medals, Oriental, Prints and Drawings and the Medieval and

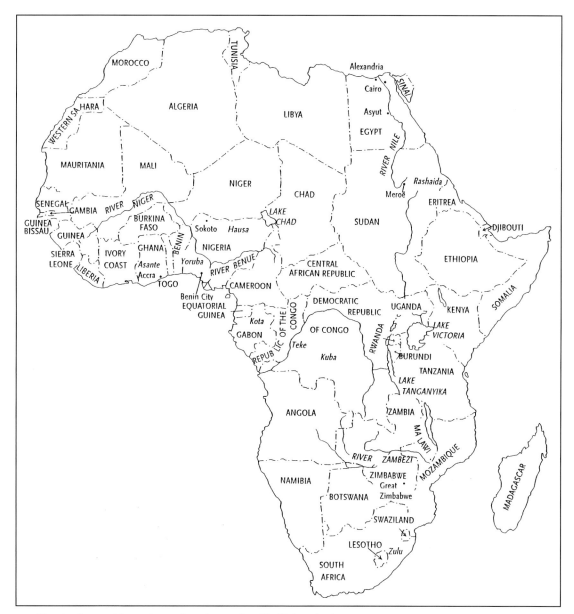

Map showing countries, regions and peoples mentioned in this Introduction.

Modern Europe Departments. North Africa has complex cross-Mediterranean links deep into antiquity. The Aksumite kingdom of Ethiopia also established bases in the Yemen; the history of the Red Sea coast, the East African littoral and the islands of the western Indian Ocean has been profoundly influenced by its maritime links to the Arabian Sea (fig. 4).

2 Queen Mother head

Brass, iron
Edo, Benin, Nigeria
16th century
Ht. 41cm, W. 15.5cm, Dp. 17cm
Given by Sir William Ingram
Ethno 1897, 10-11.1

This early head (*uhunmwun elao*), cast in memory of the first Queen Mother of Benin, Queen Idia, is one of the most famous images in African art. It ranks among the finest works of the royal guild of bronze-casters (*Igun-eron-mwon*) founded by *Oba* Ogolua, in the late thirteenth century. The term 'brass' is widely used for Benin 'bronzes' nowadays, since most of those analysed have been found to be a mixture of copper and zinc (brass), and only a few a mixture of copper and tin, with some lead and zinc (bronze). Interpretation of such studies, including alloys and trace elements, to establish a chronology and other relationships between works of art, is complicated by the practice, then as now, of melting and reusing scrap metal in casting new pieces.

The naturalism of this life-size Queen Mother head, the thinness of the casting itself, the sensitive modelling of the face and features and careful rendering of details, were seldom equalled in later centuries. Unlike most artistic traditions in Africa, known for wood-carving and abstract styles, Benin is noted for its realism and for having created the largest body of art in metal south of the Sahara. Questions of date and origin of brass and bronze casting, lists of kings and historic events in Benin and southern Nigeria will continue to be argued by historians, art historians and ethnologists, until more, and

much-needed, intensive, systematic archaeology is done in the region and beyond. But there is little doubt that the ancient kingdom of Benin is indeed very old and predates by several centuries the first recorded European contact by Portuguese explorers at the end of the fifteenth century.

This memorial head of the *iyoba*, like most Benin brasses, was cast by the *cire perdue* or 'lost-wax' method, the most complicated technique used in West Africa. It requires great patience and skill at each stage of production: from the preparation of clay cores and moulds, modelling in beeswax, to firing, melting and pouring of molten metal, and polishing and finishing each piece. A bronze-caster does not know until the metal has cooled and the mould is broken open whether or not his labours have met with success.

Iyoba Idia is the fifteenth-century *oba*'s (king's) wife who gave birth to the Crown Prince, the Edaiken, later *Oba* Esigie (c.1504–50). Unlike previous birth mothers of future kings, Idia was not put away when her son was crowned the *Oba* of Benin. Instead, he created the title of *Iyoba*, Queen Mother, and built a palace for her at Uselu, on the outskirts of Benin City. There she lived with her court, chiefs and retainers (as every *iyoba* has done since), and consulted him through intermediaries, but the two never again saw each other face-to-face. Like all good mothers she 'backed' her son by guarding his interests, and using her influence and powers to assist him. Idia was known for her skill as a native doctor, making 'medicines' and charms to protect her only son.

Queen Mother Idia is remembered to this day in Benin, as 'the only woman who went to war'. She raised an army to help her son fight powerful enemies who threatened the kingdom. *Oba* Esigie greatly expanded the kingdom in his reign; and he

exploited his relationship with the Portuguese for guns and mercenaries in his battles. These Europeans appear on brass plaques, as design elements on regalia, on ivory tusks, pendant masks and ornaments, on cloth, on brass ornaments and as sculpture.

Memorial heads such as this one are commissioned by the *oba* on the passing of his mother; and it was kept on an altar in the palace. The altar was also beautified with brass castings of cockerels, tableaux and sculptures. After the death of an *iyoba* her palace was demolished and a shrine was built in her name at or near where she had lived in Uselu. These shrines are still kept in perpetuity by caretakers, but few things of beauty are found there now. Most have been stolen or taken away and sold to dealers and collectors abroad.

Of the thousands of known Benin works in brass, ivory, wood and other media that survive in museums and collections around the world, fewer than ten per cent depict women in court art. The woman most often represented is the *iyoba* in her various guises as queen mother and priestess, and shown in a male gender role as a senior chief. She is usually shown accompanied by an entourage of retainers, pre-pubescent female attendants and others.

This fine early casting is one of only five memorial heads of *Iyoba* Idia (a sixth is problematic). The head in the British Museum and the one in the National Museum, Lagos, are evidently by the same sixteenth-century bronze-caster. Distinctive features that first appear in early heads appear in all forty-five later Queen Mother heads. They have reference to the oral tradition associated with Idia and the innovations she and *Oba* Esigie introduced. Foremost among them is the title, and the casting of a brass memorial head, a privilege reserved only for the *Oba* and his mother. Queen Mother heads are distinguished by the hairstyle invented by Idia. This hairstyle is usually wrongly identified as a 'chicken's beak'. It is a parrot's beak, *ukpe-*

okhue, a high, concave cone of hair covered with a netting of coral beads that fits, cap-like, over the queen's hair, and cascades in a series of beaded tassels around the base of the cap, in front of her ears and around her neck. Only the *oba*'s major war chief, the *ezomo*, is allowed to wear coral bead headgear besides the *iyoba*, a rare privilege that denotes their high status. Only the *oba* of Benin wears a coral bead crown.

Another distinctive feature of Queen Mother heads is the two rectangular incisions between and just above her eyes, on the forehead. They are usually inset with strips of iron, marking a place where thought and power are concentrated. These incisions refer to the oral tradition of how Idia came to be queen. An oracle decreed that medicines should be placed in two incisions to repel the *oba*, who had asked for her as a wife (and whose parents wanted to keep her from being secluded in the palace, away from them). *Oba* Ozolua defeated the oracle to become her husband, and she fulfilled her destiny as queen. Her son honoured her in her lifetime, as *Iyoba*, and as the first Queen Mother of Benin, she achieved lasting fame. Thus, this memorial head celebrates a woman's destiny in motherhood. It gives recognition to individual achievement, and it personifies the possibility of rewards still most sought-after in Benin, especially, but not solely by women – 'name' and remembrance through time.

Flora *Edouwaye* S. Kaplan
New York University
USA

BIBLIOGRAPHY

Herbert, Eugenia W., 1984, *Red Gold of Africa*, Madison: University of Wisconsin Press

Kaplan, Flora Edouwaye S., 1993, 'Iyoba, the Queen Mother of Benin', *Art History*, vol. 16, 3: 386–407

Kaplan, Flora Edouwaye S., 1993, 'Images of the Queen Mother in Benin court art', *African Arts*, vol. 26, 3: 55–63, 86

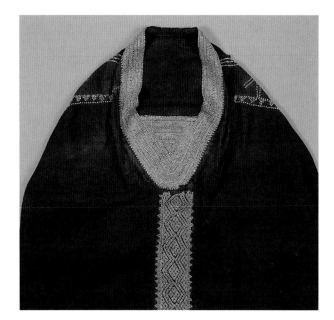

Fig. 4: The Rashaida bedouins emigrated from the Hijaz region of modern-day Saudi Arabia in the mid nineteenth century and settled in eastern Sudan. Their Arabian ancestry remains evident in the continued use of certain items of costume such as this exquisite face-veil (*burqu'*), embroidered in silver thread and embellished with coins, buttons and silver beads.
Ethno 1978, AF19.2

Fig. 5: OPPOSITE Kota reliquary figure covered with brass and copper sheeting, Gabon. These protective figures are fixed into wicker-work baskets which contain the relics of prominent ancestors.
Ethno 1956, AF27.244

The Ethnography Department in the British Museum offers an unrivalled archive of human ingenuity and achievement on the African continent. The aim here is less to provide a monolithic reinvention of African culture and history than to open up a new gateway into a collection that can be mined in very many ways to show something of African varieties of life and thought.

From this derives a second significant perspective. Is there any meaningful cultural or artistic content to the term 'Africa' to set beside its mere geographic and geo-political connotations? At times in the recent past, the eminent figures in African studies have seemed at least to imply that some kind of essence might be squeezed out of a long study and exposure to the multifarious forms of African cultural expression. At the same time as William Fagg was asserting the independence of each 'tribal' art style, he also had a sense of an underlying unity of the sub-Saharan figurative art on which he concentrated. In the conceptual field Placide Tempels sought to identify a common Bantu philosophy which explored the idea of an ontological and ethical basis to Bantu thought. From an African perspective the Zulu *sangoma* Credo Mutwa is amongst those more popular writers who have sought to generalize from local experience.

Ideas of what African art consisted in were sufficiently set and unitary that deviations from expectation were often held up not to be African at all. The representational art of Benin could not be explained by earlier generations and so had to be explained away – the arrival of the Portuguese in the fifteenth century was always to hand for those who sought an external source for Benin art (no. 2). Great Zimbabwe has historically offered a large list of potential builders ranging from the Queen of Sheba to the mythical Prester John, all brought into play to deny the obvious – that it is of African origin. Likewise when the sumptuous arts of the Kuba, with their rounded representational dynastic 'portraits' of kings (no. 33), became known at the start of the twentieth century the contrast to the faceted polychrome sculpture and masks of expectation was stark (fig. 5). Here were accessible works of art coming

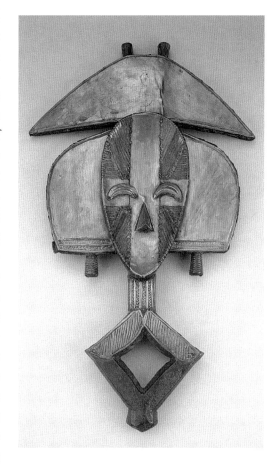

from a people living deep in the equatorial forests of Central Africa. The dimmest hint in oral tradition of remote contacts with an exterior world were elevated in significance. 'It is to my mind', wrote the eminent anthropologist A. C. Haddon, 'very suggestive that the most civilised, cultured, and artistic people in Central Africa should themselves own that hundreds of years ago there was a white ancestor somewhere behind them.'

Given the extraordinarily perverse nature of such visions of Africa, it is not surprising that in recent years such attempts to identify some kind of African essence have receded. New biases, previously invisible, suddenly become obvious, such as the tendency to punctuate out the North African heritage from the rest of the continent. Where twenty or thirty years ago there was an easy acceptance of the crudest of classification – fetish, ancestor figure etc. – many traditions have been researched

3 Beaded crown (ade ileke)

Glass, textile, metal, cotton
Yoruba, Nigeria
19th century
Ht. 72cm, W. 16cm, Dp.22.5cm
Given by Sir William MacGregor
Ethno 1904, 2-19.1

Beaded boots (bata ileke)

Glass, cotton, textile
Yoruba, Nigeria
19th century
Ht. 44cm, W. 12cm, L. 32cm
Given by Sir William MacGregor
Ethno 1904, 2-19.3a-b

Beaded container (ibo ileke)

Glass, textile, metal, leather, cotton
Yoruba, Nigeria
19th century
Ht. 25cm, Diam.13.5cm
Given by Sir William MacGregor
Ethno 1904, 2-19.12 a-b

Beaded fan (abebe ileke)

Glass, textile, cotton
Yoruba, Nigeria
19th century
L. 49cm, W. 30cm, Dp. 3cm
Given by T. R. Sneyd-Kynnersley
Ethno 1947, AF33.3

When Yoruba people say that '*Irinisi ni isonilojo*', they mean that we are what we wear, and that you wear what you are. Clothing and appearance, according to Yoruba people, reveal both the apparent self and the real self behind the cloth. Yoruba elders thus say, '*Kete ta didun, aso niwa eniyan*', meaning 'let the wheel spin delightful yarns, because one's costumes reveal one's character'. Even though he is the most powerful person in any Yoruba community, the king must still sport royal robes, Yoruba elders insist, or you are liable to take him for a commoner. Nothing better projects the power and attiring of a king than the Yoruba talking drum, when it phrases the following praise song:

> *Eru oba ni mo ba*
> *Oba to*
> *Oba to to bi aro*
> *Oba to*
> *Oba rere bi osum*
> *Oba to*
> *Oba to dade owo*
> *Oba to*
> *Oba to tepa ileke*
> *Oba to*
> *Oba to wewu etu*
> *Oba to*
> *Oba to tele yi do*
> *Oba to*
> *Eru oba ni mo ba*
> *Oba to*

I am in awe of the Sovereign
Lord majestic king
The persistently poignant king, like indigo
 dye
Lord majestic king
The crimson red king, like camwood paste
Lord majestic king
The immensely wealthy, resplendently
 crowned king,
Lord majestic king
The beaded staff-bearing, swaggering king,
Lord majestic king

The magnificent, silk-robe-sporting king
Lord majestic king
The community-founding, potentate king
Lord majestic king
I am in awe of the Sovereign
Lord majestic king

With the use of superlatives, the above song largely describes the sovereign in terms of his costumes, including the crown (*ade*), staff (*opa*) and robes (*ewu*), all made out of special materials that are exclusive to his royal office. Commoners or pretenders to the throne must not wear these items, or they will be confiscated, sometimes on pain of death. Indigenous customs forbid chiefs and other community heads who do not rise to the level of kings from wearing such royal items, as the *Elepe* of Epe, discovered to his chagrin in 1900 when the *ade* and other royal items including *bata* and *ibo* were confiscated from him by the colonial British government.

The *ade ileke* or beaded crown is the most significant emblem and embodiment of authority worn by Yoruba kings. Though there are numerous variants, two major types of *ade* are worn by Yoruba sovereigns, namely *ade nla* and *orikogbofo*, both of which are beaded headdresses. The piece in the British Museum is an *ade nla*, the most magnificent headdress sported by the monarch during public ceremonies. Since the usually shaved head of the king must never be left uncovered, the *orikogbofo* is a small beaded top that adorns his head when he is seen at court, or in his private chambers. A classic example of the *ade nla*, with its conical shape and colourful beaded patterns, this piece also depicts free-standing bird images and an intricately beaded veil hanging from the base of the cone. A short stem surmounted by the perching bird represents the royal *opa* or staff of office, while the avian figures attached to its body represent the eminence of the *iyami*, the powerful Yoruba women derogatorily referred to as witches. Anthropomorphic figures of Yoruba divinities

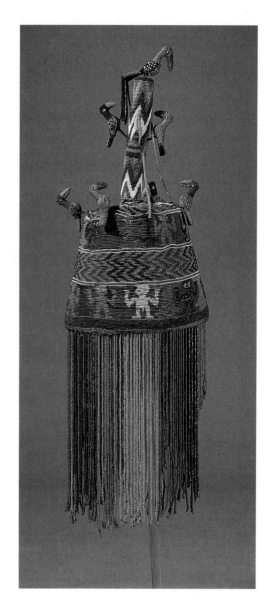

adorn two registers, separated by a band of zigzag patterns, radiating the energy and presence of mythic powers around the cylindrical form of the crown. The dangling veil covers the royal face and prevents his gaze from injuring commoners who cannot survive his direct stare.

Bata ileke or beaded boots were strictly limited to kings, who probably began to wear

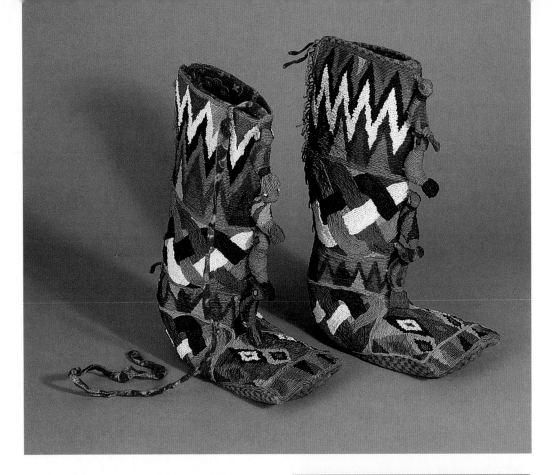

shoes during the seventeenth century, as it became increasingly necessary for kings to make public appearances beyond the covered floors of the palace. These magnificent pieces made for the *Elepe* of Epe during the late nineteenth century became controversial because they were too elaborate and exquisite for a second-class ruler, who was supposed to be satisfied with footwear of far less artistic quality. The boots were made to match the *ade ileke* described above, with their four freestanding birds elegantly poised on each boot. While these birds allude to the mysterious power of women (see *iyami* above), the total number of eight (birds) symbolically refers to the Yoruba corpus of Ifa divinity, the all-knowing deity of fate and fortune. The bold zigzag patterns on the boots, apart from its reference to the vibrating energy of the Yoruba divinities, also suggest the infinite reach or *owo* of the king within his community. Bold

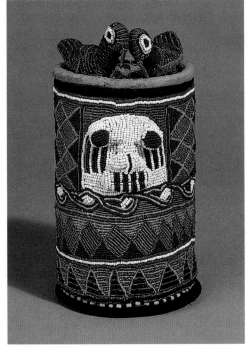

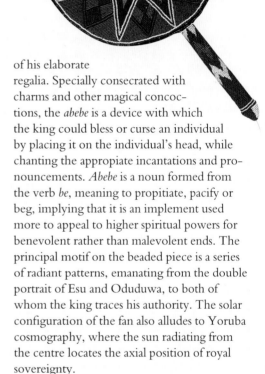

interlocking designs (*ibo*) connote serpentine potency as well as the cryptic strength inherent in communal co-operation involving the king and his people.

The *ibo ileke* is a mysteriously sealed beaded container with potent powers whose contents and secrets are known only to the king and those who sealed it. *Ibo*, a noun derived from the verb *bo*, means to cover, conceal, mask or harbour. *Ibo* also refers to voting, an important procedure that king-makers undergo as part of the elaborate process of nominating, choosing and installing a new ruler. Many rulers therefore have specially beaded *ibo* designed and executed for them, within which are kept the exclusive secrets of their installation rituals. The specially beaded *ibo* container fashioned for the *Elepe* has a conical structure and multicoloured patterns that echo both the *ade* and *bata ileke*, suggesting that they perhaps come from the hands of the same *Ijebu* master in western Yorubaland. The avian superstructure of the royal container may also refer to the peacock, or *okin*, which Yoruba people regard as the king of birds, while denoting the inimitable powers of the *iyami*, hailed as Our Mothers. Prominently placed in the centre of the container is a mythic double portrait of Esu (the Yoruba divinity of the crossroads, with whom resides *ase* or ultimate authority), and the face of Oduduwa, the legendary first Yoruba ruler to whom all Yoruba kings must trace their ancestry to entitle them to wear beaded crowns.

The beaded hand fan, called the *abebe ileke*, is a ceremonial object held by the king, not really to keep himself cool in the humid tropical climate of Yoruba country but really as part of his elaborate regalia. Specially consecrated with charms and other magical concoctions, the *abebe* is a device with which the king could bless or curse an individual by placing it on the individual's head, while chanting the appropiate incantations and pronouncements. *Abebe* is a noun formed from the verb *be*, meaning to propitiate, pacify or beg, implying that it is an implement used more to appeal to higher spiritual powers for benevolent rather than malevolent ends. The principal motif on the beaded piece is a series of radiant patterns, emanating from the double portrait of Esu and Oduduwa, to both of whom the king traces his authority. The solar configuration of the fan also alludes to Yoruba cosmography, where the sun radiating from the centre locates the axial position of royal sovereignty.

Moyo Okediji
College of Arts and Visual Arts Department
Denver
USA

BIBLIOGRAPHY

Drewal, J. H. and Mason, J., 1998, *Beads, Body and Soul: Art and Light in the Yoruba Universe*, Los Angeles: Fowler Museum of Cultural History

Trowel, M., 1960, *African Design*, London: Faber and Faber

Fig. 6: ABOVE Drum in the style of the Asante, Ghana, but acquired by Sir Hans Sloane before 1730 'from Virginia'.
Ethno Sl.1368

Fig. 7: BELOW Mancala is a generic term which refers to a specific family of count and capture games. Two-row mancala was introduced to the Americas during the slave trade and is today played on many Caribbean islands. In Speightstown, Barbados, *warri* (the local name for mancala) is extremely popular.
Photo: Alex de Voogt, 1996

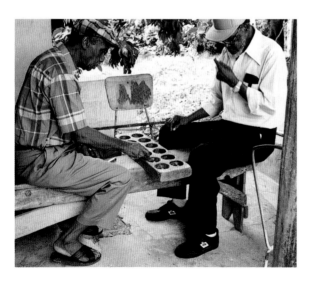

and published in much greater detail, and the vocabulary of description and routes to understanding are greatly enhanced. African scholars with a detailed internal knowledge of particular cultures have begun to publish extensively, making indigenous concepts and perception better known. With this concentration on the local (no. 3), the simplifying tendency of the grand generalization has been rendered unsustainable.

The title *Made in Africa* already sought to make the point. Choosing an object made on the northern fringes of the continent, excavated at a site far down the Nile, created by a non-African to honour a Roman ruler, emphasizes how porous is our concept of Africa. As Kwame Anthony Appiah neatly puts it: 'African art was not made by people who thought of themselves as Africans.' He was thinking not of Romans but of those with indisputable credentials to think of themselves as Africans. There is, he concludes, not one Africa, but many. The apprehension of that diversity, rather than an attempt to produce some improbable semblance of synthetic unity, is our purpose here. It is possible to argue, therefore, that, although an accident of history means that some cultures and periods of time have ended up in different arenas of interest and research, such a dispersal does none the less cohere with a diversity of cultural expression to which the continent is heir.

We have enumerated briefly the various areas in which the British Museum collections afford

a view of Africa. It is worth also mentioning some of the weaknesses. An obvious one is the whole question of the African diaspora. The eighteenth-century collection of Sir Hans Sloane, out of which the British Museum grew, included both natural and cultural products from the new lands that were then being freshly explored, and conveyed the idea of a world full of wonders. Among them was an impressive Asante drum (fig. 6). It is much like one you might see today being played in any Asante village, in modern-day Ghana. Unusually, however, it was made not in the Asante area but in Virginia, North America, by slaves. Despite the apparently fixed tribal names of many museum displays, movement and innovation, as well as the continuity of tradition, have always been an important part of African identities. Through the slave trade and the diaspora of voluntary emigration, these identities have spread around the world (fig. 7) but institutions in Europe are singularly ill equipped to reflect this global experience. Within the British Museum, the 'American Asante' drum remains an isolated piece. In terms of what has just been said, this gap may have been unavoidable and something to be rectified, but it remains unfortunate. After all, one of the most potent sources of a more unitary view of Africa is precisely the convergence that has happened as a result of the enforced migration of the trans-Atlantic slave trade, the common experiences that emerged from that tragedy, and the adoption of shared means of expressing African ancestry. Doran Ross's recent catalogue and exhibition dealing with the place of Ghanian *kente* cloth in bridging the experience of two continents and acting as an expression of a shared cultural heritage makes the point well (fig. 8).

Fig. 8: The Memorial Chapel, Acton Hill Methodist and United Reformed Church, London. The *kente* cloth is a gift from the Ghana Police Church in Accra. The multi-cultural congregation at Acton Hill includes many people from Africa, in particular Ghana, Nigeria and Sierra Leone. *Photo: Trustees of the British Museum*

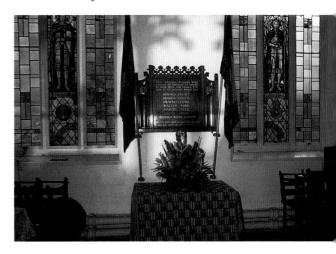

The whole contemporary field raises further issues. Most museums, especially those devoted to antiquity, devote relatively few resources and little attention to fieldwork and excavation. The British Museum is

exceptional in actively promoting research in Africa and elsewhere, in direct co-operation with colleagues and individuals in the countries concerned. This is encouraged even where current export legislation prevents partage, as for example in Egypt. It is still regarded as an important activity for the light it sheds on the general subject and the information it adds to the existing Museum holdings. In the ethnographic field, there are many examples over the past two decades of projects developed within Africa which have enhanced the collections and their understanding and which have led to mutually beneficial relationships between the British Museum's Ethnography Department and equivalent institutions within Africa. To that extent the ethnographic collection is far from static; contemporary ethnography continues to be a leading interest.

Contemporary art, however, is a more complicated subject. Should an ethnography department acquire contemporary art at all? Few, if any, do. Where it happens, there is often a contemporary evolution in the treatment of a 'traditional' subject – as for instance in the well-known representational coffins from Ghana or the tomb sculptures of the Malagasy artist Efiambelo. In these cases there is no clear line between the work of the contemporary artist and the creator of a so-called ethnographic object. The objects are made for, and used by, local clients as well as appreciative patrons internationally. In an international context they are made for display in a domestic or gallery context; locally they are used for funeral purposes. The National Museum of African Art in Washington, DC, collects more broadly in this field, but it is by title and practice an art institution with a specific brief to pursue an active interest in that area. At the time of the *africa95* festival referred to above, the Royal Academy in London took the decision not to include contemporary African art in its major exhibition – even though it is run by a community of contemporary British artists, the exhibition's curator was a senior British artist in his own right, and the Academy regularly includes the contemporary field in its exhibitions and activities. Instead contemporary African art was shown at other venues.

At the Museum of Mankind one of the exhibitions complementing *Made in Africa* was called *Play and Display*. It showed a series of specially commissioned steel figures by the Nigerian-born sculptor Sokari Douglas Camp (no. 4). They were displayed beside masks and other

objects selected by the artist from the Museum's collections and a series of headpieces used by maskers in her own home town of Buguma in the Niger Delta. Film showing masking was integrated into the display. Subsequently a number of the large steel figures were acquired for the Museum. The exhibition went on to the American Museum of Natural History, New York.

It can be argued – indeed it has been argued elsewhere – that there is no such thing as an 'ethnographic' object, merely objects regarded ethnographically. However some definition of the place of contemporary art is needed. The acquisition of these sculptures was the first purchase of objects with no clearly assignable 'ethnographic' function in the conventional sense that they were not made for use in a social or ritual context. They were not in fact even made in Africa but in a studio near the Elephant and Castle in London. The case put forward for their display and purchase, however, was that they were a direct and deliberate reflection through the medium of contemporary art on so-called 'tradition'. The figures are large, almost gladiatorial in composition. They are aggressive, imposing. In effect they are representations not just of maskers but of the power and impression that masking makes, especially on a girl brought up in a community which they enter with threatening and unpredictable intent. What the sculpture registers in artistic form is a perspective on an event which certainly would be considered central to the interests of an ethnographic department. Likewise the Egyptian artist Chant Avedissian produces large-scale appliqué textiles, a technique inspired by the tent hangings produced today, as for centuries, in the *suq* of the tentmakers in Cairo. Similarly, the work of Yoruba artist Osi Audu explores indigenous ideas of the body but does so through art works rather than textual dissertation (no. 5). He studied with the leading Nigerian art historian Rowland Abiodun at the University of Ife in the late 1970s. If it is not possible to take on the whole of contemporary art in all its complexity across the continent, this more limited definition in terms of reflections on 'tradition' does provide some workable parameters and a rationale through which to develop this interest.

In this book we have set out to review African arts and cultures as reflected in the British Museum collections, concentrating on the ethnographic holdings. Each chapter begins with an outline of the leading historical and cultural features of the different regions of the continent. In

4 Sculpture

('Big Masquerade with boat and household on his head')

Steel, feather, textile, wood
Kalabari, Nigeria
1995
Ht. 200cm, W. 90cm, Dp. 200cm
Made by Sokari Douglas Camp
Ethno 1996, AF8.2

'Big Masquerade with boat and household on his head' was inspired by a teenage masquerading group in Buguma, Rivers State, Nigeria. The group are called *Okolokurukuru*, 'Black Vagina'. I made this sculpture in 1995. I am Kalabari and come from the island of Buguma, which is the capital of the Kalabari Nation.

The sculpture is a simplified version of the *Okolokurukuru* masquerade. Their performer/masquerader had a headdress that was shaped like a combination of a fish and an aeroplane. It had small cannon and figures on

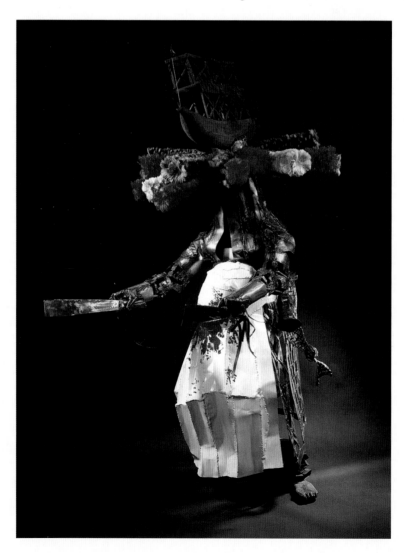

boats, parading with umbrellas and mirrors, and a little bird sculpted in wood at the tip of the headdress which looked as though it was about to take flight. These little objects were surrounded by a sea of feathers.

When considering what I wanted to make, I chose a very solid figure with a headdress. The headdress was to be viewed in conjunction with the figure, a solid image. I worried that too many figures would distract from the overall image. I wanted the sculpture to seem as if it was in motion and performing. This was what I felt was missing in ethnographic museums. As an African I had always found that these museums lacked life; especially when describing the art of masquerading which is so lively. Context and purpose were needed. Working with the British Museum's Ethnography Department, I felt that we brought life and context to the objects that were exhibited in my show *Play and Display*. It enabled the viewers to be closer than they would normally be to a masquerader in his own surroundings. But it did not detract from the character of the culture even though it was being viewed in a museum.

I put blood on the apron of the sculpture because this is an important element when a big masquerader performs. Masks are spirits, and have to receive sacrifices. The sacrifice enables the masquerader to be possessed by the spirit of the mask and to perform safely. If one believes in water spirits, to show them decapitated, or only their headdresses, as a display makes a nonsense of an art that is practised in the Delta regions of Nigeria today. The bloodied white apron and the cutlass show that this is a powerful spirit; the cutlasses show that the spirit is a warrior. The design of the headdress enables the spirit to transport his relatives into the arena and they are represented as figures. 'Big Masquerade' has this title because he is head of a family group.

The boat on the sculpture was partly carved in Nigeria with the help of my niece Dumo Bille. She was to travel to a course in the UK, but was not granted a visa in 1995. I put her name on the boat, so she was there in spirit. Traditional fishing boats have the name of their owner on them so that if anything happens the boat enables the fisherman to be traced back to his family. We have different types of boats in the Delta. Festival boats have two decks, so you have a large dugout canoe manned by thirty-five to forty men. Helped by an outboard engine in the rear of the boat, the men paddling look as if they are paddling very fast. On the next level there are about ten men parading with bunting and sometimes there is another deck just to add to the design of the canoe so it resembles a long ship. An average dugout canoe is shaped like a fish: it has a wide tail and a small head at the front. I have used some of these elements in my sculpture; but I have left out the figures, the shape and the colour being chosen as the more important elements. The colour of the boat is found on a lot of the headdresses and is created with clothes-brightening powder called 'robin blue'.

Sokari Douglas Camp
Contemporary artist
London
UK

BIBLIOGRAPHY

Horton, R. and Hubbard, S. (eds), 1995, *Play and Display: Steel Masquerades from Top to Toe, Sculpture by Sokari Douglas Camp*, London: Silvara

5 Monoprint ('Juju')

Paper, graphite, safety pins, wool, hair-plaiting thread
Yoruba, Nigeria
1999
L. 153cm, W. 122cm
Made by Osi Audu
Ethno 1999, AF14.1

There is something irreducibly real about the perceivable word. This stuff is consciousness. The Yoruba see the origin of this as *lae-lae* (i.e. eternity) – the mystical source of creation. All matter is seen as infused with mind, a spiritual potency, usually referred to as *ase*. In human beings, the seat of *ase* is located within the spiritual consciousness of each person called *ori-inu* (i.e. the inner head). This is also seen as the spirit of consciousness in all things, or the 'sacred' in all things.

In Nigeria shrines are built, usually in homes, to worship the inner head. A priest-artist is often commissioned to make a sacred icon as the centrepiece of the shrine. This piece is sometimes referred to as *juju. Juju* also refers to a selection of objects placed at crossroads as ceremonial offerings to the spirit world, the world of the ancestors. As a youth in Nigeria, from my daily encounter with these offerings, I have acquired a respect for objects, not only as vessels for the strange and mystical power which *ase* is but also as armchairs for the psyche. Objects are often containers for our memory of past experiences.

They function very intimately with every facet of our lives; psychological, spiritual and, in fact, practical.

My making of 'Juju' has been inspired by this Yoruba concept of the inner head. To create the work, I have explored and used the techniques of traditional African art – sewing, hair-plaiting, piercing, rubbing and attaching objects to a surface by tying them.

The main rectangular box shape is used as a metaphor for the head as a container of consciousness. The graphite surface refers to the hardness of the skull, which acts as a visor for the softer inner organs and defines the boundary between the inner and outer world, and between the self and the other. The plaited wool represents the hair, strengthening the metaphor; and the safety pins symbolize the sensory organs, or, more appropriately, the ubiquitous 'eyes' of consciousness.

My aim has been to create a piece in which the shapes and the elemental charge of the objects and materials used would lend it their secret magic, or consciousness, which would be felt as the piece is seen.

Osi Audu
Contemporary artist
Chatham
UK

BIBLIOGRAPHY

Abiodun, R., Drewal, H. and Pemberton III, J. (eds), 1994, *The Yoruba Artist*, London and Washington, DC: Smithsonian Institution Press

Fig. 9: RIGHT Wheel-turned pottery flask with engraved floral motifs, covered with a red haematite slip, made by a male potter in Asyut, Egypt, during the nineteenth century.
Given by J. Henderson
Ethno 5968

Fig. 10: BELOW The contents of Zulu beer pots are protected by *imbenge*, shallow pot-covers originally made of basketry. For special occasions these pot-covers were decorated with beadwork. Today, the same forms are retained, but the covers are woven from plastic-coated telephone wire. The cover on the right was made by a night watchman in Johannesburg, South Africa, while, more unusually, the other *imbenge* was created by a married woman in her home.
Ethno 1991, AF9.9 &19

line with our earlier observation that recent years have seen the development of much more detailed understanding of the significance of individual cultures, we then move to a closer consideration of specific objects, their significance and place in particular cultural settings. The objects to be discussed are not uniquely chosen from among those regarded as masterpieces. Rather an attempt has been made to select objects which reflect the breadth of the collection available and its geographical spread (figs 9, 10). Even so, it can only ever be a partial view selected out from a much larger collection, with its own strengths and weaknesses, that has grown out of many hundreds of years of interaction between Africa and the West.

Fig. 11: Young girls in Bahriya Oasis, Egypt, make these colourful necklaces (*bigma*) using tiny glass beads purchased in Cairo or from itinerant tradesmen. They are usually worn in addition to silver jewellery.
Ethno 1991 AF23.1–3

North

This is the largest, yet arguably the most culturally homogeneous, of the four regions into which we have tentatively divided the continent of Africa. To the east it includes the countries of the Horn of Africa: northern and central Ethiopia, Somalia, Djibouti and Eritrea; in the west it ends with the the Atlantic seaboard of Mauritania; to the south, like a great belt across the middle of the continent, are the lands of the Sahel lying on the fringes of the Sahara and occupying the northern regions of Sudan, Chad, Niger and Mali; in the north are the countries of the Maghrib, 'the place of sunset', the Arab name for the lands to the west of Egypt: Libya, Tunisia, Algeria and Morocco. Finally there is Egypt itself, spanning the narrow isthmus which links two continents.

Paradoxically, not so long ago much of this region might not have been included at all in the type of pan-African study which we are attempting in this book. Part of the reason for this lies in the use of terms such as 'Arab World' and even 'Islamic World' to define much of the area under consideration. These are essentially Western constructs, and, although they may be considered useful from a classificatory point of view, they tend to obscure the religious, ethnic and cultural diversity which exists within the notional boundaries thus created. They also falsely suggest the paramount importance of external influences in shaping African culture and convey the impression of a world hermetically sealed from the surrounding European, African and Asian continents.

Of course it is true to say that, apart from the ancient Christian kingdom of Ethiopia, Islam is a predominant presence throughout this vast area of the African continent and that Arab people have played a central role in the region since the invasions of North Africa in the seventh century AD. However, one has only to look at one of the smaller countries of the region such as Tunisia to realize the breadth of ethnic and religious diversity which in fact characterizes much of North Africa, giving an enduring integrity to each country and region which is reflected in its own unique material culture. In the desert and moun-

North-east Africa and the Sahara

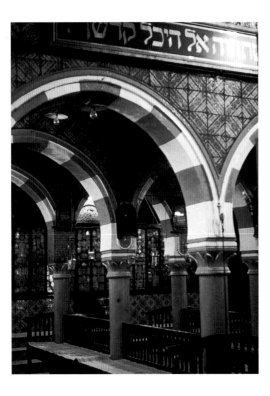

Fig. 12: Interior of al-Ghriba synagogue in the Jewish community of Hara Sghira (al-Ryadh) on Jerba Island, Tunisia. On the thirty-third day after Passover it becomes the focus of pilgrimage for Jews throughout North Africa.
Photo: C. Spring, 1998

tainous regions of rural Tunisia, Berber peoples, the indigenous inhabitants of North Africa, still make up the majority of the population, though they are joined by peoples of Arab and sub-Saharan African descent. Within the larger Tunisian towns and cities, the diversity is greater still, with substantial Jewish and Christian communities, as well as peoples of Turkish and Andalusian origin (fig. 12). Each group maintains its own customs, ceremonies and attendant material culture which is none the less very distinctively Tunisian.

Early history and trade

The urban/rural dichotomy and cultural diversity that mark Tunisia are prevalent in much of North Africa which, since antiquity, has been an area of contact and exchange between great ideologies (no. 6). Although ancient Egyptian civilization may be traced back to 5000 BC in some detail, it was not until the coming of the Phoenicians in the eleventh century BC that a little more became known of the remainder of North Africa. The Phoenicians established a trading route from the eastern

6 Lyre *(kissar)*

Wood, skin, glass, cowrie shells, metal
Sudan
19th century
Ht. 101cm, W. 95cm, Dp. 20cm
Given by Dr Southgate
Ethno 1917, 4-11.1

Lyres of this type are of great antiquity in the Nile Valley: the wide-angled Nubian lyre or *kissar* can be seen in illustrations of dancing girls in Pharaonic art. Throughout the northern, western and eastern Sudan this common string instrument is known in Arabic as *rebab* or *rababa*, an onomatopoeic word describing the throbbing sound of the instrument. In the Sudan Rebaba is also used as a girl's name. The

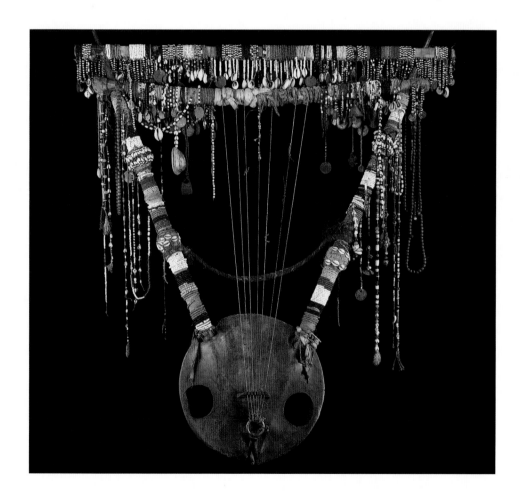

Nubian word is *kisir*. The bowl-shaped body of the *kisir* is sometimes called *kisirin ko:s*, 'the lyre's bowl', using the Nubian word *ko:s* ('bowl') which can refer also to a corresponding part of the human skull. This name is rather sinister since the Danakil of Ethiopia sometimes made the body of their *rebaba* from human skulls.

In the northern Sudan the hemispherical body is made from the *qeddah* – a shallow eating vessel carved from the white wood of the hejleej tree or from the *'ushr* bush. The *qeddah* for food vessels are smoke-blackened and have carved patterned rims; they are used for *rebaba* only when they have been discarded for domestic use, and nowadays aluminium or other metal bowls are used. In western Sudan half of a round gourd is used to give a lighter instrument which may not need an armband. In Morocco tortoise shells are commonly used.

Whereas previously, as in the case of this splendid late-nineteenth-century lyre, the strings were made of animal gut, today they are universally made of wire recycled from various industrial sources.

The lyre shown here is unusual in having two crossbars. The upper bar is purely ornamental and structurally redundant – it is flat – whereas the normal rounded crossbar, fashioned from a tree branch, has to be thick enough to have holes drilled into it to hold the wooden arms. In the rest of the Sudan outside Nubia these wooden arms are placed more closely together. A resonator made of animal skin is stretched across the bowl and held by tightly bound leather thongs. The hair is left on for decorative effect as it does not distort the sound – unlike drums, which are made of scraped hide. The resonator of this Nubian lyre has two circular holes – but three are more usual. Seven strings pass over the wooden bridge, which can be moved to adjust the tuning.

As the strings are wound over the upper crossbar they rest on bands of roughly woven cloth which act as dampers. This spectacular lyre has cloth wound around the armstruts for the purely ornamental purpose of attaching the multiple strings of coloured beads. The strap through which the player's left arm passes is in this example made of twists of plaited red cotton thread exactly like those which are still bound ritually round the wrist of the bridegroom.

Indeed the *rebab* is commonly associated with bridegrooms and weddings and even with romantic serenades. It is also commonly heard being played by lonely shepherds and goatherds. But this elaborate lyre is most unusual in its excessive but fascinating decoration: beads, cowrie shells, coins – from near and far, one as old as 1861 – bells and odd bits of brass. It is possible that, since this instrument is often used in *zar* ceremonies, the ornaments may be the accumulated offerings of grateful clients freed from torment by the music of the exorcism rite. Or it could be simply the idiosyncratic exhibitionism of the individual owner – like some overdecorated bicycles and lorry cabins frequently seen in the Sudan today.

Griselda El Tayib
University of Khartoum
Sudan

BIBLIOGRAPHY

Tobert, N., 1995, 'Lyre (*kissar*)', in Phillips, T. (ed.), *Africa: The Art of a Continent*, London: Royal Academy of Arts; Munich: Prestel

Mediterranean to Spain via a number of ports on the North African coast. Two centuries later, Carthage, near the modern city of Tunis, was founded by emigrants from Tyre. For several centuries the Carthaginians expanded the trans-Saharan trade routes, a process which was continued with even greater vigour by the Romans following the sacking of Carthage in 146 BC. Gold, ivory and slaves were traded from sub-Saharan Africa in exchange for North African pottery, cloth and glass.

One of the best-known artistic achievements, which flourished under Roman rule, was the production of polychrome mosaics which included figurative designs as well as purely geometric patterns. These detailed mosaics provide valuable information about contemporary dress styles (fig. 13), such as the straight tunic, with openings for head and arms, which was the principal item of female clothing. Today in Tunisia similar garments persist in urban environments, where they are particularly associated with marriage costumes (fig. 14).

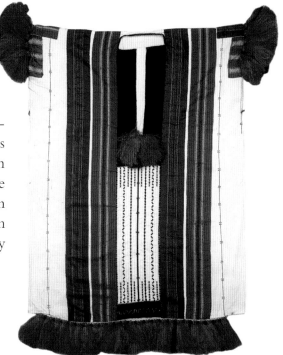

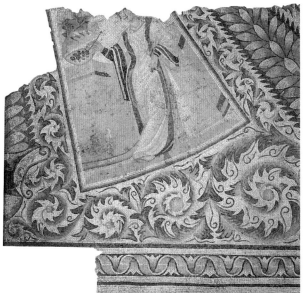

Fig. 13: LEFT Detail from a Roman-period mosaic pavement from Carthage, Tunisia, with figures representing months and seasons. This section shows 'July' dressed in a straight tunic decorated with coloured ribbons (*clavi*) similar to those seen on costumes made and worn in Tunisia today.
GR 1967, 4–5.2

Fig. 14: ABOVE In Mahdia, Tunisia, cotton tunics such as this are worn today as part of the marriage costume. Women make and attach the silk tassels and are responsible for the dense blackwork embroidery while men weave the silk ribbons.
Ethno 1998, AF1.79

Map showing countries, regions and peoples of north and north-east Africa.

Aksum and the Ethiopian empire

Apart from the desert caravans, the great trading artery linking northern Africa with the south was the River Nile. As North Africa was flourishing under the control of the eastern Roman empire with its capital at Byzantium (Istanbul), other great kingdoms were being established down the Nile at Meroë in northern Sudan and at Aksum in Tegré, a northern province of Ethiopia. Early in the fourth century AD the Aksumite kingdom was converted to Christianity and remained the focus of religious, political and military power in the region until 1632, when a capital of the Ethiopian empire was founded at Gondar in the central highlands. Even then Tegré, with its access to Red Sea ports, and thus to trade with Arabia, India and China, remained a powerful kingdom. Society in the Ethiopian empire was extremely hierarchical, with a range of material culture, particularly textiles, jewellery and arms and armour, being produced as a means of defining rank and status in religious, political and military contexts (fig. 15). In the large towns of the central and northern highlands, guilds of specialist craftsmen worked under the patronage of the church, army or state to produce the large

7 Head ornament

(*akodama*)

Silver, metal
Ethiopia
19th century
L. 60.5cm, W. 32cm, Dp. 2cm
Ethno 1866, 12-19.3

Cape (*lemd*)

Velvet, cotton, silk, metal
Ethiopia
19th century
L. 109cm, W. 103cm
Ethno 1974, AF11.11

Ceremonial shield

Skin, glass, silk, velvet, silver, gilt
Ethiopia
19th century
Diam.32cm
Ethno 1868, 10-1.1

War and hunting were always held in similarly high esteem in Ethiopia, but, following the gradual unification of the Christian empire of the central and northern highlands during the eighteenth and nineteenth centuries, the Emperor began to bestow emblems of particular distinction upon renowned warriors and hunters. The most important of these were the head ornament (*akodama*), the cape (*lemd*), and the ceremonial shield.

The *akodama*, invariably made of silver with exquisite filigree work, was described by W. C. Harris, a diplomatic member of the British expedition to Ethiopia during the reign of King Sahlä Selassé (1795–1847) as 'a type of massive silver head ornament which extends on either side of the face a considerable distance from the temples. The ends of the beam were hung with silver chains . . . whilst a row of spangled pennants across the brow, half obscured the eyes.'

Although the *akodama* was among the highest distinctions the Emperor could bestow, successful hunters received a number of other insignia. Generally these were gold earrings, bracelets and anklets (for the hunter's wife). An elephant hunter, in addition, would receive a bracelet made of elephant bones and a special headdress. The reward for a successful buffalo hunter was a pair of horn earrings. A giraffe hunter would get a silver blanket for his

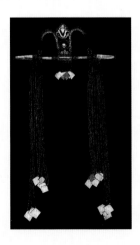

horse, weapons and a shield. The tail of his horse was bound with green silk. Since the killing of a giraffe was very highly regarded, the wife of such a hunter would receive special rights; for example, she would be allowed to draw the water first.

At the death of a successful hunter his acquired trophies were carried about in a procession. His friends loudly proclaimed the courage of the deceased and what a pity it was that he was now dead. However, symbols of distinctions like the headdress, shield and *lemd* cannot simply be passed to a son or male heir. They have to be 'earned' through bravery. For this reason many such status symbols were left to the church, to be paraded around during processions and to encourage the clergy to pray for the soul of the dead hero. Alternatively the objects were displayed in the family's home.

Magnificent capes (*lemd*) were given to noblemen with the title 'dejasmatch' or 'ras', or to famous warriors who had distinguished themselves in battle. Initially the material used for these capes was almost exclusively the skin of rare animals, but with the disappearance of many species these expensive and rare skins were replaced by fabrics such as velvet or wool. The cut of the *lemd*, however, has remained the same and still symbolizes the paws of a lion; it may have five to seven pendant strips which hang over the back and chest. *Lemd* are lined with colourful cotton or silk and richly embroidered, often with Christian motifs. Luxurious *lemd* are additionally decorated with tiny metal sequins. These capes are tied over the chest with magnificent silver or gilded buckles embellished with exquisite filigree decoration. Because lion or panther skin became so rare, *lemd* were often embroidered with the Lion of Judah. *Lemd* made of real lion skin were reserved exclusively for famous lion hunters. Ordinary warriors wore capes made of sheep, goat or monkey skin.

Ceremonial shields were generally made of buffalo or rhinoceros hide before being covered in velvet. They were subsequently decorated with silver ornaments and with strips of lion and/or leopard skin. The diameter of these shields can vary from 45 to 72 centimetres. Each province in Ethiopia has its own decorative traditions.

Ceremonial shields were usually bestowed on noblemen (*gasha*) who had distinguished themselves as big-game hunters. This example was given to a successful lion hunter; hence it is decorated with part of a lion's mane. The bearer of such a shield received great admiration and respect from the people. Ordinary 'working' shields were usually made of thick animal hide and were not decorated with metal fittings. Ceremonial shields were always carried by one of the owner's servants, who was recognized as being a brave man and who had received earrings as a mark of his courage.

Folk art paintings of noblemen and saints always show them with a number of these symbols of bravery. St George, for instance, always wears a *lemd* and carries a ceremonial shield. Although the headdress, *lemd* and shield were originally gifts from the Emperor for bravery, they became general status symbols given to high-ranking individuals and, towards the end of the nineteenth century, even to foreign dignitaries as well.

Fisseha Girma
Staatliches Museum für Völkerkunde
Munich
Germany

BIBLIOGRAPHY

Girma, F., 1988, 'The Hunt in Ethiopia', *Tribus*, vol. 37: 37–51

Girma, F. and Raunig, W., 1985, *Mensch und Geschichte in Äthiopiens Volksmalerei*, Innsbruck

Harris, W. C., 1844, *The Highlands of Ethiopia*, 3 vols, London: Longman

Pankhurst, R. and Ingrams, L., 1988, *Ethiopia Engraved*, London: Kegan Paul

range of artefacts which denoted the hierarchy within these institutions. During the eighteenth and nineteenth centuries the continued unification of the empire helped to facilitate overseas trade, and the imported velvets and silks used on capes and costume of all kinds, as well as on shields and sword sheaths, became much more easily available (no. 7). Furthermore, the Maria Theresa dollar, a coin minted in Austria from the mid eighteenth century and imported in vast quantities to north and north-east Africa, presented a source of silver to Ethiopian craftsmen and to silversmiths in rural areas of North Africa for whom this metal had hitherto been a scarce commodity. These coins may sometimes be seen on the pommel caps of Ethiopian swords, not simply as decoration but as an acknowledgement of the economic – and thus military – power they represented (fig. 16).

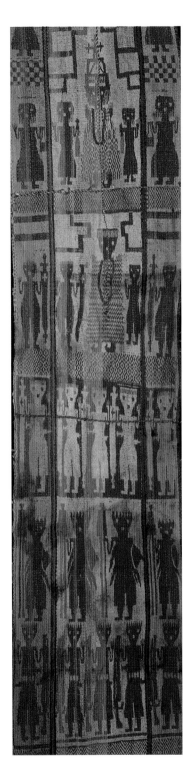

Fig. 15: RIGHT Detail from a tablet-woven silk panel, probably the central part of a triptych woven in Gondar, Ethiopia, in the late eighteenth century. This section shows Queen Mentuab in the top register, with her son, Iyasu, immediately below.
Ethno 1868, 10–1.22

Fig. 16: BELOW Detail of the rhinoceros-horn hilt of an Ethiopian sabre with a pommel cap which is a Maria Thresa dollar.
Given by Mrs Speedy
Ethno 1912, 4–10.24

The Arab invasion and the Hispano-Moresque civilization

In the seventh century AD Muslim armies overthrew Byzantine rule in North Africa and the Levant, initially aided in this conquest in Egypt by the Coptic Christian community. However, the thrust westwards was vigorously resisted by indigenous Berber-speaking groups, and the spread of Islam in North Africa was gradual and remained incomplete.

In Egypt the arrival in 969 of the Fatimids (a dynasty, named after Fatima, daughter of the Prophet Muhammad, which ruled in North Africa from the early tenth century and later in Egypt) marked the beginning of an unprecedented period of artistic patronage and expansion. Ceramic production gained impetus during the next two centuries and entailed a significant expansion of the decorative repertoire, which included human and animal figures, and a mastery of the technique of lustreware. Textile factories producing luxurious and costly goods flourished. The early rulers of the Fatimid dynasty bestowed gifts of textiles and garments on officials and relatives as marks of favour and status. Following the establishment of the Berber Almoravid dynasty in Marrakesh in 1060, the conquest of north-west Africa and Muslim Spain was finally accomplished. This, and the subsequent Almohad dynasty, heralded the establishment of the Hispano-Moresque civilization in Spain, which flourished for several centuries.

During this period of conquest and resistance, trading networks continued to expand, not only across the Sahara to West Africa but also from Spain through the Maghrib to Egypt and the Middle East, or via the Red Sea to India and China. Evidence of the trans-Saharan trade may be found in the eleventh-century grave goods discovered in caves on the Bandigara escarpment in Mali. Here fragments of cloth, bearing geometric designs and using techniques known in rural North African textile manufacture, occur alongside narrow-strip woven cloth characteristic of coastal West Africa. Not surprisingly, when the Portuguese arrived on the Guinea coast in the late fifteenth century, they found that there was a great demand among local people for cloth and other North African artefacts.

The Hispano-Moresque civilization, which represented a period of great enlightenment and cultural exchange between southern Europe and the Orient, was increasingly eroded by expansionist Christian armies in the Iberian peninsula, culminating in the fall of Granada in 1492.

At this time large numbers of Jewish and Muslim artisans were expelled from Spain and settled in the great cities of the Maghrib. Although remarkably few objects survive from the Hispano-Moresque civilization, evidence of its glory may still be found in the products of artisans working in North Africa today and in the recent past. The development of silk weaving in Tunisia reveals something of the weavers' origins and of the

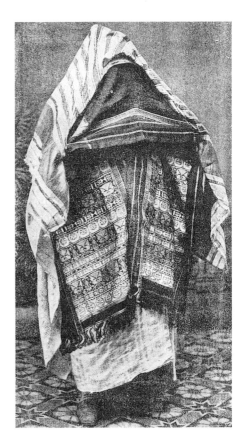

Fig. 17: RIGHT Wealthy women in urban Tunisia during the nineteenth and early twentieth centuries wore veils when outside the home. This example ('*ajar*) has a central opaque section which preserves her 'modesty' while allowing her to see.
From L. Bertholon and E. Chantre, Berbérie orientale, *Lyon, 1913, vol. I: 460.*

Fig. 18: BELOW Interior of a workshop in Mahdia, Tunisia, showing a draw loom in action. The young boy operates four supplementary heddles which he draws up in sequence to produce the pattern elements on the silk ribbons (*hashiya*).
Photo: J. Hudson, 1998

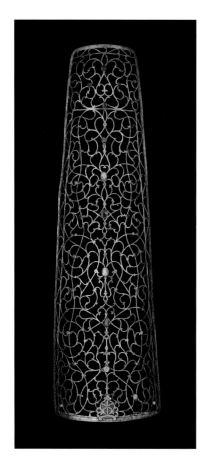

Fig. 19: For a short period until the end of the nineteenth century distinctive openwork gold or silver headdresses (*sarma*) were worn in urban Algeria by Muslim women. Jewish women wore similar headdresses, but only in silver, as the use of gold was prohibited.
Given by Mrs Eustace Smith
Ethno 1906, 12–20.1

patterns and technology they employ. In the village of Testour during the nineteenth century, families of Andalusian descent produced magnificent women's veils (*'ajar*) employing elaborate patterns drawing on motifs influenced by Andalusia and Turkey (fig. 17). Exiled weavers also introduced new techniques and equipment, notably the 'draw loom' which is used today in Tunisia to weave narrow silk ribbons with complex design elements (fig. 18). During the Hispano-Moresque period patterned cloths were woven in Spain and Portugal using this same technology.

Immigrant Jewish craftsmen rapidly established themselves as skilled metalworkers, forming jewellery guilds, based in major towns. The techniques of filigree, cloisonné, niello and enamelling formed the basis of jewellery-making in the Maghrib (no. 8). In this craft, as in most others, there is generally a clear distinction between rural and urban traditions: the use of gold or gilded silver was primarily associated with urban jewellery, while rural populations showed a preference for silver (fig. 19).

The Berber peoples

Although initially the Arab invasion of North Africa was strongly resisted by the indigenous Berber population, over time the various groups which make up this diverse but linguistically related people were forced to retreat to mountainous rural regions or, like the Tuareg, to the desert. This pattern remains very much the same across North Africa today. Berber peoples tend to be concentrated in remote areas from Siwa Oasis in the east to the Atlas Mountains in the west and in the Sahara to the south where, for many centuries, the Tuareg controlled the major caravan routes and still occasionally exert their influence.

Early accounts, such as that of Herodotus in the fifth century BC and of Strabo in the first century, refer respectively to the ostrich-skin

8 Head ornament
(taounza)

Silver, niello
Aït Seghrouchen, Talsint, Middle Atlas, Morocco
20th century
L. 52cm, W. 23cm
Given by Major and Mrs P. H. G. Powell-Cotton
Ethno 1936, 10-5.12

Throughout North Africa jewellery is more than simply an ornament or a sign of wealth, it is the very basis of social status and a sign of belonging to the tribe. It is regarded as the family's cash capital and plays the same role as our modern-day bank accounts. But it also has a deeper meaning because it is endowed with magical, therapeutic and prophylactic powers according to the form, the materials or the colours used. As an essential part of the wedding costume, jewellery protects, brings good fortune and guarantees female fertility. The profusion of head ornaments, necklaces, pectorals, earrings, bracelets, rings and anklets, for example, protects the vulnerable young bride from the evil eye. The acquisition of a bride's jewellery requires a substantial financial investment which few families can afford; wealthier families, therefore, willingly lend their jewellery to a young bride of more modest means so that she can be richly endowed on her wedding day. It is believed that the jewellery will be returned charged with the bride's good fortune (*baraka*).

Berber jewellery is always made of silver or of copper covered with silver. This silver is obtained by melting down coins or jewellery that has been sold or is damaged. Whether

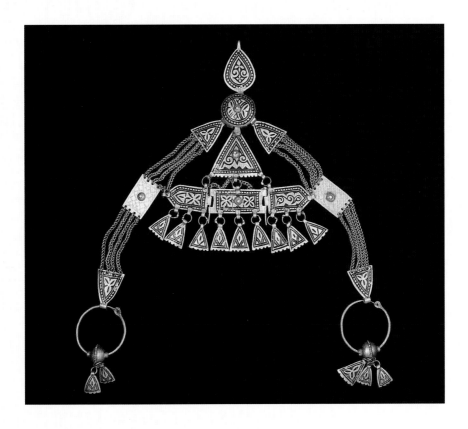

low-grade or sterling silver, it is melted, moulded, perforated, worked in repoussé, stamped, engraved, chiselled and granulated, but also decorated with filigree or inlaid with niello (a black oxycedar resin). Jewellery may also be embellished with coloured stones or glass cabochons, inset with enamelled cloisons, or with amber and coral and further ornamented with pendants and coins.

In Berber jewellery the decoration is mainly geometrical in shape (triangles, lozenges, check patterns, zigzags, chevrons, circles, lines and parallel stripes), but also includes stylized floral motifs and animal figures to which the Berbers ascribe magical powers: depictions of the head of a snake or the horns of a ram, the lizard, the salamander, birds and fish are found on bracelets, earrings and brooches. The powers associated with these animals date from ancient pre-Islamic beliefs. Cosmological motifs (the crescent, star, moon and sun) are also believed to be prophylactic and to bring good luck because they symbolize fecundity. Although jewellery is worn on a daily basis as women pursue their everyday chores, the most beautiful pieces are stored inside the house in wooden chests and are reserved for major family celebrations or religious ceremonies.

The Aït Seghrouchen tribe, which inhabits the north and south-east of the Middle Atlas mountains, is renowned for the forms, techniques and ornamentation of its jewellery, which is characterized by the use of niello. While geometric patterns belong to a pre-Islamic rural-based cultural family, surface decoration in the form of arabesques and stylized floral motifs is reminiscent of Hispano-Moorish traditions. These decorative motifs, mastered by Jewish smiths, have thus enabled the fusion of two cultures to create an autonomous artistic form which survives today, even if regional styles are disappearing in the wake of the influence of Western models and fashions. However, local traditional jewellery continues to be worn for significant life-cycle ceremonies, such as marriage, because it remains invested with the messages and functions which generations of women have associated with it.

The greatest variety of forms is seen in the range of fibulae and head ornaments (worn on the head or around the forehead). The *taounza* is the most valuable head ornament: it changes its form and decoration from region to region. This *taounza* was acquired in 1936 in Talsint, in the south-east of the Middle Atlas mountains, by Major and Mrs Powell-Cotton. The history of jewellery (and of niello) in that region remains obscure, although we do know of a *mellah* (district set aside for Jews) in the town of Talsint, which was active until the middle of the twentieth century. This *taounza* has all the traditional characteristics: three central plaques linked with small chains and decorated with triangular pendants form the forehead ornament while earrings are suspended from further plaques and chains. The finely engraved geometric and stylized floral motifs are inlaid using a technique typical of the Middle Atlas region. A black oxycedar resin (*taqa*) is melted, then laid on the engraved sections of the jewellery, which is then heated; once it has cooled, the top surface is filed and scraped so that the black colouring remains only in the hollowed-out areas. A similar piece is to be found in the collections of the Musée des Arts d'Afrique et d'Océanie in Paris.

Marie-France Vivier
Musée des Arts d'Afrique et d'Océanie
Paris
France

BIBLIOGRAPHY

Besancenot, J., 1939, *Bijoux Arabes et Berbères du Maroc*, Casablanca: Édition de la Cironge

Eudel, P., 1906, *Dictionnaire de bijoux de 'l'Afrique du Nord'*, Paris: Ernest Leroux

9 Shield (*ayar*)

Skin, metal, wool, leather
Tuareg, central Sahara
20th century
L. 114cm, W. 79cm
Ethno 1990, AF11.1

The piece shown here is a classic model of Saharan Tuareg shields. A defensive device, it protected its bearer against the double-edged blade of his opponent's sword (*takouba*) and against the spears, arrows and even the lead bullets of old firearms used by his enemies. It also protected him from the claws of wild animals.

This shield is made from the hide of an oryx (*ehem* in Tuareg), an antelope from the savannah with long straight horns, hunted down until it dies of exhaustion so that the

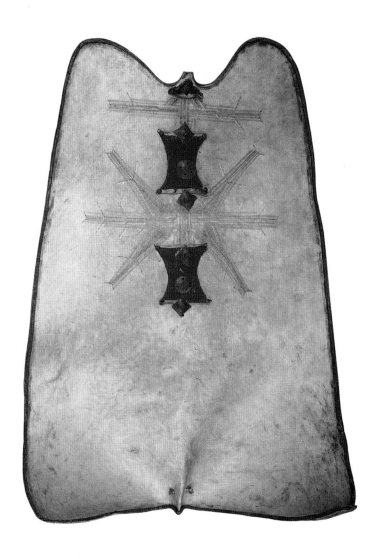

hide remains unscathed. Once all the hairs have been removed, the skin is tanned and hardened using plant-based products. Although nearly translucent, it is extremely resistant to blows and will capture any blade which may have succeeded in penetrating it.

The overall shape of the shield is that of a trapezium, higher than it is wide and with top and bottom edges that are symmetrically concave and curved at the corners indicating where the legs of the animal began. A slight bulge remains in the centre of the top and bottom edges where the base of the neck and tail used to be. Each of the bottom corners is folded out towards the front so that the shield can be held vertically and close to the ground; it also helps to keep an opponent's legs at a distance and to form a wall of shields when held side by side. Around the edges of the shield, the hide is rolled towards the front, thus forming a tight rim, dyed black, which reinforces the rigidity of the shield. An iron handle in the shape of a stirrup is fixed vertically at the back of the shield with rivets. A small rope is tied to the handle so that it can be carried over a man's right shoulder if he is on foot or tied to the left side of the saddle if he is mounted on a horse or camel.

The upper part of the shield is decorated with a stylized cross. The horizontal band of decoration near the top of the shield has a small triangle above it, while the lower horizontal band is divided by other bands, placed at 90 degrees, like the spokes of a wheel. The structure of the drawing is composed of parallel lines arranged in pairs of unequal length, similar in design to a section drawing of cylinders fitted into each other, with the longest and the narrowest in the middle and with flaring extremities. All of these lines are engraved with a knife. For some Europeans the motif is reminiscent of the emblem of the Crusaders, but the Tuareg call it the *agaïs*, the bustard, a savannah wader with a short and ponderous flight. Three pieces of red material

edged with green leather are fixed to the vertical bar of the cross intensifying the decoration. The upper triangular piece and the other two rectangular ones with concave sides are held at each corner with a small brass stud. The latter pieces are each further embellished with two pyramid-shaped tin-plate ornaments and a perforated semi-sphere. These ornaments are actually the heads of the rivets which fix the handle. Some believe that the circular shape of two of these ornaments, together with the intersections of the cross, represent the letters of the word *tifinagh*, an auspicious term having the value of a talisman.

There are other models of Tuareg shields, different in shape (more curved or with one 'leg' larger than the other), or in texture (using hides of giraffes, lions, Mohor gazelle or buffalo), or in decoration (stamped design and ironwork only without additional pieces of cloth or with, on the contrary, additional textile patches near the edges).

Old shields are rare. Many did not survive the impact of colonization and the ineffectiveness of leather against modern weapons has halted their production. Some chiefs still carried shields at official ceremonies in the 1930s to enhance their imposing bearing. Military personnel and administrators brought examples home and these have been handed down as inheritance and can be found at auctions and in museums. The shields that are used today in Tuareg festivities are, generally speaking, mediocre imitations of fanciful shape and size.

Michel Vallet
Membre de la Société des Explorateurs Français
Nantes
France

BIBLIOGRAPHY

Gabus, J., 1958, *Au Sahara*, Neuchâtel: Baconnière

Spring, C., 1993, *African Arms and Armour*, London: BMP

shields and the iron javelins of peoples living on the Mediterranean littoral of North Africa. These may well be the forerunners of the modern-day Tuareg shield (*ayar*), made of white, translucent antelope skin, and the iron spear (*allarh*), both quite unique in their form and composition (no. 9). The first substantial account of these shields, however, is drawn from the thirteenth-century reports of al-Maghribi, an Arab traveller who witnessed their manufacture in a town known as Kakudam, probably in the north-western Sahara. Al-Maghribi makes reference to the magical properties of the shield, which, in more recent examples, is enhanced by the accumulation of symbolic elements on its face designed to avert the 'evil eye'.

Egypt's western oases and the Sinai

The inhabitants of Egypt's marginal agricultural areas (those based away from the Nile Valley) display distinctive cultural traditions which confirm historical and trading links with the Nile Valley and Nubia as well as with the Bedouin tribes of the Sinai, Palestine and Jordan. In the Western Desert the oases of Dakhla, Kharga, Bahriya and Farafra share certain common characteristics in costume and jewellery styles. Married women's dresses made of black cotton are A-line in shape with long straight sleeves. The chest panel, front and back hems and sleeves are richly embroidered using a variety of stitches and further embellished with coins or stamped metal discs. However, oases, and even individual villages, retain distinctive styles of embroidery and colour preferences.

Jewellery types appear to draw some inspiration from Nile Valley models. Metal discs worn in the oases presumably derive their form and decoration from the popular *zar* amulets (used in a ceremony to ward off evil spirits). Colourful bead necklaces and collars worn in Bahriya Oasis today closely resemble nineteenth-century examples which were produced in the region around Asyut (fig. 11). More ancient links, possibly dating back to the Egyptian Predynastic period (c.3500–3000 BC), may be seen in a distinctive type of pottery vessel made by men, using a kick-wheel, in Dakhla Oasis today. These elongated pots, used by women for churning butter, display continuity of both form and function (fig. 20). 'Milk-churns' of similar shape were recorded by Sir Flinders Petrie at Ehnasya (modern Ahnas al-Medina); further examples appear in tomb scenes dating to the New Kingdom (c.1650–1070 BC).

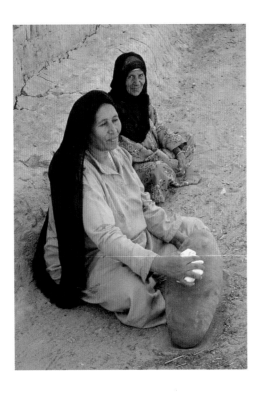

Fig. 20: Today in Baris village, Kharga Oasis, Egypt, women make butter using locally made pots (*garra*). The process of tipping the pot from side to side separates the curds and whey.
Photo: C. Spring, 1991

Dresses worn by Bedouin women living in the Sinai and the Eastern Desert of Egypt are of a similar basic form to those of the Western Desert oases, although the exclusive use of cross stitch, and the more formal floral and geometric patterns and their placement, show a marked resemblance to Palestinian costumes. Prior to 1948 inter-marriage between Palestinians and Egyptians was common in this region; subsequently refugees from Palestine settled in the area, bringing with them local embroidery styles and patterns. Further evidence of cultural exchange is seen in specific items of silver jewellery worn today by Bedouin women of the Negev Desert but crafted in Egypt.

The evil eye

Throughout North Africa recurring decorative motifs appear on a whole range of rural artefacts – textiles, pottery, woodwork, weapons (fig. 21), leatherwork and jewellery – as well as being incorporated into buildings and used to decorate the human body. It is thought that many of these designs are associated with protection against the 'evil eye'. Put simply, this concept represents the fear of envy, in particular the first covetous glance cast by one person on the property of another. It is a belief which is by no means peculiar to the Berbers – it was prevalent throughout the Mediterranean long before the coming of Islam and was

assimilated into the teachings expounded in the Qur'an. In North Africa one of the most widespread means of countering the evil eye is by use of the number five (*khamsa*). Patterns or stylized representations of objects incorporating five elements, such as the hand or combs, are popular protective motifs (no. 10). The first and most dangerous glance is often directed towards a repellant object, such as a skull or a bone. Mirrors or designs in the form of the eye are frequently used to reflect the malevolent glance. Ayt Hadiddu brides from the High Atlas mountains of Morocco cover their faces during the wedding ceremony with headscarves decorated with tie-dyed yellow lozenges on a red base; the pattern created is called the 'little mirrors' and is believed to be efficacious in reflecting the evil eye. Similarly the splendid semi-circular cloaks (*akhnif*) used by men in the Ouaouzguit region of Morocco bear a distinctive orange-red 'eye' across the back (fig. 22). Other prophylactic devices include sharp implements such as knives or swords which symbolically pierce or attack the eye. Geometric patterns woven into women's shawls from southern Tunisia are given names such as 'scorpion' or 'snake', which may be interpreted as defensive elements.

A similar repertoire of mainly geometric motifs is also seen on pottery. In rural areas across North Africa women are primarily responsible for producing utilitarian pottery for their own domestic use. Rural pots are invariably unglazed, although certain vessels from the Kabylie region in Algeria

Fig. 21: Detail of the hilt and upper part of the sheath of a sabre (*flissa*) used by Kabylie Berbers in Algeria. Many of the decorative motifs are prophylactic devices against the 'evil eye', particularly the exaggerated eye of the stylized creature on the pommel cap.
Given by Henry Christy
Ethno 1626

bear a surface resin (no. 11). Function, form and decoration continue long-established traditions: white-slipped Kabylie pots with brown-black geometric patterns show a remarkable resemblance to Neolithic Cypriot vessels (fig. 23). As with textiles and other objects in rural North Africa, patterns on pottery vessels are named. Terms most frequently used include 'serpent', 'fibula' , 'eye of the partridge'. However, these may not always be applied to the same motifs, perhaps suggesting that

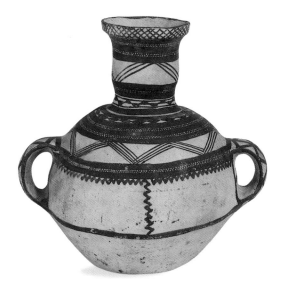

Fig. 22: TOP Detail showing the 'eye' design which decorates the back of men's wool and goat hair cloaks worn in the Anti-Atlas mountains, Morocco. The cloaks are woven in a semicircular shape on vertical looms by women; further patterns are embroidered by men.
Given by A. W. Franks
Ethno +5773

Fig. 23: LEFT An unglazed, hand-built pot from the Kabylie region, Algeria, decorated with geometric patterns based on lozenges, zigzags and triangles. A similar set of motifs is employed on textiles and used for women's tattoos.
Given by Mrs Eustace Smith
Ethno 1899, 12–8.6

names have symbolic value rather than being based on actual resemblance.

The use of specific images such as the fish appears to have a more direct prophylactic motivation. Urban ceramics in Tunisia are frequently decorated with fish. Weavers suspend fish-tails from the sides of their looms and stylized fish are carved on to carding combs. Buildings under construction prominently display fish-tails or bones and brightly coloured plastic or cloth fish covered with sequins hang from car mirrors (fig. 24). This popular image is widely believed to protect against the evil eye at home, at work and in transit.

Fig. 24: Fear of the malevolent influence of the 'evil eye' pervades all aspects of daily life. A fish-tail fixed to the radiator grille and a fish-shaped amulet suspended inside this van provide ample protection for the vehicle and its contents (olives), as well as the driver and passengers in Sfax, Tunisia.
Photo: C. Spring, 1998

On certain auspicious occasions such as birth, marriage or circumcision, the fear of malevolent forces is especially prevalent, and numerous measures are taken to avert this perceived threat. Costumes and textiles prepared for the event will be endowed with amulets, thought to protect or bring good luck (no. 12). Wedding dresses worn in Siwa Oasis in Egypt are liberally decorated with beaded hand amulets and, today, with coloured plastic horseshoes.

Although the combinations of colours and design elements employed on artefacts in rural areas of the Maghrib vary enormously, and may be known by different names in different regions, the morphology of the elements themselves is remarkably homogeneous. After so many centuries of invasion and occupation by foreign peoples, it is a testimony to the resilience of the cultures of North Africa that this symbolic language still plays such a vital part in the products of weavers and other artisans.

The Ottoman period

The Ottoman expansion into North Africa during the sixteenth century heralded a period of cultural exchange which remained undiminished until the colonial period in the late nineteenth century. Turkish designs and techniques were integrated into existing material systems,

10 Man's tunic (*gandura*)

Wool
Berber, Mzab, Algeria
Early 20th century
L. 92cm, W. 78cm
Given by Mrs Eustace Smith
Ethno 1910, 5-3.2

The term *gandura* was generally used to refer to a specific type of straight, sleeveless tunic worn by men on formal occasions or during the winter months. This item was particularly associated in Algeria with the valley of the Mzab, where its form remained remarkably consistent.

This tunic was notable for its coloured blocks of discontinuous weft-faced plain weave, known as tapestry weave, a technique especially associated with Berber areas of North Africa. It was the first cloth woven for a male child by its mother and was also produced by women for the marriage of their sons (if the wedding took place in the winter). Today it is also worn at 'folklore' festivals.

Each family had its own loom and made its own *gandura*. The tunic usually has a dark-coloured background which the weaver decorates with a wealth of motifs inspired by aspects of her surrounding environment, her daily life and her beliefs. The motifs used reflect her maternal concerns: grains of couscous indicate fertility and wealth, candlesticks symbolize light, while weaving combs and the scorpion are included as protective devices against the evil eye. Numerous other designs are used such, as the bed or jewellery. The motifs, which are woven predominantly in red, orange and green, are strikingly arranged in vertical bands.

Today, the term *gandura* no longer refers to this item of clothing. The name has been transferred to describe wall-hangings, woven using the same technique, which employ a similar repertoire of motifs, colours and symbolism.

A. Aiche Amamra
Musée National des Arts et Traditions Populaires
Algiers
Algeria

BIBLIOGRAPHY

Parienti, R., 1953, 'Les tissages Mozabites', *Cahiers des Arts et Techniques de l'Afrique du Nord*, vol. 3: 49–57

Reswick, I., 1985, *Traditional Textiles of Tunisia and Related North African Weavings*, Los Angeles Craft and Folk Museum (distributed by University of Washington Press)

11 Amphora

Pottery, pigment, plant resin
Berber, Grande Kabylie, Aït-Mesbah, Algeria
20th century
Ht. 89cm, W. 34cm
Ethno 1973, AF11.1

In rural areas of Algeria pottery production
remains one of women's main domestic
activities. The optimum period of production
is springtime; vessels that have been broken
during the year are replaced, and the temper-
ate climate allows a slow and even drying
process. Potters select clay to suit the type of
vessels they are making and whether they will
be fired or left to dry naturally. Once the clay
has been collected, any impurities which
might cause cracking during the firing process
are removed and the clay lumps are crushed
and left to dry in the sun. The clay is then
soaked in water which is left undisturbed in
order to avoid the formation of air bubbles.
The following day, this paste is kneaded and
temper, in the form of powdered potsherds, is
sieved and then mixed in to improve the
quality of the composition. Individual potters
will determine the correct proportions of fired
to non-fired clay. This process of preparation
is the same throughout rural Algeria; the main
differences in pottery production lie in the
application of the decoration, which varies
from potter to potter.

The potter uses a plant resin, obtained from
the Aleppo pine tree, to give the pots a shiny
surface. Amongst the ceremonial objects made
in Aït-Mesbah is an amphora used to carry
water, with two long symmetrical handles

which extend from the neck to mid-body. The circular base is sufficiently large to enable it to stand upright easily. The lavish decoration draws on a wealth of local symbols and motifs from earlier periods.

Undoubtedly the most important decorative element on this vessel is the *khamsa* (five), which occurs on the front and back surfaces. The *khamsa* is used as a popular protective motif against the evil eye and in this instance is doubly efficacious as it takes the form of a snake, itself associated with fertility. The line of interlocking red and yellow chevrons represents the snake's skin.

On either side of the *khamsa* two raised medallions, with central chequered motifs in black and yellow (originally white, prior to the application of the resin), represent the cells of a honey-comb; the bee is associated with hard work, abundance and marital faithfulness. The medallions are encircled by yellow dots on a red background which symbolize tortoise eggs, thought to protect people from jaundice.

The upper part of the body of the pot is separated from the bottom section by a black line symbolizing the earth. The five wavy 'furrows' emanating from this line represent the soil and fertility, whilst the black dots below it symbolize the beads of a necklace, signifying wealth. The rural origin of this elegant pot with its slender foot and elaborate handles is confirmed by the abundant use of agrarian symbolism in its decoration. Women potters draw inspiration from their local environment incorporating jewellery, plants and animals into their decorative repertoire. Today the *khamsa* is often replaced by the horseshoe.

A. Aiche Amamra
Musée National des Arts et Traditions Populaires
Algiers
Algeria

BIBLIOGRAPHY

Balfet, H., 1966, 'Ethnographical observations in North Africa and archaeological interpretation: the pottery of the Maghreb', in Matson, F. R. (ed.), *Ceramics and Man*, London: Methuen & Co. Ltd

Van Gennep, A., 1911, *Études d'ethnographie Algérienne*, Paris: Ernest Leroux

12 Wedding tunic

Cotton, wool, tulle, metal, silk
Raf-Raf, Tunisia
20th century
L. 110cm, W. 116cm
Ethno 1991, AF15.1

There are two essential components in the traditional costume of Tunisian women. One of these is a draped cloth, comprising a large rectangle made of silk, cotton or wool, which women wrap around their body and fix with one or two fibulae on the chest and a belt around the waist. The second is a very simple 'cut-and-sewn' tunic. Although its width varies, this garment is usually straight with seams on either side; the material is folded over at the shoulders. Not all designs include the addition of sleeves, but, when they do, these are often cut from a more luxurious material than the one used for the body of the tunic. The neck-line is round or square, sometimes with a collar, and always extended with a straight slit for the head to fit through the neck.

This basic Tunisian costume of draped cloth and tunic has been in place since time immemorial but is increasingly being replaced by universal fashion styles and is now only really commonly used for weddings. Although both items of costume occur in towns and villages throughout Tunisia, the details of their design vary from region to region. Each area is characterized by the use of specific cloths and colours and particularly by different styles of decoration, often based on embroidery.

In the small village of Raf-Raf in the north-east of Tunisia, women have invented one of the most original costumes of the country with lavish embroidery decorating the numerous jackets, trousers and tunics. Each tunic, worn for a particular ceremony, is cut from a different cloth. Silk, wool or standard cotton cloth are frequently used to make the tunics which the women then decorate with embroidery. The *mouechma*, or 'tattooed' tunic, which the bride wears on the third day of her wedding, is uniquely characterized by 'overflowing' decoration. A simple tunic made of plain cloth in a basic design has become a work of art in the hands of the embroideress. The luminous colours of the wool so typical of Raf-Raf compete with the sparkle of the golden sequins and blue and pink metal threads which are unknown outside the village. In Tunisia, the widespread use of embroidery with sequins and gold-covered wire thread is epitomized in this tunic where techniques and styles come together to please the eye.

This *mouechma*, with its tulle sleeves embroidered with wool and silver and its imposing bodice on which flowers are blossoming and colours and motifs are entwined, cannot simply be described as part of a costume. It is a hymn in praise of the embroiderers from this village rocked by the nearby sea.

Samira Gargouri-Sethom
Musée National du Bardo
Tunis
Tunisia

BIBLIOGRAPHY

Ginestous, L., 1954, 'La tunique brodée de Rafraf', *Bulletin de Liaison de l'Office des Arts Tunisiens*, vol. 1: 13–20

Stone, C., 1985, *The Embroideries of North Africa*, London: Longman

the resulting garments and other artefacts having recognizable elements which none the less combine to form magnificent hybrids which are characteristic of particular regions. This influence was almost entirely confined to the accessible urban areas, whose cosmopolitan populations encouraged this eclectic approach.

The art of embroidery expanded significantly in urban Algeria during this period. Algiers in particular established a reputation for the exquisite quality of its linen-based hangings, curtains and garments, many of which were produced in the home in preparation for marriage. The use of low wooden embroidery frames (*gourgaf*) and the predominant floral design elements (stylized carnations, tulips and roses) reflect Turkish inspiration. A related corpus of design elements can be seen on the elaborately painted wooden furniture which graced wealthy urban homes (fig. 25). In contrast to the manufacture of rural pottery, urban ceramics were produced for a commercial market by male artisans employed in workshops or specialist guilds. The vessels were wheel-made, glazed and decorated with a wider range of motifs which incorporated external influences alongside indigenous designs. A small square (*Place des potiers*) on the north-east edge of the Tunis medina (old city) today provides the only tangible evidence of the extensive quarter

Fig. 25: OPPOSITE BELOW In urban Algeria beautifully decorated chests were used to display and then to transport the bride's trousseau to her new home. This twentieth-century example, from Algiers, was painted by the well-known artisan Mustafa Adjaout. *Photo: Musée des Arts et Traditions Populaires, Algiers*

Fig. 26: TOP RIGHT This house in Kharga Oasis, Egypt is decorated with the image of an aeroplane (presumably the pilgrim's mode of transport on the *hajj*) as well as the Dome of the Rock, Jerusalem, and the Ka'ba in Mecca. Men and women who have made this journey enjoy local esteem, and such representations are a public expression of family pride. Photo: C. Spring, 1991

Fig. 27: RIGHT The swords depicted in this fourteenth-century Arabian manuscript, the *Zoology of al-Jahiz*, have straight blades and cross-hilts. It seems probable that they are the prototype of contemporary weapons from Sudanic Africa such as the *takouba* and the *kaskara*.

formerly known as al-Qallaline, which was renowned for the quality of its ceramic production from the beginning of the Hafsid period (1207) to the end of the nineteenth century.

Although cultural exchange with Europe was diminished following the fall of Granada, trade with the Middle East and Asia continued unabated. The constant passage of pilgrims making their way to Mecca assisted enormously in this process. One major route led through the Maghrib countries to Cairo, another along the southern fringe of the Sahara to the Red Sea ports. Today buses, trains and aircraft make the trip easier, modes of transport which are exuberantly recorded on the whitewashed walls of houses belonging to pilgrims who have made the *hajj* from the Saharan oases to the holy cities (fig. 26).

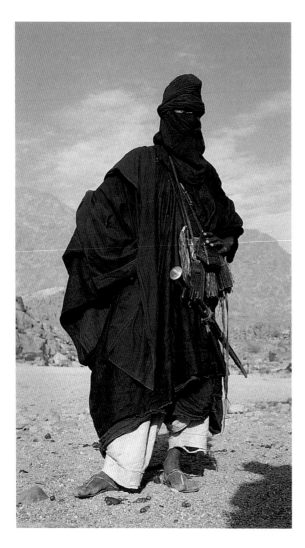

Fig. 28: LEFT A Tuareg man from the Aïr Mountains, Niger, wearing a sword, *takouba*, with finely worked leather sheath, as well as dyed and tooled leather pouches and charm cases.
Photo: R. Balsom

Fig. 29: RIGHT Detail of a finely tooled, dyed and painted leather water bottle from Mauritania. The central design of five interlocked squares is one of the myriad variations of the motif *khamsa* (five) used to deflect the evil eye.
Ethno 1979, AF1.461

Evidence of this cultural exchange between Africa and Arabia is still recognizable in contemporary material culture. To take just one example, the cross-hilted, straight-bladed swords which are still the most prized possessions of men in this region, stretching from the Niger to the Nile, were long assumed to be archaic survivals of Crusaders' weapons (no. 13). Nothing could be further from the truth, however, though the assumption that the cross is an exclusively Christian symbol has led Europeans to misinterpret African iconography on more than one occasion. In fact, these weapons derive their form from the straight-

bladed medieval Arabian swords which the early pilgrims from Africa would have encountered on their travels (fig. 27). The curved swords which are associated with Islam in the Western imagination, and indeed the depiction of *dhulfaqar*, the sword of the prophet Muhammad, with bifurcated blade, are all later inventions. The sword is an immensely more important symbol in Islam than in Christianity and this, combined with the fact that *dhulfaqar* was a straight-bladed, double-edged sword with cruciform hilt, perhaps accounts for the enduring importance of this weapon in the African Sahel. Although from the sixteenth century fine blades were traded across the Sahara from European smithies, the production of this single weapon remained the luxury stock-in-trade of smiths and other craftspeople in the Sahel for centuries and it is still produced in large quantities.

13 Sword and sheath

Iron, silver, metal, leather, skin
Sudan
L. 111cm
On loan from H.R.H. the Duke of Edinburgh
Ethno 1975, L1.3.a-b

Sword and sheath

Iron, leather, brass
Gbaya, Cameroon
L. 86cm
Given by University College of Wales
Ethno 1969, AF35.71a-b

The smaller sword with the tapering blade and small broad crosspiece is typical of the Tuareg *takouba* sword and is used by many groups in northern Nigeria and neighbouring regions. Tuaregs of the Bouzo clan migrate from the Sahara to work periodically as nightwatchmen in Kano and carry these swords at their hips as they go patrolling by night with their right hand on the hilt and their left hand grasping a torchlight. During daylight they lovingly sharpen their sword blades with a large pebble and shine up their leather scabbards. These are dyed with indigo and polished with beeswax and are decorated with raised and embossed patterns. The woollen baldric worn over the shoulder is usually of brightly coloured wool and is intricately macraméd by women for their often absent husbands. The Hausa and other south Sahara groups also use this type of *takouba* sword for serious fighting. In May

1966, during a major uprising in Kano, hundreds of such swords suddenly appeared from hidden stores inside the market of the walled city.

From Chad and Darfur right across the Sudan to the Red Sea, the longer, heavier, double-edged broadsword has been in use since the fifteenth century and is still commonly carried when travelling by tribal groups in Darfur, the Shukriyya in the Butana and the Hadendowa of the Red Sea hills. The Hadendowa come to Kassala to sell their well-worn 'antique-looking' swords to the tourists and then order new ones from the blacksmith. He adds the hilt and wide crosspiece, which resemble the old Crusader sword, to the imported steel blades and decorates the hilt with leather and reptile skin and the pommel with a silver finial. The finest swords of this kind are handed down from generation to generation in the northern Sudan in families of traditional warrior ascendancy. As ceremonial symbols of masculinity, they are still brandished by the bridegroom during the wedding procession or placed on the bed of the newly circumcised boy even in urban areas today.

The leather scabbard of the Sudanese sword is typified by the bulging leaf-shape tipped with brass or silver. This bulge is designed to protect the leather from being rubbed by the sharpest part of the sword-blade. In Darfur this leather scabbard with its wide shoulder strap and attached leather triangles is dyed dark red and the scabbard is often decorated with embossed patterns and additional bands of reptile skin, all of which are finely polished. However, in the northern and eastern provinces the leather is tanned in bright orange and has a coarser, unpolished finish,

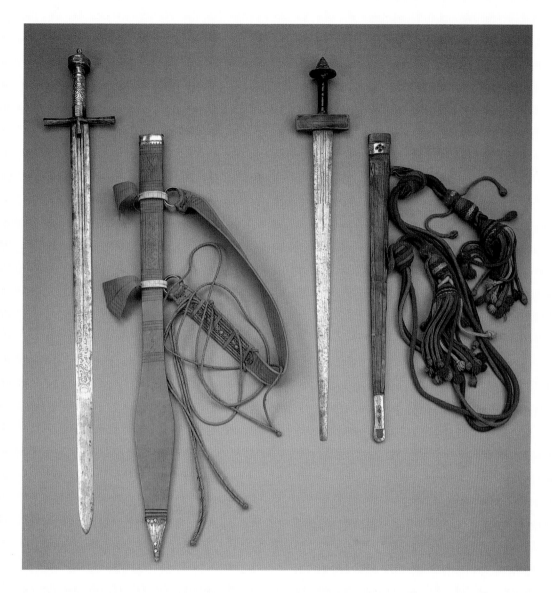

but is also embossed and embellished with bands of brass or reptile skin near the hilt. The broad shoulder strap has an attached ornamental leather triangle at each end; today these are decorated with metal studs and additional bits of coloured plastic with decoratively punched holes and indentations.

Abdulla El Tayib
University of Khartoum
Sudan

BIBLIOGRAPHY

Cabot-Briggs, L., 1965, 'European blades in Tuareg swords and daggers', *Arms and Armour*, vol. 5: 37–92, London: Journal of Arms and Armour Society

Spring, C., 1993, *African Arms and Armour*, London: BMP

In many African societies the smith's apparently magical transformation of rock into iron has helped to surround him with a mythology which separates him from the rest of society and makes him eminently suitable for the various ritual duties, such as circumcision, which he often performs. It also invests his products, such as tools, jewellery and weapons, with a particular significance. Interestingly enough, the smith's wife, particularly in western Sudanic Africa, is frequently a potter – another 'transforming' profession. It is likely that the discovery of metalworking in Africa was made during the much more ancient practice of firing pots. The wives of Tuareg smiths, by contrast, are often leatherworkers, though their profession is closely linked with the luxury items, such as jewellery and fine swords (*takouba*), produced by their husbands (fig. 28). The tooled and embossed leatherwork to be found on the sheaths of these swords is part of a tradition which is very strong throughout the Sahel, Mauritania and Morocco. Horse and camel trappings, bags, pouches and accoutrements of all kinds are made from beautifully embellished leather (fig. 29).

The colonial period

In common with the rest of Africa, the late nineteenth century witnessed a period of colonialism in North and North-east Africa. In Sudan the establishment of the Mahdist state in 1885 briefly challenged this domination, though Mahdism itself, as represented by the Umma party, continues to be a vital force in contemporary Sudanese politics. In the thirteen years of its existence a remarkable politico-religious evolution took place which is clearly reflected in the material culture it engendered. Through the development of the *jibba*, the appliqué patterned tunic worn by the followers of Muhammad Ahmad the Mahdi, one can trace the rapid evolution of the Mahdist ideology from religious zeal to military and political expediency. Museum collections include many examples of *jibba* with neatly tailored and often gaudily coloured 'patches' and pockets. One particular example in the collections of the British Museum stands out from the others, though not because it is more beautifully tailored or coloured – quite the reverse, in fact (fig. 30). It is extremely ragged, with rough, asymmetrical woollen patches crudely stitched to the main garment. However, it is often the object which is the least appealing to the Western eye which is of the most

interest to the ethnographer. Such ragged tunics (*muraqqa'a*), had for centuries been the dress of the Sufi religious orders, and signified their contempt for worldly goods. The early date of the British Museum tunic, 1886, shows that it must have been made and worn by one of the first followers of the Mahdi. By contrast, most of the tailored brightly coloured *jibba*, together with weaponry, banners and quilted armour, are likely to have been made in one of the well-documented factories supplying the increasingly militaristic autocracy which characterized the Mahdist state immediately prior to its demise at the battle of Omdurman in 1898 (no. 14).

The Mahdist armies included men from a wide area of Sudanic Africa, as well as conscript slaves from Central Africa, many of whom were no more than nominally Muslim. However, their material culture had to reflect their newly adopted ideology. Consequently, a range of objects, including wooden slit gongs

Fig. 30: The first followers of the Mahdi, called the *darawish* (poor men) or Dervishes, wore ragged tunics such as this, covered with rough woollen patches. Subsequently a stylized, tailored version of this tunic became the 'uniform' of the Mahdist movement, whose followers were redesignated *ansar* (helpers). Given by Surgeon-Major H. J. Waller-Barrow
Ethno 1886, 6–28.1

and iron throwing knives, while preserving the form of their Central African models, were suitably Islamized by the inclusion of carved inscriptions or acid-etched Arabic script (fig. 31).

In Ethiopia a successful campaign of resistance to colonial domination, unique in Africa, was mounted, culminating in the battle of Adwa in 1896 in which the forces of the Emperor Menelik defeated a large Italian force. To Ethiopians this battle has the significance which Trafalgar and Waterloo have to the English, for it effectively ensured the independence of Ethiopia, apart from a short period of domination by

Fig. 31: Wooden slit drum probably carved in the non-Muslim Bahr al-Ghazal region of southern Sudan. It was later decorated with geometric and floral patterns suggesting Islamic inspiration and was used in the service of the Mahdist movement.
Given by HM King George VI
Ethno 1937, 11–8.1

the forces of Mussolini in the 1930s. The battle, a lively rendering of which appears in a fine painting in the British Museum's collections, is one of numerous secular subjects depicted in a tradition of Ethiopian popular painting which has grown up since the Second World War and has its roots in the ancient and intricate conventions of Ethiopian religious art (fig. 32). A somewhat similar development can be seen in the Ethiopian textile tradition, in which certain garments commonly worn today were once reserved for very specific ceremonies or for the exclusive use of particular individuals within the hierarchy of church and state. To take just one example which is well illustrated by the collections of the British Museum, the dress customarily worn by noblewomen of Tegré in the nineteenth century was made of cotton sheeting imported from Manchester and skilfully embroidered in silk by the lady herself. The modern version of such dresses is still worn by well-to-do ladies of Tegré, but is no longer the exclusive preserve of the nobility. The embroidery is executed in rayon and lurex by male Muslim craftsmen in the larger towns (figs 33, 34). The cotton from which the dress is made will be locally grown and hand-woven, as likely as not, by Konso or Dorze men from the Gamu Gofa highlands of southern Ethiopia. As such it represents a part of the enormous increase in cloth hand-woven from locally grown cotton which has taken place in Ethiopia over the past century (no. 15). It is a pattern which is by no means peculiar to Ethiopia, and gives the lie to predictions of the imminent demise of hand-woven cloth throughout the African continent.

The colonial period witnessed attempts to fix the language of material culture in North Africa by subsidizing and regulating production. In Morocco and Tunisia French government-appointed officials

14 Tunic (*jibba*)

Cotton, wool
Sudan
19th century
L. 90cm, W. 126cm
Given by Miss M. D. R. Collins
Ethno 1972, AF11.14

Tunic (*jibba*)

Cotton, wool
Sudan
19th century
L. 130cm, W. 130cm
Given by Mrs E. Pendlebury
Ethno 1980, AF1.1

These two *jibba* are from the Mahdiyya era in Sudan (1881–98). This Islamic reform movement arose in rebellion against the deemed corruption of the Turkiyya regime (1820–81) which followed the conquest and annexation of the Sudan by the armies of Ismail Pasha. This had brought many new commercial, political and social innovations, and the Sirdar Musa Pasha had even ordered the citizens to wear Turkish dress. As a puritanical reformer, the Mahdi placed a ban on all imported styles. In addition to the economic and political stringencies of isolationism, a religious puritanical discipline was imposed on the clothes of men and women.

The military nature of the Mahdi's *jihad* (holy war) dictated the need for a short garment which enabled the infantryman to run with ease and the cavalryman to sit astride his horse. The basic material (*damur*) was made of stout handspun and handwoven locally grown cotton.

Most interesting here are the artistically arranged appliquéd coloured patches. These originated with the practices of the Sufi

dervishes who affected asceticism by wearing patched garments as symbols of ritual poverty and unworldliness. Cuzzi, the nineteenth-century traveller, reported 'the Jaaliyin tribes who were *not* amongst the first to join the Mahdiyya added patches to their clothes when the movement spread north to Berber'. What began as a voluntary group identification ended up as a form of state uniform. This decorative patchwork survives in the patched costumes of the mendicants (dancing dervishes) wandering around some of Sudan's religious centres today.

A close examination of the *jibba* which survive from the battle of Omdurman (1898) shows that this tunic had developed from a poor man's garment mended out of necessity with odd patches. The smaller *jibba* here has beautifully balanced patches on the sleeves, front and back, with highly decorated insert-pockets at the sides. Its small size and elaborateness seems to indicate that the owner was a high-ranking youth yet old enough to be a warrior. The larger *jibba* is somewhat cruder in its patchwork; the tailor has deliberately

imitated the kind of coarse stitching of the original poorer garments, but here the bold black stitches are carefully arranged. The elaborateness and fine workmanship of these *jibba* show what began as pious symbol of austerity developed into a highly stylized art form.

The reversibility of the *jibba* with its large round neck opening, easily slipped over the head, and its pockets both back and front are elements developed as a result of the Mahdist warriors' practice of turning their dirty *jibba* back to front when frantically engaged in fighting or campaigning or when enduring the privations of desert marches. These reversible neck and pocket features are still seen on the longer *jallabiya* of those maintaining allegiance to the Madhist faction in Sudan today.

Griselda El Tayib
University of Khartoum
Sudan

BIBLIOGRAPHY

Gleichen, A. E. W., 1905, *The Anglo-Egyptian Sudan*, 2 vols, London: Harrison and Sons

Spring, C. and Hudson, J., 1995, *North African Textiles*, London: BMP

Trimingham, J. S., 1949, *Islam in the Sudan*, Oxford: Oxford University Press

Trimingham, J. S., 1971, *The Sufi Orders in Islam*, Oxford: Clarendon Press

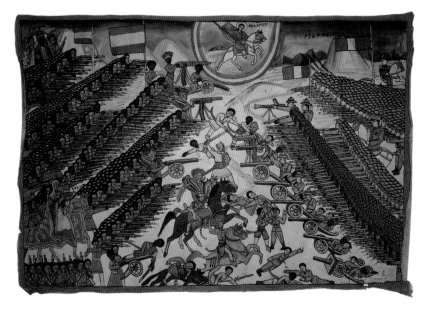

Fig. 32: ABOVE Painting depicting the opposing armies in the battle of Adwa in 1896. It is notable that the Ethiopian forces are protrayed full face, whereas the colonial soldiers are depicted in profile; this was a common convention in Ethiopian painting to indicate good and evil.
Given by H. L. Littler
Ethno 1974, AF11.34

Fig. 33: BELOW A noblewoman of Tegré province, Ethiopia, wearing a lavishly embroidered tunic and wrapped in a cotton *shamma* (shawl). During the nineteenth century shawls with plain red borders were worn by men and women and denoted social status.
From T. Lefebvre, Voyage en Abyssinie, *Paris, 1845–8.*

Fig. 34: RIGHT A contemporary example of a woman's dress (*kamis*) decorated with rayon and lurex embroidery. This type of garment is worn by wealthy women on special occasions in towns and cities in northern and central Ethiopia.
Ethno 1993, AF16.1a

15 Man's trousers and tunic (*dunguze*)

Wool, cotton
Dorse, Ethiopia
20th century
Tunic: L. 66cm, W. 55cm;
trousers: L. 98cm, W. 62cm
Ethno 1993, AF16.6a-b

This colourfully striped ceremonial garment, the so-called *dunguze* trousers and tunic, may be worn only by retired dignitaries such as communal or regional leaders, successful warriors or big-game hunters and the newly circumcised on their first ceremonial procession around the market square.

The Dorse in southern Ethiopia, one of the smaller ethnic groups, have long been famous throughout Ethiopia for their weavers' craft. Indeed, the word 'Dorse' or 'Dorzya' is often synonymous with 'weaver'. Originally the Dorse were farmers. But as a result of their inheritance laws the formerly large farms were divided so many times that the farmsteads became too small to provide subsistence for the family. Weaving offered an additional source of income and became the main occupation for the families. Besides, weaving is one of the few trades not reserved for a particular social group; any man with the right skills could engage in it. The spinning of the yarn, however, is generally done by women and girls.

Weavers learn their trade from their father or a close male relative. Even the children take on small tasks such as rolling up the thread and so become familiar with their future occupation at an early age. It is rather more difficult for a young man to become a weaver if he is not from a weaver's family. As the social position of a weaver is quite good and the income considerably better than that of a farmer, it is a popular profession. Young men from non-weaving families will have to find a weaver prepared to induct them into the secrets of the trade. It might be a weaver without male heirs or someone in whose family there are not enough male workers.

Looms all over Ethiopia consist of the same basic elements: two thick posts securely rammed into the ground, connected at the top with a cross-plank. Between the posts a small ditch is dug out. These fixed looms can be found also in villages without resident weavers and are used by travelling craftsmen when needed. The weavers carry their 'mobile' weaving equipment in their tool bags. In such a manner many Dorse weavers travel up and down the country with portable equipment, such as the weaving comb, shuttle and other accessories, and weave where they find a demand. However, most weavers practise their craft from home, moving their loom into their own huts, or out into the open under a sheltering roof, depending on the season.

The weavers produce strips of fabric, about 50cm wide and up to 3m long. This hand-woven cotton cloth is a natural white, because the thread has not been tinted or bleached. The fineness of the fabric depends on the thickness of the yarn and the number of braids used. It is also customary to weave in imported coloured yarns in black, red or yellow, which give the traditional wrap, the *shamma*, its distinctive look. The fabrics are used not just for the typical large wraps but also for shirts, knee-length trousers and dresses. In some areas weavers also use other materials, such as wool or goats' hair, from which coats or tent awnings are made.

Fisseha Girma
Staatliches Museum für Völkerkunde
Munich
Germany

BIBLIOGRAPHY

Girma, F., 1988, 'The Hunt in Ethiopia', *Tribus*, vol. 37: 37–51

Haberland, E., 1963, *Galla Südäthiopiens*, Stuttgart: W. Kohlhammer

Straube, H., 1963, *Westkuschitische Völker Süd-Äthiopiens*, Stuttgart: W. Kohlhammer

instigated programmes of collection and classification drawing on the finest existing examples of local crafts (particularly those of weaving and embroidery). Training programmes were introduced to encourage young artisans to learn specialist craft skills. However, the emphasis was on modernization rather than the consolidation and expansion of traditional methods of production. The rigid organization as well as the creative and quality control imposed on the artisans institutionalized rather than revitalized these crafts. Elsewhere the trend was towards European fashions and commodities.

The postcolonial period

Following the struggle for independence, the need to reinvent and reinforce national identity led to a revival of interest in more traditional forms of material culture, particularly those associated with important ceremonies and rituals such as marriage. Meanwhile contemporary artists, many of them trained in the Western tradition, sought both to establish their own individual identities and to found schools which

would draw upon the national cultural heritage. Artists such as Osman Waqialla in Sudan, Nja Mahdaoui in Tunisia, Ali Omar Ermes in Libya and Ahmed Moustafa in Egypt were, in their different ways, concerned with reinventing the calligraphic tradition in Islamic art. While respecting and drawing upon the deep significance of the written word in Islam, they sought to examine the infinite possibilities of how to depict and redefine the Arabic script, rather in the way Western artists have sought ever different ways of interpreting the human body. In Mahdaoui's case he followed his love of music, costume and performance by using different media to apply his 'calligrams' to a whole range of objects (no. 16). Large denim hangings, musicians' costumes and a bass

Fig. 35: OPPOSITE The percussion group *Joussour* performing at Tunis railway station. The waistcoats, drum and wall-hangings were designed and decorated by the contemporary artist Nja Mahdaoui.
Photo: N. Mahdaoui, 1997

Fig. 36: RIGHT Skin-covered wooden panels by Farid Belkahia, Morocco, decorated with symbolic signs and characters from the Berber alphabet (*tifinagh*). Belkahia carefully selects natural dyes such as henna, saffron and cobalt which produce warm earth tones.
Ethno 1997, AF8.3–4

16 Drum

Wood, skin, pigment, synthetic, metal
Tunisia
1998
Diam. 67cm, Dp. 47.5cm
Decorated by Nja Mahdaoui
Ethno 1998, AF3.1

Even when it is silent, the drum is an instrument of rhythmic beat, revered as a symbolic vessel, a repository of innumerable tonal variations. This quality distinguishes it from other ritual objects, particularly among the

sects of the Islamic world who venerate the written word, which itself often carries theological or mystical meanings.

According to conventional ethnomusicology, the various forms and functions of the drum relate to a group of instruments known as membranophones which are played with sticks and originate in India (although the most ancient historical evidence is confirmed by a Sumerian representation dating to the third millennium BC). These instruments are capable of producing a great variety of rhythms: syncopated, free, cyclical and counterpoint; in Arabic these instruments are known by a variety of names such as *tanbur*,

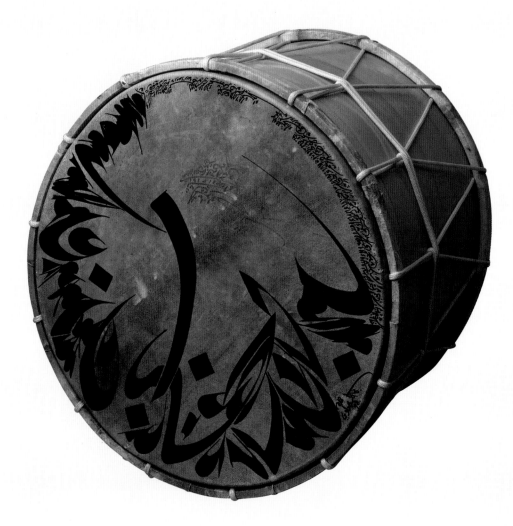

tambor, *tabor*, *deff*, *tabl* or *tball*, and as *ganga* by the Sudanese.

The quintessential beat of the drum, that most simple form of communication, continues to transport the collective memory of innumerable people to a time before the advent of the written word. It is a voice which tells of the relationship between people and the natural world, a relationship which is at once conflictive and harmonious; it tells of both the simplicity and the complexity of life in Africa which is reflected in innumerable songs accompanying triumphant war dances or glorifying royal splendour, the return from pilgrimage, mystical chants of spirit possession, family festivities, circumcision, marriage, visits to the tombs of saints, laments in temples reserved for profane music, evocation of the spirits of the seasons through contesting recitals of poetry and song, the rhythmic heights aspired to by young Nuba men in invoking the rain or the fertility of women, processions in honour of fishermen and hunters, epic, folkloric or historical chants and stories which mystically evoke a reverence for the Prophets.

In response to the essential nature of this drum, I have modified its traditional appearance by physically inscribing free calligraphic signs on the two blank, circular membranes. I decided to conceptualize it as a silent, sculptural object and intentionally transposed its original role as the sonorous accompaniment of an oral tradition. Consequently, this drum has taken on a new physical presence. From a conceptual point of view it is a new, three-dimensional installation; from a functional point of view its two voices have been silenced by its re-contextualization as a work of art.

This drum, transformed into a silent sculpture, has temporarily ceased to be an instrument, it simply exists. Its cultural function – as a catalyst to the senses articulated through formal and improvised melody – has been interrupted. More importantly, it has renounced its particular voice as part of a collective artistic performance. Instead, with its multiplicity of resonances, it has become a dynamic symbol of cultural pluralism, a kind of 'total art' to which people throughout the world can respond in a myriad different ways.

Nja Mahdaoui
Contemporary artist
La Marsa
Tunisia

BIBLIOGRAPHY

Issa, R., 1995, *Signs, Traces, Calligraphy: Five Contemporary Artists from North Africa*, London: Barbican Centre

Samrakandi, M. H. and Heller-Goldenberg, L., 1999, 'Calligraphies: hommage à Nja Mahdaoui', in *Horizon Maghrebins: le droit à la mémoire*, no. 35/6 and *Cahier d'Études Maghrébines*, no. 11

17 Gravestone (*jadath*)

Ceramic
Tunisia
1992
Ht. 49cm, W. 45cm, Dp. 6cm
Made by Khaled Ben Slimane
Ethno 1998, AF2.2

One day, while I was a student at the École des Beaux Arts in Tunis, I discovered by chance in my grandparents' house in Maamoura (my home village) a bundle of old manuscripts and deeds which had been executed and authenticated by a notary. Most of these were bills of sale or purchase and marriage settlements. I was fascinated by the writing, which was beautiful yet difficult to read and by the magical and enigmatic signatures of the old notaries. This was a critical moment which presented me with a pictorial pretext for beginning research on this inheritance. The fascination was such that my entire vision as a young contemporary artist was completely revolutionized.

I spent some time reflecting about all those generations of my family, all those human beings who were born and then died. While birth is accepted with joy and happiness, death is not accepted, even in sadness. Yet they are both natural events in the history of humanity.

With this thought in mind I began the piece shown here. From 1986 onwards I created a number of horizontal and vertical stelae and tombstones that were quite light and thin. These two forms were used to symbolize the attitude of human beings to death: some are frightened and lie down, while others accept its inevitablity and remain standing. An exhibition presenting these works, which took place in Tunis in 1989, shocked many people.

Death, like sex, is a taboo subject in our society; it is rarely discussed.

Towards the end of 1991, following the 1989 exhibition, I started making heavier and thicker tombstones – a reference to the weight of tradition in Arab-Muslim society. Initially it was quite difficult to make pieces that were 6 or 7 centimetres thick. At each firing the tombstones would crack in the kiln. I was able to achieve a satisfactory result only by mixing together clays from different regions such as Nabeul, Moknine and Tabarka and by adding fire-resistant clay. It was difficult and time-consuming work, but eventually satisfactory. For the decoration I applied a darker slip using the red clay of Nabeul. On the surface I scratched some signs and symbols which drew inspiration from the old manuscripts in my grandparents' house. Realizing that the final result might be rather bland, I embellished it further with other graphic motifs and applied iron and manganese oxide which darkened the surface decoration. The whole piece was covered with a semi-lustrous glaze using sand from Sidi Salem, an abandoned quarry near Nabeul. Until the beginning of the twentieth century this quarry was used by potters who established a reputation for fine glazes; following the introduction of industrial glazes the quarry was abandoned.

Khaled Ben Slimane
Contemporary artist
Tunis
Tunisia

BIBLIOGRAPHY

Centre Culturel International de Hammamet, 1996, *Khaled Ben Slimane*, Tunis

Lisse, P. and Louis, A., 1956, *Les potiers de Nabeul*, Tunis: Bascone & Muscat

18 Appliquéd wall hanging

Cotton
Cairo, Egypt
20th century
L. 264cm, W. 310cm
Made by Chant Avedissian
Ethno 1999, AF2.1

This hanging was created in the 1980s during the period I spent working with the Egyptian architect Hassan Fathy. After studying applied arts in Paris, centre of the art world, where I'd been taught to look inside myself, working with Fathy opened up for me the means of seeing myself through the cultural traditions of Egypt and from there to the Arab world.

Traditional Arab architecture draws its two main elements of 'colour' (or what we would today refer to as interior design) from calligraphy and pattern. The al-Ghouri mosque (1504–5) in Islamic Cairo provides a useful example. During prayer times the worshipper kneels on the floor. Surrounding him on the walls, from floor level to a height of about 2 metres, rise marble panels. The lower part of these panels is decorated with bold vertical geometrical patterns using different coloured marble inlays, while the upper horizontal section comprises calligraphic inscriptions drawn from verses of the Holy Qur'an. Thus these two important elements – calligraphy and pattern – are brought together. It is significant that they meet at approximately the eye level of an upright human being (whose average height is around 1.60–1.70m). While the worshipper is in the position of prayer on the floor, the height of this panel attains harmonious proportions and accords well with the human scale. The rest might be described as 'pure architecture'. This hanging faithfully follows the actual dimensions of these traditional proportions with regard to the viewer. The colours have been altered, but the essence of the composition – meditation – has been retained.

A second strand of inspiration for this appliqué hanging derives directly from Arab tents (closely linked to similar forms used by native North Americans and Mongols) and their inherent mobility. Whole villages or temporary structures could be packed away with relative ease and transported to a new location to accommodate seasonal weather changes or social needs. The spirit of this non-permanent architecture can very easily be applied to painting, for instance the splendid examples of Far Eastern scrolls which when rolled are easily transportable and thus non-permanent. In Cairo today temporary tents are still used for numerous occasions including weddings, political meetings and funerals, three non-permanent events, which ironically create so many permanent situations in human destiny.

This wall-hanging is composed of a series of cotton panels, hand-dyed in my studio to produce harmonious earth tones. The technique of appliqué is inspired by indigenous traditions still practised today by the tent-makers of Cairo. Designs are drawn on paper and transferred to the base cloth; coloured pieces of cotton cloth are placed over these motifs and hand-sewn to the heavy backing. The geometric patterns which dominate the designs on the tents produced in the *suq* of the tentmakers also draw their inspiration from the marble inlays adorning the walls and floors of Cairo's mosques.

Chant Avedissian
Contemporary artist
Cairo
Egypt

BIBLIOGRAPHY

Feeny, J., 1896, 'Tentmakers of Cairo', *Aramco World Magazine*, vol. 37, 6: 16–25

Spring, C., 1996, 'Pavilions of Paradise: Egyptian ceremonial tents', *Quilters' Review*, no. 21, Summer, pp. 1–3

Fig. 37: Detail from the 'ticket' stencil by Chant Avedissian, Egypt. Superimposed on to a series of bus tickets are images of personal inspiration – a bicycle, sunglasses – as well as Cairo street scenes, in this case the notoriously busy al-'Ataba.
Given by R. Issa
Ethno 1999, AF10.1

drum (all of them embellished with calligrams), which featured in a musical performance to mark the end of Ramadan in 1997, have been acquired by the British Museum following a recent fieldwork programme in Tunisia (fig. 35).

Other artists from the region, while acknowledging the Islamic tradition, have been inspired by different elements of their culture. The lexicon of Berber iconography and the *gnawa* rituals which have their roots in Niger and Senegal inform the work of Moroccan artist Farid Belkahia (fig. 36). Berber as well as Islamic signs and symbols feature in the work of the Algerian Rachid Koraichi and the Tunisian Khaled Ben Slimane, who is also fascinated with the monolithic forms of Islamic funerary architecture (no. 17). The Egyptian Chant Avedissian finds the past and the present equally stimulating: his stencilled works on recycled cardboard and his appliquéd textiles (no. 18) draw inspiration as much from images of everyday life in Cairo as from Pharaonic temples (fig. 37). Examples of the work of all four artists may be found in the collections of the British Museum.

Fig. 38: Male (right) and female (left) 'fertility dolls', late twentieth century, Dowayo, Cameroon. In unadorned form, such figures may be treated as toys for little girls. When empowered by the addition of beads and other materials, however, they are a powerful cure for female sterility.
Ethno 1984, AF13.1–2

t was the twin urges of serving God and making money that, in the fifteenth century, drove the Portuguese to push ever further down the coast of West Africa and begin the modern, direct contact between Europe and the west coast that has endured ever since. It is the coast that defines West Africa, stretching from Senegal, and linking all the modern states of the Gambia, Guinea-Bissau, Guinea, Sierra Leone, Liberia, Ivory Coast, Ghana, Togo, Benin, Nigeria and Cameroon. Curiously, Africa was the last continent to be systematically explored, despite its relative closeness, so that its interior fostered wild European imaginings. In their search for allies against the Muslims of the Iberian peninsula, the Portuguese made much of the presence of brass crosses seen in the Benin empire of what is now Nigeria (fig. 39). Immediately they believed themselves to have found the mythical, non-European Christian realm of the legendary Prester John. The brass crosses, of course, had nothing whatever to do with Christianity but they began that process of interpreting and misinterpreting West African objects that has continued ever since. Although West Africans sometimes had a well-developed local system for the evaluation and explanation of objects, this was usually ignored by outsiders.

Early contacts

In West Africa people often met to exchange objects but ended up exchanging ideas. Among the earliest fruits of that contact to arrive in the British Museum collection were the Afro-Portuguese ivories from Sierra Leone and Benin (fig. 40) – salt-cellars, horns, spoons and dagger handles made as exotic tourist souvenirs in the fifteenth and sixteenth centuries, objects to be brought home from Africa by sailors. Carved by Africans to appeal to Europeans and drawing on Western models such as book illustrations, they are truly a hybrid form, showing African artists wrestling with bizarre foreign concepts such as angels, mermaids and bears as well as unfamiliar clothes, weapons and physiognomies. Stylistic comparison suggests that there is a clear kinship between the Sapi carvers of these works who lived along the coasts of Sierra Leone and

West Africa

19 *Awele* board

Wood, brass
Mano, Ivory Coast
20th century
L. 62cm, W. 14.5cm, Ht. 19.5cm
Given by Mrs Webster Plass
Ethno 1956, AF27.21

This object is one example from a large collection in the British Museum of mancala boards, which are used to play different variations of a basic form of a count-and-capture game. Seeds, shells or counters are moved around the two-, three- or four-row boards following local rules of play; two end-holes hold the captured counters. Although in Asia certain forms of the game require the use of end-holes during play, in most parts of Africa and the Caribbean the inclusion of end-holes is optional. The object of the game is to capture the majority of the counters.

The rules of the game have a direct influence on the shape of a board: in this case the game of *awele* requires two rows of six holes. The holes accommodate the size of the players' hands: in Asia, where the game is primarily played by women and children, the hole size is proportionately smaller than in Africa, where it is a male pastime. The hands and fingers wear the surface of the board smooth and create ridges in the holes. This heavy wooden board bears a fine and polished patina – a testament to its repeated use as a functional object.

Ivory Coast is one of the few countries that has received specific attention in the literature when it comes to mancala games. The large collections of West African mancala boards in museums are often regarded as works of art in their own right, which partly explains the absence of more detailed accounts of the games played. In Ivory Coast, however, mancala players have even been studied in psychological works. This research provides us with the names of players, the rules of play, strategies and psychological insight. It allows us to identify our object as an *awele* board.

Awele is a mancala game played in most parts of Ivory Coast and without much variation in other parts of West Africa and even the Caribbean. In different regions it has different names such as *awari*, *wari* and *oware*. The *awele* rules prescribe four counters in each hole, with each player owning one row. During one turn all the counters from one hole are distributed in a counter-clockwise direction, one-by-one in consecutive holes. If the last counter drops into a hole on the opponent's row, making a total of two or three counters, then a capture is made. The captured counters are deposited in the player's end-hole. Each player takes turns to distribute counters.

A special rule that allows multiple captures enhances the popularity of this game and also adds an element of skilful strategy. If the last counter lands in a hole to make two or three, and if the holes directly preceding this hole also have two or three counters, then all these counters are taken. The possibility of multiple

captures is the object of many strategies and the source of many variations. Region, knowledge of the game and personal preference determine the rules governing the games that may have been played on this board.

This *awele* board is also part of a collection of sculptured objects. Sculptured mancala boards are common in West Africa. The boards frequently serve a ceremonial purpose when they become prestige gifts or when they are used on special occasions. The carvings may point to a region or even to a particular artist. This board has all the characteristics of a 'used' object, but it also reveals geometric carvings, four legs, decorated end-holes and a rim in between the rows of holes. All these features have little purpose in play. Even

though the ceremonial purpose may be minor, it appears that this *awele* board exemplifies both worlds: the physical marks of play and the decorative elements of art. It is a board for the hands and the eyes.

Alexander J. de Voogt
Leiden University
Leiden
The Netherlands

BIBLIOGRAPHY

De Voogt, A. J., 1997, *Mancala Board Games*, London: BMP

Russ, L., 2000, *The Complete Mancala Games Book*, New York: Avalon Press

20 Figure of man riding an elephant

Steatite
Sapi, Sierra Leone
Prior to mid 16th century
Ht. 15cm, W. 9cm, Dp. 10cm
Ethno 1953, AF19.1

Within the corpus of stone figures from the coastal area of Sierra Leone there are a fair number of representations of an animal that seems to be the elephant. At least nine of these are mounted by a male human figure. Two are in the British Museum, Department of Ethnography. A few other representations exist, seeming to represent simply the elephant itself (e.g., Museum für Völkerkunde, Basel). Characteristic to all these are a long protrusion extending downward from the face of the animal resembling an elephant's trunk. Sometimes the animal has huge ears, large circular feet, and indications of a small tusk on either side of the trunk. In at least one case (The Baltimore Museum of Art), the surface of the animal is scored with cross-hatch lines to resemble the tough, creased skin of the elephant. In another case the animal is somewhat anthropomorphic, standing upright and grasping its trunk with its hands (National Museum of African Art, Washington, DC).

The example depicted here, set upon a round socle, shows what appears to be a large male figure seated upon an elephant. The figure has a beard that is braided from the hairline to the chin where it forms a loop hanging down from the chin. The figure's hands grasp the animal's neck, and his legs reach the ground, with no feet indicated. The elephant is shown with a short length of trunk touching the ground, with huge, flapping ears, two short tusks, and a slender tail that reaches the ground.

As these stone figures from Sierra Leone were probably all made before the mid sixteenth century and were not clearly documented in ritual use by European writers at the time (although some vague references exist), we cannot say with any certainty whom the figures represent, who made them, how they were used or when such carving began. Radio-carbon dates on a wood figure in a similar style from Sierra Leone suggest that they may date at least to the twelfth century. The occupation of the coastal area of Sierra Leone in the first half of the second millennium AD is also obscure, but the evidence suggests that the occupants were of the Mel language group, known to the Europeans in the sixteenth century as Sapi. The particular area where the stone figures have been found was dominated at various times by the ancestors of the Bullom (who dominate today) and those of the Temne

(who today are somewhat to the north), before the entry of the Mende people. Current ritual use of stones and carved stone figures in ancestral shrines among the Temne and the Kissi (close linguistic relatives of the Bullom on the Sierra Leone/Guinea border), suggests that the ancient stone figures may have represented important deceased persons, such as chiefs and kings, and that sometimes they may have been grouped in community shrines. The beard, especially a braided beard, was known in the past as a sign of a chief.

The riding of elephants is certainly metaphorical, as there is no history of elephant-riding in this area, and, indeed, little in Africa as a whole. Symbolically, the elephant as a support for royalty is documented today in this region among the Temne, Mende, Kuranko and Kono. The elephant is a metaphor for the chief, suggesting his support by a broad constituency of his people, and it is a positive attribute somewhat in contrast to another metaphor as leopard, which suggests his right to seize whatever he wishes (some mounted stone figures seem to show a leopard as mount). The elephant's tail and tusk are emblems of chieftancy, and slaying an elephant was a prerequisite for the founding of a settlement, perhaps as a metaphor for the displacement of power. The transformation from human to elephant represents the movement from life to death. In an oral narrative the elephant is rewarded by God with its great size because it had carried the chief (of the animals) on its back. The chief's hammock, in which he is carried in procession, has been associated with the elephant. And the killing of the elephant has always required tribute to the chief. It seems reasonable to assume, from its broad base today, that the association between chief and elephant is one of long standing.

Frederick Lamp
The Baltimore Museum of Art
Baltimore
USA

BIBLIOGRAPHY

Allison, P., 1968, *African Stone Sculpture*, New York: Frederick A. Praeger

Hair, P. E. H., 1969, 'Some French sources on Upper Guinea 1540–1575', *Bulletin de l'Institut Française de l'Afrique Noire*, series B, vol. XXXI, 4, Paris

Lamp, F., 1983, 'House of stones: memorial art of fifteenth-century Sierra Leone', *The Art Bulletin*, vol. 2: LXV, 219–37

Lamp, F., 1990, 'Ancient wood figures from Sierra Leone: implications for historical reconstruction', *African Arts*, vol. XXII, 2: 48–59, 103

Lamp, F., 1992, *La Guinée et ses heritages culturels: articles sur l'histoire de l'art de la région*, Conakry, Guinea: United States Information Service

Rutimeyer, L., 1901, 'Über westafrikanische Steinidole', *Internationales Archiv für Ethnographie*, vol. XIV: 195–215

Tagliaferri, A. and Hammacher, A., 1974, *Fabulous Ancestors; Stone Carvings from Sierra Leone and Guinea*, New York: Africana Publishing Co.

Tagliaferri, A., 1978, 'Stone carvings from Sierra Leone and Guinea', *Galleria Lorenzelli: News and Comments*, March: 4–8, Milan

Tagliaferri, A., 1989, *Stili del potere (Styles of Power): Antiche sculture in pietra dalla Sierra Leone e dalla Guinea*, Milan: Electra

Fig. 39: FAR LEFT Brass cross-bearer, sixteenth century, Benin, Nigeria. This figure has been variously interpreted as a priest or a messenger from Ife. Westerners saw the cross worn round the neck as evidence for the proximity of the kingdom of Prester John.
Ethno 1949, AF46.157

Fig. 40: LEFT Ivory salt-cellar, sixteenth century, Benin, Nigeria. Made as souvenirs for visiting Westerners, these are among the first 'airport art' from Africa.
Ethno 1897, 7–1.1a-c

the makers of a style of ancient stone figures, known as *nomoli*, that are still excavated there today (no. 20). Many coastal Sapi were displaced by Mande-speaking peoples from further inland, a process noted by early European chroniclers, and nowadays such figures are seen by Mende as having power over the earth. Accordingly they may be kept in fields or ironworkers' forges and variously supplicated or beaten to obtain benefits. Changing material culture and new interpretations of ancient objects are as much an internal African phenomenon as an intercontinental one.

Pottery

In their design of the vessels to contain the salt and pepper, the ivories give us our first images of African coastal pottery at that period, yet African pottery goes far back beyond this time. In the rich Saharan sites that flourished before desertification, fired clay objects are traceable

back to the eighth millennium BC and in Nigeria at least to the fourth millennium BC. Pottery is nowadays virtually ubiquitous in West Africa, except among nomadic Fulani, who increasingly abandon their traditional carved calabashes for imported enamelware. It ranges from simple domestic vessels to ornate ceremonial pots of great elaboration but is generally hand-built (not wheel-turned), unglazed and fired at relatively low temperatures (fig. 41). This makes it cheap, able to withstand the thermal shock of being placed directly over a fire and porous so that evaporation keeps liquids, stored in pots, cool. In West African pottery complete utility and formal beauty go hand-in-hand (fig. 1). Pottery is also extraordinarily versatile and provides coffins, weights, architectural elements, furniture, lamps, toys and objects of personal adornment. Despite forecasts since the fifteenth century of its imminent disappearance, West African pottery output is enormous and increasing.

The overwhelming majority of African pots are made by women, ranging from non-specialists to those organized in strict guild or caste-like groupings. A common pattern in West Africa is for the potter to be

Map showing countries, regions and peoples of West Africa.

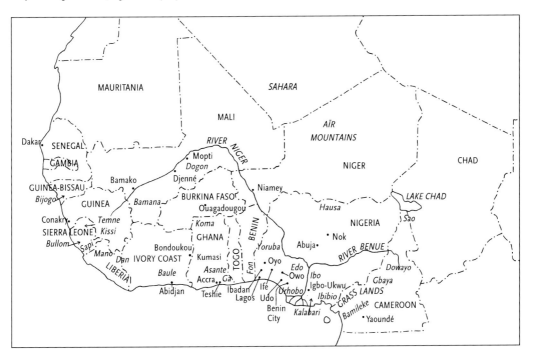

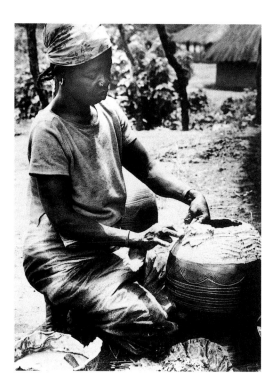

Fig. 41: LEFT Gbaya potter Pauline Bazama completing the bottom of a pot whose top half is already dry. Meiganga, Cameroon.
Photo: Cambridge University Expedition

Fig. 42: RIGHT Terracotta altar for the yam cult, Ibo, Nigeria. With its complex human figures showing elaborate body scarification, this piece was probably made either by a man or by a post-menopausal woman.
Ethno 1951, AF1.1

the wife or daughter of the smith and to belong to a separate and 'unclean' social group. Pottery and female bodies and their powers are often associated, so that procreation may be explicitly compared to the process of potting with the principal midwife as the potter. In West Africa marriage often involves the making of new pots and death the deliberate smashing of old ones. The patterns used to decorate pottery are not infrequently those used to mark the human body, so that pottery becomes an idiom in which to think about fundamental issues of life, death and social transformation. This relationship has been obscured in recent years as Christian, Muslim and modernizing secular authorities have all conspired to suppress bodily scarification.

Clay sculpture is widely diffused over West Africa. Notable works are from the Nigerian Nok culture (500 BC–AD 200), North Ghanaian Koma (700–1500), the Djenné area of Mali (1000–1200), the Cameroonian Sao culture (1000–1200), Nigerian Ife (1100–1400), Nigerian Benin (1400–) and the Akan-speaking part of Ghana (1600–). Stylistically these cover the whole range from rudimentary modelling

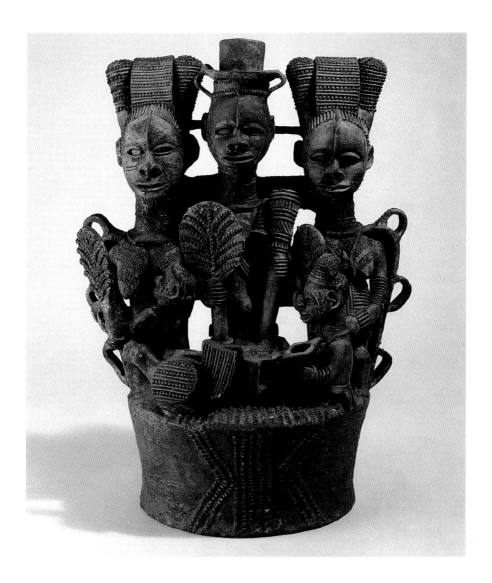

(Koma, Sao) to extreme naturalism (Ife and Benin) and to elegant stylization (Djenné). Many clay sculptures occur in a funeral context, as do the innovating, modern cement sculptures of the southern Nigerian Ibibio. Much discussion has been given to the question of whether these works were made by men or women but unfortunately such debates have often taken little account of African notions of gender in which femininity centres on childbearing. While fertile women may not be allowed to make human or animal images, post-menstrual women often

Pottery vessel

Pottery
Asante, Ghana
19th century?
Ht. 46cm, W. 30cm
Ethno 1938, 10-4.1a-b

Captain R. S. Rattray, the first Gold Coast Government Anthropologist, collected this unique and puzzling vessel. He described it briefly in his book *Religion and Art in Ashanti*, published in 1927. Rattray calls it a *mogyem-ogye* pot and says that it was used to contain wine poured upon the Golden Stool (the ultimate symbol of Asante kingship). Rattray had a vast knowledge of Asante and access to places and information never accorded to any other outsider. It is therefore a matter of regret that he seems to have left no further information about this vessel.

The pot itself is unlike any other known from Asante. Most Asante vessels are far more shallow and none has the type of elaborate decoration found on this one. The most complex Asante pots, those used in funerary rites, often referred to as *abusua kurawa*, are of a totally different form. What is certain, however, is that this pot shows a fusion of local and European influences. The body shape is based on that of imported European vessels, and the decorative motifs are adaptations of ones found on European metal wares. A similar use of these motifs is found in the gold work associated with the Asante court at Kumasi and in particular *kra* discs and some gold ornaments for attachment to the sheaths of state swords. The term *mogyemogye* given by Ratttray may refer not only to the cursive decorative motives but perhaps also to the practice of tying the jawbones of defeated enemies to the King's ivory trumpets and drums. The Golden Stool is itself now decorated with images of such slain enemies of Asante.

The date and the exact origin of the vessel are obscure: the main body of the pot gives the appearance of being wheel-turned although there is no decisive evidence to prove if this is the case. The handles and the top, however, are far inferior work to the rest of the vessel although they do not appear to be later additions. The anomalous position of this vessel in the corpus of Asante pottery may partly be explained by its relationship with the Golden Stool, as we know that imported pots and metal vessels were often placed in the rooms where blackened ancestral stools were kept, but, again, little is now known about how the Golden Stool was cared for and what offerings or prayers were made near it. We do not even know exactly what type of wine was kept in this pot, although Rattray probably meant palm wine, even though schnapps is the usual offering to stools and gods; the Asante word *nsa* refers to both drinks.

Rattray was writing just after the dreadful period in Asante history when the Golden Stool was first hidden to keep it from the British and then desecrated by a number of Asante who removed golden ornaments from it. What happened before the Golden Stool was treated in these ways, and what happened after it was restored, may have been very different. Since Rattray was able to acquire this vessel one can only conclude it was not considered of much importance by the Asante in the latter circumstances.

Malcolm McLeod
University of Glasgow,
UK

BIBLIOGRAPHY

Rattray, R., 1927, *Religion and Art in Ashanti*, Oxford: Clarendon Press

22 *Kra* disc

Gold
Asante, Ghana
19th century
Diam.9.5cm
Ethno 1942, AF9.1

These gold discs were worn by the male servants of the kings of Asante (*Asantehenes*) and major chiefs (*Amanhene*). These servants, usually referred to as *akra* (pl.) or 'souls' of the king, were young males who were being trained for higher office. They acted as messengers, observers and, one suspects, conveyors of gossip and unofficial information. The discs themselves, signs of their status, were worn round the neck, suspended from cords of pineapple or cotton fibre whitened with clay.

The complex construction of this disc is typical of many which were made by the Kumasi court goldsmiths in the nineteenth century. The body of the disc is made from sheet gold with designs in repoussé work. These motifs are made clearer by being outlined from the front with small punch marks. The outer ring of marks also emphasized by being encirled by two thin threads of gold wire soldered in place. The central conical boss, a lost-wax casting, is inserted and soldered from the back. As occasionally happens, this casting is defective and has been patched with a scrap of sheet gold soldered to its rear. The edges of the disc have been bent back to help fix in place the two semicircular cast 'ears' and the oval suspension lugs.

The similarities between this *kra* disc and others in the British Museum's collections strongly suggest that all were made by the same goldsmith or, at the very least, that they were produced in the same workshop. These discs formed part of an indemnity paid by the *Asantehene* in accordance with the Treaty of Fomena in 1874 and were subsequently purchased from the Crown Agents for the Colonies.

Malcolm McLeod
University of Glasgow
UK

BIBLIOGRAPHY

McLeod, M., 1981, *The Asante*, London: BMP

are (fig. 42). It is quite possible that the 'men' who allegedly made these astonishing works were – in Western terms – older women. Elsewhere there is often a clear technological line between the pottery of males and females. In the Cameroon grassfields women model clay but men carve it.

Metal and trade

One of the basic aims of early Europeans was to divert trade from the ancient routes across the Sahara and down to the coast where the European hunger for gold (no. 22) was matched by the African hunger for copper and brass. The possession of traditional gold objects has often been tightly tied to social position, giving impetus to the development

Fig. 43: LEFT Gold spectacles, Baule, Ivory Coast. Contemporary gold castings such as this are used both decoratively and as marks of status.
Ethno 1987, AF3.1

Fig. 44: BELOW A late-ninteenth-century photograph of a courtyard in the royal mausoleum, Bantam, Asanteland, Ghana. Several ancient containers of English origin are in the foreground.
Photo: Courtesy of M. D. McLeod

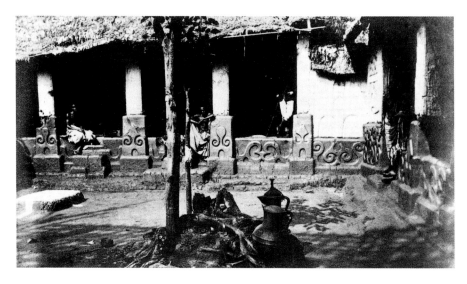

of ever-new forms (fig. 43) of prestige castings, notably by the Akan peoples of the Ghana–Ivory Coast border, to accommodate the upwardly mobile. Long before European contacts, trans-Saharan links had already brought strong north African influence to bear on the designs of Asante metalwork, such as brass weights for weighing gold dust and the elaborate containers known as *kuduo* and *forowa*. Occasionally European objects underwent a similar acclimatization, such as the thirteenth-century English ewers found at the Asante royal mausoleum at Bantama (fig. 44), but much of the new European metal was imported into Africa in the form of cast brass manillas, penannular bracelets with flared ends. But these were themselves simply a European version of a very old African design (a related form is found in the southern Nigeria Igbo-Ukwu bronzes of the ninth to tenth centuries, long before European contact). And then the picture becomes further complicated by local casters who, in turn, imitate these European imitations.

The development of arms and armour in the region similarly shows Africa's links with Renaissance Europe and medieval Arabia. The equation between forged metal, power and personal achievement is still strong today – the iron-bladed weapons and agricultural implements which once brought military and economic strength to ancient empires and kingdoms continue to be celebrated in contemporary cults, masquerades and ceremonies. In their creation myths the culture of peoples such as the Bamana and Dogon of Mali was forged by the first blacksmiths, while among the Edo of Nigeria and the Asante of Ghana iron-bladed weapons remain the primary symbol of power in contemporary politics. Ogun, the Yoruba god of iron, hunting and warfare, today includes among his worshippers train drivers, pilots, even barbers – in fact anyone who depends on iron for making a living.

The whole history of West African metalworking is dogged by the question of origins, for the area is unusual in not offering a neat picture of copperworking as predating and subsequently being replaced by iron, a chronology that is often assumed to be universal. Copperworking is attested in the first millennium BC in the Aïr region of Niger but thereafter data are patchy and inconclusive. In some regions stone gives way directly to iron, while in others copperworking seems to appear at the same time as ironworking or even after it, since it occupies a distinct ritual and technological space. Copper was often a royal metal in a way

that iron was not. In West Africa the smelting of local ores seems to have largely died out in the nineteenth century in the face of abundant imported supplies but the forging of metal remains important even in the smallest village. In West Africa metalworking is often the task of local specialists, who may be itinerant or drawn from a restricted and marginalized caste or even be referred back to a different ethnic origin. Smiths are often also possessors of special powers as circumcisers, healers and handlers of the dead, and because of their powers of transformation may be regarded with extreme ambivalence.

Central to African scholarship has been a concern with Nigerian lost-wax casting whereby an object is modelled in wax, usually over a clay core and covered with further layers of clay. Baking hardens the clay, melts the wax and allows it to be poured off so that a hollow mould is left, ready to receive molten metal. Each object is thus unique as the mould must be broken to extract the casting. According to Yoruba tradition the whole world was first created about the city-state of Ife, and scholars have tended to accept this Yoruba notion at least as far as brass casting was concerned. Yet there are good grounds for seeing Ife casting technology (twelfth to fifteenth centuries) as derived from trans-Saharan links, later passed south to Benin, while close study of the Igbo-Ukwu tradition (eighth to tenth centuries) shows it to rest on locally developed technology and materials. Indeed, Igbo-Ukwu is only one of a whole set of largely unstudied and ill-understood casting traditions, using bronze (an alloy of copper and tin) not brass (an alloy of copper and zinc), scattered across southern Nigeria and lumped unhappily together as the Lower Niger Bronze Industries. It only complicates matters further to note that some early Benin castings are of bronze, not brass, and that a number of clearly Lower Niger pieces were found in Benin by the British expedition of 1897. Since copper alloys were associated with kingship in southern Nigeria, it seems likely that all the powerful kingdoms of the area simultaneously disseminated brass or bronze regalia as marks of their authority and drew them (and possibly craftsmen) back to the centre as tribute (no. 23). It is significant that, when the Benin vassal city of Udo made a bid for power in the sixteenth century, it apparently seized Benin brass casters and set them to work making its own castings as a sign of its independence.

23 Pectoral mask with bells

Brass
Apapa, Lagos, Nigeria
16th century ?
L. 43cm, W. 35cm, Dp. 6cm
Ethno 1930, 4-23.1

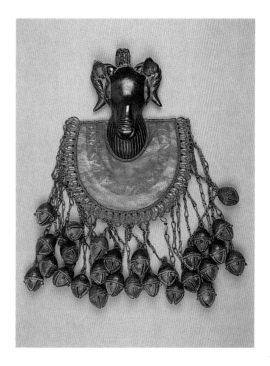

This superb casting is part of a large hoard of metalwork discovered accidentally in 1907 at a depth of about 3m while a well was being dug. It impresses by its subdued elegance and technical mastery. The central semicircular panel has been edged in cast plaitwork and ornamented with a stamped design. The large bells are attached with links of wire. The horns and ears have been artfully spread to frame the suspension loop that surmounts the hollow head. It was probably worn as a pectoral mask, hanging around the neck.

Rams' heads are well documented in the art of southern Nigeria, being frequently associated with chiefship and ancestral powers, but commentators have not been slow to connect this piece with superficially similar works of ancient Egyptian origin. Although such links are nowadays out of favour, stylistically it is hard to place exactly. It certainly recalls some of the finest works of Benin origin but the form and execution of the eyes and the unusual design of the bells recall the non-canonical castings grouped under the catch-all title of Lower Niger Bronze Industries. Indeed, Lower Niger versions of rams' head pectorals do exist. This stylistical ecclecticism has led the Apapa pectoral to be attributed to the Yoruba kingdom of Owo, which was long under Benin influence, rather than to Benin itself.

Nigel Barley
British Museum
London
UK

BIBLIOGRAPHY

Fagg, W. B., 1930, 'A bronze breastplate from Lagos', *British Museum Quarterly*, vol. V: 30

Fagg, W. B., 1963, *Nigerian Images*, London: Lund Humphries

24 Head

Leaded brass, pigment
Yoruba, Ife, Nigeria
12th–15th centuries
Ht. 35cm, W. 12.5cm, Dp. 15cm
Given by the National Art Collections Fund
Ethno 1939, AF34.1

The brass heads of Ife were 'discovered' at least twice, once by the German anthropologist Frobenius, when he visited the Olokun Grove in 1910, and again in 1938 when two caches of castings were unearthed within the Ife palace walls. Since then, further excavations have revealed many more brass and terracotta works of similar style. Frobenius's response was to assume that such castings must have been of Western inspiration, given that naturalism was held to be a mark of advanced civilization, a status he withheld from Africa. The Ife castings contradicted many existing assumptions about Africa – the absence of sophisticated technology, the lack of historical depth and state organization, the instability of kingship. Instead of questioning these, Frobenius found it more probable that the pieces had been made in a Greek colony of submerged Atlantis and represented Poseidon, the sea god, under his African name of Olokun.

It was not until after the Second World War that William Fagg, of the British Museum, declared controversially that the Ife castings were wholly African and predated European influence of the fifteenth century. This has come to be the accepted view.

The function of such pieces is far from certain. This head clearly represents a ruler and it is possible that it was made for attachment to a wooden body, by the holes in the neck, as part of a funeral rite that marked the passing of the individual king while celebrating the eternity of kingship. It seems that these works were repeatedly reburied and disinterrred as circumstances required, and this is the most likely explanation for the impact damage on the jawline.

Nigel Barley
British Museum
London
UK

BIBLIOGRAPHY

Frobenius, L., 1913, *Und Afrika Sprach*, 3 vols, Berlin

Willett, F., 1967, *Ife and the History of West African Sculpture*, London: Thames and Hudson

Fig. 45: The Olokun head and its keeper, Ife, Nigeria. The picture was taken by a British District Officer, Charles Partridge, after he had obliged the anthropologist Frobenius to return a number of works to the shrine.
Photo: Trustees of the British Museum

Metal and kingship

In all this, mythical histories continue to play a large role. Local rulers were often keen to adjust their own genealogies to confirm links with rising dynasties, as in contemporary Nigeria they may still be revised in the light of the origins of a new regional governor or president. Benin origins are claimed by many smaller Nigerian peoples, while Benin kingship is locally traced back to Ife. Europeans, of course, brought their own mythologies to bear. When Frobenius, the German ethnographer, visited Ife in 1910, he was astonished to find brass (and terracotta) heads of a strikingly classical naturalism in the grove of Olokun (fig. 45). It seemed that they had been excavated in the mid nineteenth century and subsequently reburied and re-excavated as occasion demanded. Equating Olokun with the Greek sea-god Poseidon, Frobenius convinced himself that he had discovered the site of ancient Atlantis, a Greek outpost in Africa. This seemed to him much more likely than the – to us – obvious inference that such works could simply have been made by local African artists (no. 24). This view was deeply rooted in Western scholarship, since naturalism was considered a sure sign of refined civilization whereas West Africa was seen as wild rather than civilized. Similar cultural-historical and racist assumptions dogged the perception of Benin castings when they first became widely known in the West

following the British punitive expedition of 1897. All manner of 'explanations' were offered for their being found in a West African city, from the lost tribe of Israel to ancient Egyptians and Portuguese mariners. The self-evident local African source was frequently ignored, and it was largely through the tireless efforts of the scholar Charles Hercules Read, a Keeper at the British Museum of the time, that it became generally accepted.

Ivory

Yet similar processes were at work when West Africans observed Westerners and their possessions. Africans found it impossible to believe that the Western rapacious obsession with ivory was for a material with which to make frivolous billiard balls, knife-handles and piano keys. More general explanations were sought. So in Benin Europeans were understood through association with the white-faced god, Olokun, who lives beyond the sea and sends children and wealth (no. 25). Conveniently, legend relates that Olokun was defeated by the Oba of Benin in a battle and stripped of his fine goods so that it was here appropriate, where there was a royal monopoly of foreign trade, to melt down European manufactures and recast them to fit the requirements of the court. As foreign metal became more abundant, so the 'bronzes' themselves were transformed, becoming ever heavier and larger. At the end of the nineteenth century the royal palace itself was rebuilt using imported metal sheeting and girders.

Textiles

The local production of woven cloth from cotton, wool and other fibres is very old in Africa, the most ancient dated examples from south of the Sahara being from ninth-century Igbo-Ukwu. Across the area there is extraordinary richness of design and technique. Pattern may be woven within the cloth itself or applied later, but printing, appliqué (fig. 46), resist processes and embroidery are all used. Dyes may be of vegetable or mineral origin, or, more commonly nowadays, imported. As is often the case in Africa, technology varies according to gender, with men mostly weaving narrow strips of cloth that are sewn together to form larger textiles and women weaving integral pieces directly on broader looms. Attempts have been made to equate the distribution of loom

Fig. 46: Composite 'firecloth' of indigo-dyed cotton and applied, imported felt, Dowayo, Cameroon. Such cloths are used at male circumcision and death festivals.
Ethno 1984, AF2.1

types, as with metalworking technology and pottery decoration, with an expansion of Bantu-speaking peoples across central and southern Africa from a putative point of departure on the Nigerian–Cameroonian border in the last millennium BC and the first AD. Given the paucity of reliable archaeological data in Africa, such speculations remain problematic, and it is hardly surprising that there is no perfect fit between linguistic, cultural and technological markers over such a huge area.

The Museum textile collection inevitably reflects a whole range of relationships, imperial, commercial and academic, between Europe and West Africa (no. 26). It contains cloth bundles, used as a widely circulating currency within Nigeria and purchased by the exploratory Niger Expedition of 1841. It features a collection made by Charles Beving, a Manchester cloth manufacturer, in the early years of the twentieth century to serve as models to be cheaply machine-copied in his factories and exported back to West Africa. And a recent collection, made by a doctoral student as part of fieldwork research, documents over three hundred varieties of rapidly changing Yoruba narrow-strip *ase oke* cloth from Oyo.

Foreign contact, in textiles too, offered West Africa new opportunities. In the fifteenth century, before the iniquities of the trans-Atlantic slave trade, the first local commerce in which Europeans became involved was the export of 'country' cloth from southern Nigeria to Ghana where there was a ready market. Dutch textiles were carried too,

25 Royal crown
(erhu ede)

Coral, agate, copper
Benin, Nigeria
Late 15th century
Ht. 15cm
Ethno 1898, 6-30.5

Beaded flywhisk
(ugbudian-ivie)

Coral, agate, copper
Benin, Nigeria
19th century
L. 103cm, W. 17cm
Ethno 1898, 6-30.3

Beaded shirt
(ewu-ivie n'ovien iye)

Coral, agate, copper
Benin, Nigeria
19th century
L. 71cm, W. 65cm
Given by Mrs H. G. Beasley
Ethno 1944, AF4.63

This crown forms part of the royal regalia and is recognized as belonging to *Oba* Ovonramwen, having been inherited from *Oba* Ozolua, who ruled in the late fifteenth century. It was purchased by the Museum from Captain E. Roupell, an officer of the Niger Coast Protectorate, who took part in the British punitive expedition of 1897 and subsequently became British Resident at Benin City.

This type of crown is different from the later nineteenth-century types called *olikekeze*. These have flanged tops emblematic of *ada*, the royal swords, symbolizing the *oba*'s supreme authority. Today the earlier type is worn on casual occasions as the red cap while the later is worn on stately functions as well as installations when the full beaded regalia is worn. The dignity of kingship, the associated aura and awe are summed up in the Benin saying, 'He who adorns the royal beads must conduct himself properly; else woe betide him who abuses the privilege of adorning beads.'

The full regalia also included a coral shirt (*ewu-ivie n'ovien iye*) and flywhisk (*ugbudian-ivie*) of considerable weight so that on formal ocasions the *oba* might be supported by a page on either side. The possession of bead regalia is emblematic of the *oba*'s role as terrestrial counterpart of the sea god Olokun, and it needed to be strengthened by offerings at a special annual ceremony (*ugie ivie*).

Joseph Eborieme
National Museum
Benin City
Nigeria

BIBLIOGRAPHY

Ben-Amos, P., 1980, *The Art of Benin*, London: Thames & Hudson

Bradbury, R. E., 1973, *Benin Studies*, London, New York and Ibadan: Oxford University Press for the International African Institute

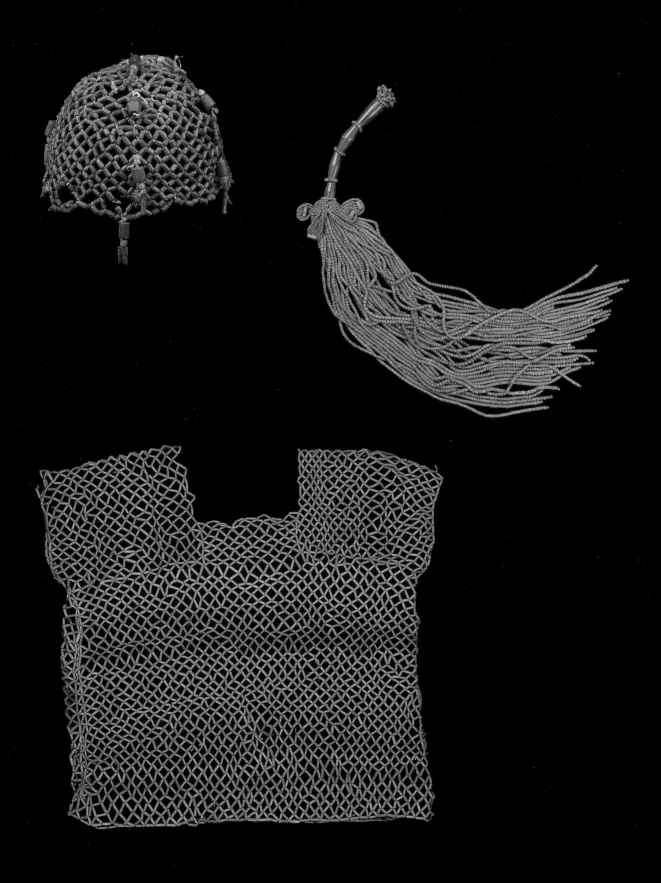

26 Resist-dyed textile
(adire)

Cotton, indigo
Yoruba, Nigeria
20th century
L. 167cm, W. 193cm
Ethno 1971, AF35.24

Textiles resist-dyed in indigo are known collectively in Yoruba as *adire*. An identical pair of cloths was prepared, using either raphia fibre or starch paste to resist the dye, and then sewn together edge to edge. They were used by women as wraparound skirts, always relatively inexpensive and without the prestige status of hand-woven *aso oke* fabrics, the manufacture of which still flourishes. *Adire* cloth production as known in the twentieth

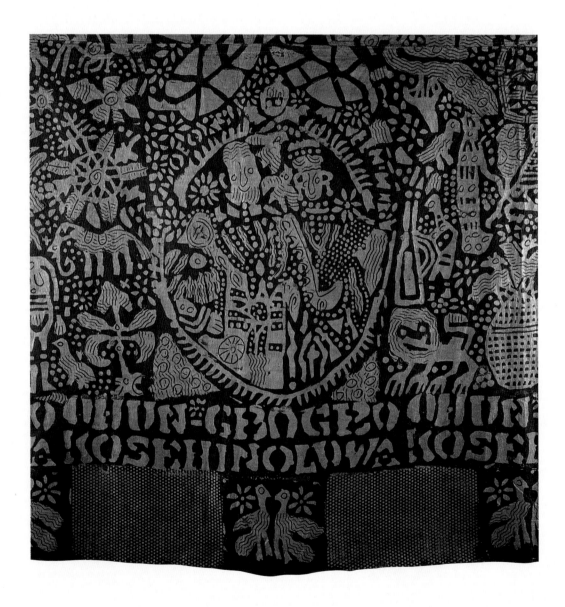

century was evidently a response to the material culture of colonial rule although production began to decline in both quantity and quality during the 1980s with the increasing popularity of candle wax for resisting dye – a technique known as *kampala* introduced to Nigeria in the late 1960s.

The stitching and tying with raphia, widespread through the Yoruba-speaking region and beyond, probably developed from the practice of redyeing old worn-out cloths in indigo to renew them for further use. The fine decorative quality achieved in the twentieth-century *adire* was dependent upon the availability of factory-made shirting, however, and would have been impossible with local hand-spun cotton cloth.

The application of starch paste was associated with the cities of Abeokuta and Ibadan, both nineteenth-century foundations arising from the displacement of people within the Oyo empire because of the Fulani *jihad*, cities which soon became centres for colonial administration. In Abeokuta, also an early locus of Christian missionary activity, starch was applied using metal stencils cut from the linings of tea chests, though eventually they were also cut from tinned iron sheeting. Many of the patterns imitated tied and stitched designs, but this technique also allowed for the development of figurative imagery and lettering. In Ibadan the starch was applied by freehand painting, initially in imitation of Abeokuta, but also allowing a freedom in design different in character from the stencilled forms.

The textile illustrated here was purchased for the Museum in Ibadan in 1970, shortly after it was made. It is a freehand copy of a stencilled design, as evident in the lettering along the edge, *gbogbo ohun kosehin oluwa*, 'all things gather behind the lord' (i.e. God knows everything). A medallion at the centre of each cloth shows King George V and Queen Mary, with vestiges of lettering above, and gives this design its name, *oloba*, literally 'it has king'.

It is probably derived from advertisements and souvenirs of the 1935 Silver Jubilee of their accession to the imperial throne. At each side there is a rich catalogue of human, animal, plant and other forms, many still unidentified, though including *al buraq*, the horse that carried the Holy Prophet of Islam from Mecca to Jerusalem and up into heaven in the Night Journey. This is from a popular Cairo print available throughout West Africa showing a winged horse with a woman's head, crowned, and peacock's tail. The configuration of British royalty and Islam may seem a random assemblage of topical events and novel images; but once put together it remained popular within the repetoire of *adire*-cloth dyers until the decline of this art some fifty years later.

John Picton
School of Oriental and African Studies
London
UK

BIBLIOGRAPHY

Barbour, J. and Simmonds, D. (eds), 1971, *Adire Cloth in Nigeria*, Ibadan: Institute of African Studies, University of Ibadan

Picton J. and Mack, J., 1989, *African Textiles*, London: BMP

and silk thread unpicked from them inspired the huge elaboration of traditional Asante *kente* cloths, worn by notables. Imported foreign 'batik' (itself based on Indonesian techniques) has developed into a distinctive style of wax-printed cloths, drawing on African designs and sometimes manufactured locally, that now dominates every cloth market the length of the coast. In the 1980s a common textile of this kind was one depicting the best-known classic works of African art, Benin heads, Asante dolls, Baule sculpture etc., all reproduced the same size. Curtains of this material were popular in the brass workshops along the coast, and artists would often work with one eye on the images on their curtains. Thus, thanks to cloth, a truly transnational, African art became a reality, with Cameroonians making Ife heads and Benin casters Fumban masks and no account being taken of differences of scale.

The contrast between change and tradition or foreign and local is not a simple matter, and many different kinds of cloth may be used in a single culture in different ways. In the Kalabari area of southern Nigeria, great prestige is still attached to chequered cloth from India, while a whole new form of hand-made, elaborately patterned textiles for local use has been created by removing threads from imported, machine-woven cloth. Elaborate Ibo textiles are also used in ritual decoration of the beds of the dead and despite their constant innovations are regarded as being just as 'traditional Kalabari' as the indigo resist-dyed Ibo *okorepi* cloth used to conceal the faces of masqueraders while they perform.

Masquerade

Although widely distributed around the world, it is masquerade that is often considered as the most quintessentially African of art forms (no. 27). A masquerader in performance seems to be depicted in a Tassili rock-painting from the Sahara some time before the second millennium BC (the image has been taken up as the logo of a current rock (music) group). Contemporary masquerades may be used for politics, social control, to deal with the dead, to cure disease, to initiate the young or for pure entertainment (fig. 47). Often a number of elements are combined. While masquerades are multi-media events, interweaving dance, music, costume and speech, Western collections from West Africa tend to

isolate the static headpiece artificially as the artistic element – especially if made of carved wood – to the detriment of all else. Such headpieces, of course, have been a principal influence on twentieth-century Western artists, although in actual performance they may be obscured by other elements, or face upwards or even come out only at night so that visual prominence may be of secondary importance. Knowledge of masks and masking may be widely spread through the community or restricted to special groups. While masquerades may be of great antiquity, they constantly mutate, with new items being taken up into the repertoire or dropped as they cease to interest, and it is not unusual for whole masquerades, complete with dances and songs, to be simply sold by one community to another. Masquerade often brings the power of outsiders, foreigners, monsters, the dead into contact with the human sphere so it is inevitably open to the new (no. 28). Most masking societies have a youth group who not only undergo training but adopt new masquerade forms that may be taken up into the senior grade and so ensure its constant evolution.

Fig. 47: OPPOSITE Swordfish mask of wood, iron and bone, Bijogo, Bissagos Islands, Guinea-Bissau. Masks such as this, representing violent and unpredictable animals, are restricted to older youths.
Ethno 1983, AF4.1

Fig. 48: RIGHT Pair of wooden figures *blolo bla* (female) and *blolo bian* (male), Baule, Ivory Coast/Ghana. Such figures refer to the lovers of mortals left behind in the spirit world who may trouble them in this.
Ethno 1969, AF9.1–2

27 *Gelede* mask

Wood, pigment
Yoruba, Nigeria
20th century
Ht. 68cm, W. 33cm, Dp. 55cm
Ethno 1942, AF7.24

Gelede mask

Wood, pigment
Yoruba, Nigeria
20th century
Ht. 47cm, W. 35cm, Dp. 45cm
Ethno, 1942 AF7.6

Found mainly in south-western Yorubaland, the *Gelede* mask performs in identical pairs during ceremonies intended to promote social harmony and spiritual well-being in a given community. Each mask consists of an elaborately carved headdress and a costume of colourful fabrics. A typical headdress is in the form of a human head surmounted by motifs intended to entertain and, at the same time, address a specific concern – be it social, economic, political or spiritual, a concern that may also be expressed in songs.

Gelede mask with snake and banana motifs: This headdress seems to embody a prayer for a fruitful life. To the Yoruba, the banana plant signifies opulence and fecundity partly because it has a succulent stem and stalk and partly because it grows in clusters and its fruits are in bunches. It thrives best in the swamps and marshes; hence the popular Yoruba saying: *Ogede ki gb'eti odo ko y'agan* (the banana plant in the swamp is never barren). Although it normally dies shortly after producing fruits, the plant develops many suckers to survive the parent. That is why a prayer for worthy and responsible children is usually reinforced with the maxim: *B'ogede ba ku, a f'omo re ropo* (the

banana plant is always survived by offspring). The plant's ephemeral life is often likened to premature deaths (*abiku*) among humans – which makes its stems and suckers important ingredients in rituals aimed at prolonging life.

In this headdress the artist has taken great care to finish the stalk, emphasizing the ripeness of the nine bananas in such a way as to recall what the Yoruba consider as the three cardinal blessings: prosperity, living to ripe old age and being survived by many children in whom the dead continue to live. Note the sprout at the end of the stalk.

The snakes flanking the carved head complement and contrast with the vertical thrust of the banana stalk. First of all, Yoruba identify the snake with the dynamism and rejuvenation because of its fast spiral or zigzag movements and its ability to cast off an old skin to reveal a new one. It is implicated in increase rituals because of its ability to bear several offspring at one time. Yet many Yoruba fear the snake, large or small, given its poisonous and sometimes lethal bite. There is a popular notion that snakes seldom bite unless provoked. Thus most snake bites are interpreted as a manifestation of witchcraft or retributive justice. Hence

the popular prayer: *Olorun ma je a te oka n'iru mole* (may we not step on the tail of a cobra). In the Egbado town of Idofoyi (Ayetoro), *Gelede* masks perform annually to honour Onidofoyi, the tutelary deity of snakes in the town and whose worship is aimed at attracting the good things of life and averting such dangers as deadly snakebites. This headdress is in the Egbado sub-style and could very well have been carved in the Ayetoro/Imaala area, although this is uncertain because the *Gelede* headdress commonly associated with the Onidofoyi consists of the two heads (one male, the other female) joined horizontally by two or more intertwined snakes.

Gelede mask with snake and porcupine motifs: One of the most important functions of the *Gelede* mask is to use the visual and performing arts to amuse and, in the process, educate the public about the evils of witchcraft and other anti-social behaviour. This headdress shows two snakes attempting to swallow a porcupine whose perforated body indicates that it was originally fitted with quills. What immediately captures the attention is the artist's imaginative treatment of the subject and the exceptional skill with which he balances mass and void. But the viewer soon begins to wonder: 'Can the snakes really swallow the porcupine along with the quills?'

This theme, represented on other *Gelede* headdresses in the form of a snake attempting to swallow a tortoise, reflects the Yoruba belief in the limitations and relativity of power, both spiritual and temporal. It seems to have been inspired by a Yoruba myth on the origin of witchcraft which claims that, in the beginning, the Supreme Being (Olodumare) gave the first female called Iya Nla (the Great Mother) and her closest disciples known as *aje* a potent spiritual power (*ase*) with which to sustain life on Earth in their role as mothers. And, since the power can be used for positive or negative purposes, the Supreme Being, acting through Esu, the divine messenger, made these women recognize their limitations

and they promised to honour certain axioms by which ordinary mortals could protect themselves from the power. Two of the axioms are that 'nobody eats a tortoise along with the shell' and 'nobody eats a porcupine along with the quills'.

So it is that motifs signifying these axioms frequently appear on *Gelede* headdresses not only to plead with the powerful women in Yoruba culture to use their power for the benefit rather than the detriment of human-kind but also to warn the public at large of the nemesis that awaits foolhardiness or any abuse of power. For snakes that do succeed in swallowing a tortoise or porcupine often die eventually of injuries inflicted by the shell or quills. This theme also reveals the Yoruba belief that every creature, however small or seemingly harmless, is endowed with certain powers with which to defend itself. It thus constitutes a warning against oppression and the use of force in settling a disagreement simply because of the assumption that one could easily subdue a supposedly weaker opponent. Who knows what could happen? And why take chances? Hence the *Gelede* society personifies Iya Nla as the Mother of All, encouraging all human beings to interact as the children of the same mother and so avoid as much as possible the use of force in resolving problems and disagreements. This headdress is in the Egbado sub-style, although its exact provenance cannot be identified.

Babatunde Lawal
Virginia Commonwealth University
USA

BIBLIOGRAPHY

Drewel, I I. J. and Drewel, M. T., 1983, *Gelede: Art and Female Power among the Yoruba*, Bloomington: Indiana University Press

Lawal, B., 1996, *The Gelede Spectacle: Art, Gender, and Social Harmony in an African Culture*, Seattle and London: University of Washington Press

28 Elephant mask
(*mbap mteng*)

Cotton, glass, fibre
Bamileke, Grasslands, Cameroon
Early 20th century
Ht. 150cm, W. 60cm, Dp. 20cm
Given by the Wellcome Historical Medical Museum
Ethno 1954, +23. 3446

Elephant mask
(*mbap mteng*)

Cotton, cowrie shells
Bamileke, Grasslands, Cameroon
Early 20th century
Ht. 135cm, W. 55cm, Dp. 25cm
Given by the Wellcome Historical Medical Museum
Ethno 1954, +23. 3445

These magnificent elephant masks come
from the south Grasslands area of western
Cameroon inhabited by the Bamileke people.
They were transferred to the British Museum
(Department of Ethnography) from the Well-
come Historical Medical Museum, having
probably been bought through dealers in the
1930s. Used by Bamileke secret societies in
ritual dances and funerary ceremonies, such
masks are called *mbap mteng* (literally 'animal
with huge ears'). The main centres of the
intensive use and the manufacture of this kind
of mask are concentrated on the Bamileke
plateau, the place of its historical origin. How-

ever, these objects spread across the north and
west of the Grasslands (Bamenda plateau,
Ndop plain, east Cross River border), through
trade and migration. Their role in those areas
is less important than in Bamilekeland where,
for hundreds of years, there have been the best
artists and their works. These masks, which are
held in German and American museums, were
mostly collected in some fifteen Bamileke
kingdoms between 1900 and 1914.

The Bamileke (numbering some three to
four millions), a Bantu-speaking group, are
well known for the vigour and splendour of
their art. They are organized into a hundred
kingdoms (*gung*), the biggest being Bandjoun
(population 150,000). Every kingdom is
headed by the king (*fon* or *fo*), who represents
god and the ancestors. The *fon* is at the apex of
Bamileke social organization, which is highly
stratified. But in spite of his important reli-
gious, political and supernatural powers, the
fon is controlled by notables (*kam*) organized in
secret societies (*mkem*) which are the heart and
soul of the kingdom both at the social and
spiritual level. These associations used various
masks during dances and ritual performances.

The elephant mask is the main liturgical
garment of a member of the secret society
mkem during the royal and ritual dance of the
elephant, the *tso*. This dance is associated with
the symbolism of the royal power and the
sovereignty of the kingdom, and also with
funerary rituals. Several secret societies which
are associated with the sacred royal forest, *fam*
(the main location for religious and ancestor
worship in every Bamileke kingdom) employ
elephant masks on the occasion of the *tso*
dance. But only two of them, the elephant
men, use these beaded hoods as their principal

attribute in this context. First there is the *kemdje* society, an association of the priests and guardians of custom and tradition. Then there is the *kwosi* society (the *Aka* society in the west Bamileke plateau and often with some influences coming from the rainforest), the followers of the king, originally a warriors' club, a group of the country's rich, initiated men. The *tso* dance performed by the *kwosi* society is the most spectacular and prestigious of Bamileke ritual performances.

The *kwosi* dancer wears a complex costume of local blue and white batik cloth (*ndop*) and sometimes a leopard skin is attached to the back. The elephant mask can be surmounted by a beautiful headdress made of feathers or represented by a beaded animal figure (leopard, crocodile, bird, buffalo). He appears to the accompaniment of sacred drums and gongs. He lopes in slow motion, like an elephant, round the marketplace in the royal residence, carrying horse tails and poles demonstrating the prestige and power of the kingdom and the notables.

The elephant mask is associated with wealth, prosperity, royalty and occult power. The elephant symbolizes power, authority, prestige and leadership. It is believed that the *fon* (king) and some prominent initiate notables may at will turn into elephants and leopards, thanks to *ke* (transcendental and dynamic power, occult, and fertile force, magic). The cowrie shell is not only a symbolic allusion to wealth but of itself constitutes wealth and prosperity. For hundreds of years it was used as the main medium of exchange in the Grasslands. It is believed to have occult or supernatural powers so it is used in divination, traditional medicine,

several cults (cult of twins, cult of fertility, ancestor worship) and rituals.

Beaded elephant mask:

This splendid example of an elephant mask is made of fibre and cotton cloth decorated with striking and multi-coloured beads creating remarkable geometric and symbolic motifs (triangles, lozenges, circles, etc.). Its visual appearance is defined by its three-dimensional form as a cloth sculpture and by its surface pattern as beadwork. Horizontally, two huge circular, stiffened ears are sewn on each side of the hemispherical head. The face shows two circular eyes. The nose and the mouth are stylized and highlighted with geometric shapes. Vertically, the hood extends through a long flap hanging down behind and in front to represent an elephant trunk. The frieze and geometric designs were chosen by the artist with an eye to establishing harmony and balance between the aesthetic and symbolic significance. The basis of the repertoire of forms is constituted by the isosceles triangles (here the sign of the leopard) and its variants. The leopard and the elephant are not only the principal symbols of leadership, royal power and prestige, but also play a fundamental role in the rites involving *ke* (transcendental and dynamic power, occult and fertile force, magic). Besides this, beads symbolize wealth, prosperity and distinction.

Cowrie shell elephant mask:

This second elephant mask, a good example of three-dimensional cloth sculpture, is decorated with cowrie shells. Masks of this kind, fully covered with plain cowrie shells, can be found in the field but are not numerous in the Grasslands. Another elephant mask very similar to this piece was photographed by Pastor

Christol (a French missionary) in one of the northern kingdoms of the Bamileke plateau in 1925. The masks of the *kungang*, a Bamileke religious secret society of medicine men, show some similarities with these cowrie-covered elephant masks.

This piece is notable in that the white cowrie-shell design spreads across the whole of the background and depicts the features of a human face (nose, circular eyes, mouth), a long and stylized trunk that drapes from the head to the ground, and two large hinged animal ears that flap during performances. The artistic tradition of covering different objects (sculptures, clothing and gourds etc.) with cowries (or beads) has a long history in Bamilekeland. Because cowries were highly valued in Bamileke society, the mask was called 'thing of money' and was a good example of the ostentatious display of wealth. Bamileke society is highly stratified and hierarchical so it is not surprising that the form and decoration of the mask indicated the owner's status. This object belonged to a rich member of the high grade of an important secret society.

Jean-Paul Notue
The University of Yaoundé I
Yaoundé
Cameroon

BIBLIOGRAPHY

Gebauer, P., 1979, *Art of Cameroon*, Portland, Oregon: Portland Art Museum

Northern, T., 1975, *The Sign of the Leopard: Beaded Art of Cameroon*, Storrs: The University of Connecticut

Notue, J.-P., 1988, *La symbolique des arts bamilekes (Ouest-Cameroun): approche historique et anthropologique,* 4 vols (doctoral thesis), Paris: Université de Paris I

Notue, J.-P., 1990, *Place du kè et du sacré dans les arts de l'Ouest-Cameroun*, Yaoundé: Mesires-Orstom

Notue, J.-P., 1993, *Batcham: Sculptures du Cameroun: nouvelles perspectives anthropologiques*, Marseille: Musée de Marseille et Éditions de la Réunion des Musées Nationaux

Perrois, L. and Notue, J.-P., 1997, *Rois et sculpteurs de l'est Cameroun: la panthère et la mygale*, Paris: Éditions Karthala

29 *Bedu* mask

Wood, pigment, iron
Bondoukou region, north-east Ivory Coast
19th century
L. 145cm, W. 70cm, Dp. 18cm
Ethno 1934-2

Bedu plank masks are made and used throughout the north-eastern region of Ivory Coast.

There, peoples speaking Koulango, Nafana, Abron, Dyula and Degha live together in the town of Bondoukou and the many villages of the frontier region between the subtropical rainforest and the northerly savannah. Already in its material components, *Bedu* occupies a border zone between the savannah and the forest: the mask is cut from the upper part of the roots of the kapok tree, a tall forest tree, while its costume is made of bark taken from the baobab tree, the African savannah tree *par excellence*.

Sculpting the mask, beating the bark off the tree, and knotting the strings of the bark into a costume that covers the entire body of the masquerader, is the work of men. Women are responsible for painting the mask, an activity which is repeated every year when the *Bedu* reappears in public for a short period – up to three weeks – of communal new year celebrations and masquerading.

Today *Bedu* continues to be the focal point of important festivities, which also now include playful competitions between teams of Muslim and Catholic urban youth in the town of Bondoukou or political rallies in large villages. Unlike the 'real' *Bedu* masks which are conceived as reproductions ('domestication')

of an original ('wild') mythic (antelope-like) animal, other *Bedu* masks are seen as just copies of these reproductions. Miniature *Bedu* masks are ordered by local people who keep them as souvenirs on display in their houses. Mainly during the 1960s and 1970s a considerable number of *Bedu* mask 'copies' were also produced for non-local clients such as tourists and art collectors.

This mask is one of the three earliest *Bedu* masks preserved in collections which were acquired by two British officers, Wilfred Davidson-Houston and Cecil Armitage, most probably in 1896, in the course of a joint expedition to the Gold Coast (now Ghana) border zone with Bondoukou. In a travelogue which reported on a 1889 diplomatic mission to the same region, Richard A. Freeman described the *Bedu* masquerade he had witnessed; but he wrongly called it 'Sakrobundi mask', the name under which this mask has been recorded in the museum archives, and known ever since. *Sacra* or *Sacrabundi* is the name of a once-renowned witch-chasing cult involving no masks, but public dances and sacrifices to a shrine; the animal helmet mask it was incorrectly associated with was the *Gban* or *Do* mask that does not dance but hunts witches in the company of initiates.

Freeman's description reveals how for more than a century *Bedu* masquerading has remained largely unchanged in its general lay-out: the nightly performance, the acrobatic movements of the masquerader and the broken circle of separately grouped men, women and children dancers. All important formal characteristics have also persisted through the ages. The late nineteenth-century and early twenty-first-century *Bedu* masks show the same use of triangular and semicircular decorative patterns in red, white and black pigment, the round 'human face' in the middle of the vaguely triangular 'animal' mouth, and the horns which (if intact, unlike in this case) almost touch each other and form a nearly perfect circle.

Another type of *Bedu* mask has a disc-like superstructure with four 'moon crescent' cut-outs. This second type is referred to occasionally as female, as opposed to the male type with horns. This gendered distinction should not obscure the fact that all *Bedu* masks combine animal and human, as well as male and female, attributes. Like many other masquerades, *Bedu* is about the transgression of these basic categories. The long history of *Bedu* shows how this basic scheme has been inscribed in colonial and postcolonial mask-making and masquerading in the Bondoukou region.

Karel Arnaut
University of Gent
Belgium

BIBLIOGRAPHY

Bravmann, R. A., 1974, *Islam and Tribal Art in West Africa*, Cambridge: Cambridge University Press

Bravmann, R. A., 1979, 'Gur and Manding masquerades in Ghana', *African Arts*, vol. XIII, 1: 44–51, 98

Bravmann, R. A., 1995, 'Mask (sakrobundi)', in T. Phillips (ed.), *Africa: The Art of a Continent*, London: Royal Academy of Arts; Munich and New York: Prestel Verlag, pp. 452–3

Fagg, W. B., 1969, *African Sculpture*, Washington, DC: H. K. Press

Segy, L., 1958 (reprint 1975), *African Sculpture*, New York: Dover Publications

Sieber, R. and Walker, R. A., 1987, *African Art in the Cycle of Life*, Washington, DC, and London: Smithsonian Institution Press

Underwood, L., 1948, *Masks of West Africa*, London: Alec Tiranti

Masquerade performance in West Africa is an almost exclusively male occupation, as is wood-carving. It is significant that, while men play drums of wood, women make percussion instruments of pottery. While everyday wooden items may be made by almost any man, masks and other figurative carvings are usually the work of specialists, and in West Africa these are frequently blacksmiths. Contrary to established ideas concerning the anonymity of tribal art, the names of these artists may be well known within the community. While amongst the Dan of Ivory Coast, for example, individual masks may have elaborate careers and be serially promoted to more serious uses involving ever-greater powers, amongst others, masks, when not in actual use, may be just wood and even be simply thrown away after performing. Such is the case among the Kalabari of southern Nigeria, who have incorporated playing cards, mirrors, umbrella parts and above all feather dusters into masquerade headpieces. These will be stripped from a mask after performance and carefully preserved while the wooden core itself is hung up in the men's house and allowed to decay slowly.

Most of the African wood-carvings in Western museums are no older than the nineteenth century, given that they are usually made of softwood and a prey to termites and other dangers in their original setting. Some, however, are of great antiquity, such as the Tellem sculpture of the Dogon of Mali (fourteenth century) and rare wood-carvings of the Sierra Leone interior that may be even older. West African figurative sculpture is diverse in its uses, fixing and channelling power from the ancestors (fig. 48), the beings of the bush (fig. 49) or other sources. Such power may come from the incorporation of special substances or the attraction of spiritual forces or simply be built up as an object is used. In the case of Dowayo 'fertility dolls' in the collection (fig. 38), the most important constituent was the carver's acknowledged personal paternity of twelve children. West African carvings may also be used to control a part of one's own body. A common opposition is that made between the head and the hand, the first comprising inborn elements, the second skill in the execution of actions. Interplay between these two goes a long way towards explaining the often surprising courses of people's lives, and in West Africa representations of heads frequently act as bridges to the world of the dead, while 'altars of the hand' strengthen and protect in dangerous undertakings. Often masks

may turn up as 'quotations' in other sorts of carving. The Kalabari carve ancestral screens (fig. 50) to the dead in a form inspired by Western two-dimensional images such as paintings or photographs. While most carvings from the area are from a single piece of wood, these use the techniques of carpentry to fit many pieces together and incorporate a Western-style mitred frame. Within these the deceased is identified by the mask headpiece he performed in life but with his own face revealed as it never would be in performance. Such works were created by African artists of the eighteenth and nineteenth centuries, drawing on a mixture of foreign and indigenous sources, to cope with a new problem caused by the many powerful Kalabari of foreign origin who were playing an important role in social life at that time but could not approach traditional sources of ancestral power. A number of these screens came into the Museum collection following an incident at the end of the First World War when an innovating Christian preacher, Garrick Braide, was urging his followers to destroy traditional sculpture. Unwilling either to keep or destroy the screens, some gave them instead to a local British administrative official to dispose of safely.

Their heir can be seen in the modern works of the Kalabari female artist Sokari Douglas Camp, whose steel sculptures show masquerade figures in performance. Once again, they rework both Kalabari and Western concepts to produce something that neither alone could have created. As more generally in West Africa, women are not allowed to make human images in Kalabari nor to participate individually in masquerade, yet history tells that it was a woman, Ekine, who was the first to receive the secrets of masquerade from the water spirits. This creates a conceptual space for Sokari Douglas Camp, who is sometimes referred to by male Kalabari as 'the Ekine woman'.

A constant source of friction in Kalabari is the making of offerings to screens, usually in the form of strong drink. It is through such offerings that a screen becomes powerful, and they form part of the duty of a trading house head. Kalabari Christianity, however, does not normally permit such libations and so a deputy may be appointed to perform them. It is the sort of problem common to many West African societies where practices such as circumcision, brideprice and polygamy have to reach their own compromises with the world religions and the new religions that Africa is constantly generating within itself.

Islam arrived early in West Africa. The ancient empire of Ghana had already converted to Islam by the time it was overthrown by Moroccan forces in the eleventh century, and itinerant traders, warfare and trans-Saharan links have continued to spread it throughout large parts of the area. The effect of Islamicization on art, architecture and cultural life is often profound, yet it is too simplistic to assume that it leads inevitably to the total disappearance of institutions such as figurative sculpture and masquerade. Compulsory Islamicization in Guinea led both to repression of masquerading and to the development of a new headdress based on al-Burraq, the steed of Muhammad. In West Africa masked performance can be tied up in various ways with the

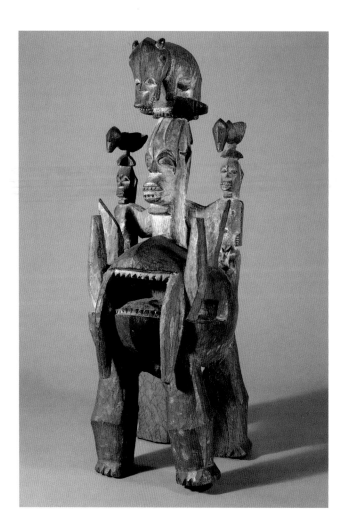

Fig. 49: LEFT Complex wooden carving (*ivwri*), probably nineteenth century, Urhobo, Nigeria. Such a piece may be owned by a particularly powerful individual or, more likely, a whole community. It both protects and directs greed and aggression towards the outside.
Ethno 1949, AF46.188

Fig. 50: RIGHT Ancestral screen, *duein fubara*, eighteenth to nineteenth centuries, Kalabari, Nigeria. It shows a powerful house head, probably of Barboy house, wearing the Bekinarusibi ('white man's ship on head') masquerade. Modern versions are often in the form of a liner and may be filled with chewing gum to spill out for children as they dance.
Given by P. A. Talbot
Ethno 1950, AF45. 334

Fig. 51: Coffin of wood with rayon lining in the form of a parrot-fish, Paa Joe's workshop, Teshie, Ghana. Such coffins are made for anyone involved in fishing.
Photo: N. Barley, 2000

internal chronology of Ramadan, the phases of the moon or the communication of the Qur'an. The collection contains two contemporary *Bedu* masks from the Ivory Coast that simultaneously support both animistic and Muslim interpretations, so that religion and social life may interpenetrate each other in many different ways (no. 29). Both Muslim (Sierra Leone) and Christian (Gambia) groups have taken up the construction of large paper lanterns or floats for street processions, but the former use them for Ramadan, the latter for Christmas and New Year.

Sculpture and change

Christianity has similarly been transformed by contact with West Africa. A relatively recent development is the ornate, 'fantasy' coffins of the southern Ghanaian Ga people (fig. 51), a speciality of the town of Teshie, near Accra. Developed from 'traditional' chiefly palanquins and prestige funerals, these coffins in the form of fish (for fishermen), giant milk cartons (for women market traders), oil tankers (for drivers) and even a womb (for a gynaecologist) drew on the carpentry skills fostered by the Second World War, the post-independence economic boom, a yearning for self-expression by a new middle class and a tradition of hundreds of years of adaptation and innovation in material culture. There has been a protracted local discussion about the acceptability of such coffins among the variety of Christian sects of the area, with a model in the shape of a giant bible being the most widely approved for actual entry into the church, while other models may be permitted into the churchyard but not the building. The coffin-makers of Teshie are now in the position of many contemporary West African artists, catering both for a local audience and for a wider international public since today their productions are to be seen in many of the art galleries of the West and have been the subject of several exhibitions. The coffins themselves reflect these new identities. Rich traders and middlemen will be buried in sleek Mercedes saloons, woodworkers in giant woodplanes and academics in huge, gaudy parrots clutching pens in their beaks.

Fig. 52: Raphia textile decorated using a combination of cut-pile and conventional embroidery. Kuba, DR Congo. *Ethno 1979, AF1.2674*

n terms of a common colonial language the countries considered here are almost entirely Francophone, a residue of Belgian and French rule. They include parts of southern Cameroon, Gabon, Loango, the Republic of the Congo (formerly part of the French Congo, and hereafter 'Congo'), the Democratic Republic of Congo (the former Belgian Congo, then Zaire, and hereafter 'DR Congo'), and the Portuguese-speaking northern Angola. British interest in the region has been limited. None the less Central Africa has had a significant part in the British Museum for at least a century.

This is a reflection less of the minor role played by British citizens in the colonial process of Central Africa than of the activity of certain major figures in promoting the artistic heritage of the region through links with the British Museum (no. 33). The qualities of the sculpture, textiles, basketry and domestic objects, particularly from kingdoms and chieftaincies in the southern part of this area, have challenged some of the more negative ideas that were promoted especially in the early periods of the twentieth century (fig. 53).

It was in Central Africa that Joseph Conrad situated his seminal novel *Heart of Darkness* (1902). The story, set on the Congo River, exploits a pervasive Western image of the region to reflect on the moral turpitude at the core of European consciousness. The deep brooding galleries of the Equatorial forests which dominate Central Africa are an appropriate backdrop for all this. Yet, far from being distant and unknown, at least the coastal and riverine areas of Central Africa had been extensively explored since Portuguese ships first appeared at the mouth of the Congo in 1482. Before the end of the fifteenth century the rulers of adjacent parts of the Kongo kingdom had already converted to Christianity and the first churches been built. In the sixteenth century King Afonso I Mvemba Nzinga sent some younger members of his family to Portugal, where one became a bishop and another a professor. Before long, images of the Virgin Mary and of St Anthony were being manufactured by local African craftsmen. However, there are indications that Christian imagery was not simply

Central Africa

Fig. 53: Ornate wooden and metal swords of the Kuba-Bushoong, DR Congo, collected by the Hungarian ethnographer Emil Torday at the beginning of the twentieth century.
Ethno 1909, 5–13.177, 181, 188–9, 191–2

adopted wholesale, but adapted to local Kongo conception. The image of the cross, which (unlike the situation encountered by the Portuguese in Benin) had no local model, was becoming an insignia of chiefly office as much as the sign of a catechist. Tellingly, some of the earliest collections from the region are now in the Vatican Museum in Rome.

Figurative sculpture

It may be that it is one of the Kongo seated figures known generically as *ntadi* (plural: *mintadi*) which Conrad had in mind in talking about an indigenous object as 'the Buddha of the Congo' (fig. 54). Although the reference to a Buddha-like figure recalls the serenity of the image, the transcultural reference is not as irrelevant as it might at first seem. Boma, the main entrepot near the mouth of the Congo River, was the centre of carvers and potters selling a variety of figurative sculptures in wood, stone or clay to traders from inland, or to Europeans. The names of most of the artists are now lost, though the ceramics of Voania Muba

30 Headrest with female figures

Wood
Luba, Democratic Republic of Congo
19th century
Ht. 16.5cm, W. 12.5cm, Dp. 9cm
Given by Mrs Webster Plass
Ethno 1956, AF27.270

Luba headrests, like those of other cultures around the world, were used as pillows by people of earlier generations to keep the neck cool during sleep and also to preserve labour-intensive hairstyles that could take days to create. Luba were called 'the headdress people' by early explorers, owing to the magnificence of their hairstyling and the creative techniques used to achieve such complex coiffures. It is no wonder that Luba elders considered their headrests to be among the most precious of all personal articles. A headrest was not only a channel to dream-states and other worlds but also a statement about the importance of personal adornment.

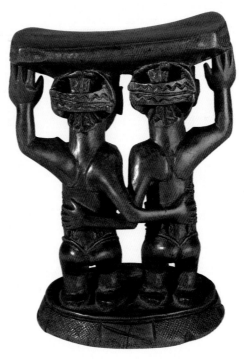

The hand of the artist of this exquisite headrest is recognizable also in a headrest at the National Museum of African Art in Washington, DC. In both cases, the support of the rest comprises two female figures shown in a gentle arm-in-arm embrace. The two women appear to be identical, with the exact same scarification patterns and hairdos. They stand parallel, as if mirror images of one another.

Twin births are highly symbolic in Luba thought, and are considered to be ambivalently powerful occurrences. Twins are referred to as 'children of the moon', in recognition of the dualistic nature of the moon, which both illuminates and conceals. Luba worship the moon as a symbol of hope, rejuvenation and benevolence. Its reappearance each month following a few days of dangerous darkness is a source of intense celebration. On the night of a new moon, Luba people rejoice in the auspicious return of the spirits' blessing. 'Children of the moon' (twins) are both honoured for their positive side and punished for their maliciousness, and mothers of twins are treated with reverence and awe for their excessive fertility.

It is unlikely that the two women depicted in this sculpture are suggestive of human twins as much as they are the mediums of spirit twins, or *bavidye* that dwell in male and female pairs. As recently as the 1980s, *bavidye* twinned spirits were still worshipped at sacred locales in the Luba area where they were mediated by actual women living in pairs at these sites. Like priestesses, the female spirit mediums served to protect the spirit sites and to summon the spirits in times of need. The manner by which Luba female spirit mediums attract the spirits' attention is through the singing of highly symbolic songs called the 'songs for twins'.

No single explanation can suffice for the appearance of doubled female figures in Luba art. In Luba royal rites such as investiture ceremonies, the chief or king is often seated between two women, his first wife on his right side and his sister on his left. Women played such critical roles in Luba royalty as political advisers, ambassadors and dignitaries that their prominent place in Luba visual vocabulary is not surprising.

There are other references to pairs of women in Luba thought and practice. In the great oral epic, which recounts the origins of Luba kingship, the culture bearer Mbidi Kiluwe comes to visit the kingdom of a cruel despot, Nkongolo Mwamba, and takes up with his two sisters. The product of one of these unions is a son who becomes the first legitimate Luba ruler, Kalala Ilunga, a symbol of refined and progressive leadership.

Headrests are structurally similar to stools, yet they have more intimate and personal significance. Stools are metaphorical and literal seats of royal authority, whereas headrests were treasured family heirlooms that Luba people today remember from their grandparents' days. Although they seem to have gone out of use, they are still thought of in the most endearing terms, almost as if they were symbols of the ancestors themselves.

Mary Nooter Roberts
Fowler Museum of Cultural History
University of California
Los Angeles
USA

BIBLIOGRAPHY

Roberts, A. F. and Maurer, E. (eds), 1985, *The Rising of a New Moon: a Century of Tabwa Art*, Seattle and Ann Arbor: University of Washington Press for the University of Michigan Museum of Art

Roberts, M. N., 2000, *Body Politics: the Female Image in Luba Art and the Sculpture of Alison Saar*, Los Angeles: UCLA Fowler Museum of Cultural History

Roberts, M. N. and Roberts, A. F., 1996, *Memory: Luba Art and the Making of History*, New York: Prestel and The Museum for African Art

Fig. 54: RIGHT Stone figure (*ntadi*) of mother and child, Kongo, DR Congo. Many of these figures were intended for use on graves, where they were prominently displayed.
Ethno 1954, AF13.1

Fig. 55: BELOW Figurative vessel made and signed by Voania Muba, a male potter who started making pots at the end of the nineteenth century and continued until his death in 1928. Voania's pots are well known in the collections of European and American museums and appear to have been principally made for an expatriate market. DR Congo.
Given by the Wellcome Historical Medical Museum
Ethno 1954, AF23.1746

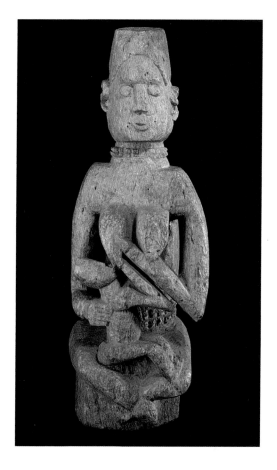

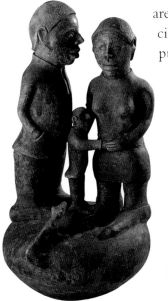

are distinctive. The objects were not made for any specific ritual context and were thus available for display purposes to any purchaser with sufficient wealth to acquire them. They were also eclectic in subject rather than formulaic statements of Kongo identity (fig. 55). They were available for interpretation in any number of different contexts, though their most familiar local deployment was on graves where they acted to honour the dead.

About the time Conrad was writing, other figurative sculpture with equally impressive aesthetic characteristics was being reported from much deeper inland. Luba, and what we now identify as Hemba, figures from the far south-east of the then

31 Female figure

Wood, skin, metal
Luba, Democratic Republic of Congo
19th century
Ht. 46cm, W. 11.5cm, Dp. 13cm
Ethno 1910-441

One of the most important and classical Luba figures, this regal standing female sculpture expresses profound Luba ideals of beauty and power. Luba sculpture served the rulers of the precolonial era as emblems of their status and authority, but more importantly as receptacles of spiritual vitality and efficacy. Luba art conjoins the ineffable and the tangible through forms that invoke the spirits of Luba kingship past and present.

From approximately the seventeenth to the nineteenth century, the Luba kingdom expanded throughout south-eastern Congo, incorporating many neighbouring ethnic groups into its domain. Luba royal authority is referred to by Luba people as *bulopwe*, a sacred realm governed by the *bavidye*, tutelary spirits that reside in pairs and inhabit sacred sites, such as hot springs, mountains and especially lakes. *Bulopwe* refers to a set of complex principles and elaborate ritual practices surrounding and upholding royal prerogative.

Luba rulers were primarily male, yet their emblems always depicted the female form. Previous scholars assumed that the preoccupation with the female form must be a reference to matrilineality, yet the Luba are patrilineal, with descent passing through the male line. Women predominate in Luba regalia because women are considered by Luba people to be the ultimate custodians of royal secrets and the most effective magnets for the *bavidye* spirits. Women also played critical roles in eighteenth- and nineteenth-century Luba political life as ambassadors, advisers and titleholders.

The depiction of the female form in Luba art is sometimes a reference to a particular named woman in Luba history, such as the mother of a chief or king, or a wife who was sent to establish a new domain in an outlying territory. More often, however, it is a generic representation of the feminine dimensions of Luba power that alone can ensure the blessing of the spirits. Luba individuals explain that the female form is depicted on Luba king's emblems because, as a Luba proverb states, 'only the body of a woman is strong enough to hold a spirit as powerful as that of a king'.

Each of her physical attributes contributes to her spiritual efficacy. Soft, organic forms are accentuated by textured scarifications and a radiant coiffure. Luba people value scarification and hairstyling as enhancements of the female body that simultaneously transmit information about a woman's identity. The figure also expresses the inward side of Luba feminine power. Downcast eyes are a reference to insight, as well as to the humility that a person must exercise before the *bavidye* spirits. Her gesture of hands upon the breasts expresses a Luba belief that the secrets of royalty are safely guarded within a woman's breasts. By feminizing their emblems and objects of power, male rulers and diviners ensure that the spirits will remain in close range to comfort, protect and empower the community and the kingdom at large.

Although little is known about this figure's provenance, it is carved in a style usually

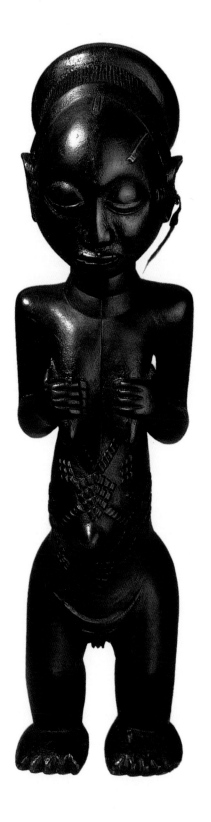

associated with 'eastern Luba', the most pro-
lific art-producing group during the height
of the kingdom. It shares some attributes with
a female figure in a private Belgian collection,
especially in the rendering of the face, head
and the ringed coiffure that rises halo-like
above the head in a swell of elegant
composure.

Mary Nooter Roberts
Fowler Museum of Cultural History
University of California
Los Angeles
USA

BIBLIOGRAPHY

Reefe, T. Q., 1981, *The Rainbow and the Kings:
a History of the Luba Empire to 1891*, Berkeley:
University of California Press

Roberts, M. N., 2000, 'The king is a woman:
gender and authority in Luba and Hemba arts', in
Austin, R. (ed.), *Nature, Belief, and Ritual: Art of
Sub-Saharan Africa at the Dallas Museum of Art*,
Dallas: Dallas Museum of Art

Roberts, M. N. and Roberts, A. F., 1996, *Memory:
Luba Art and the Making of History*, New York:
Prestel and The Museum for African Art

32 Caryatid stool

Wood
Luba, Democratic Republic of Congo
19th century
Ht. 52cm, W. 27cm, Dp. 25cm
Ethno 1905, 6-13.1

The virtuoso style of this caryatid stool has become widely recognized as the trademark of the so-called 'Buli Master', an artist who lived in the nineteenth century and left a distinctive body of sculptures that resonate in character and style. Although the Buli Master created his works on the model of traditional Luba object types, his manner of carving the figures and their distinctive facial features is singular. The figures are not youthful as they are in most Luba sculptures. Rather, they seem to portray elderly women and men, and in a style that merges Luba conventions with Hemba stylistic attributes.

The corpus of Buli-style figures now totals nineteen, yet it is debated whether these were made by a single hand, or whether there was a single early master followed by one or more later disciples. In any case, this stool is among the earliest and most impressive examples of this artistic corpus. It forms part of an early group of figures first identified by Frans Olbrechts in the early twentieth century as belonging to 'the long-faced style' to which he assigned the name 'the Buli Master' for the otherwise anonymous master of these works.

Since that time, further research has revealed that the 'Buli Master' was referred to as 'Ngongo ya Chintu', and he spent most of his life in the village of Kateba. Ngongo ya Chintu is a generic honorific title for a sculptor, and Kateba is a village that borders the Luba and Hemba regions, explaining this artist's remarkable merging of the two styles. It is likely that the artist was responding to complex interactions between his own lineage and those of his patrons, resulting in the idiosyncratic blend that is Buli.

Stools were used as thrones by Luba kings and client chiefs for investiture rites and other important ceremonies of state. Although a female figure supports the seat in a seemingly subservient pose, Luba stools are symbolic statements about the pivotal roles that women played and continue to perform in Luba royal culture, and not literal depictions of actual practice. The presence of a female figure is an allusion to the fact that after death a Luba king was incarnated by a female spirit medium called Mwadi who guarded the deceased king's spirit and preserved his memory for posterity. She would reside in his former palace and adopt his insignia, titleholders, and even his wives who became her own. After her own death, another woman in her lineage took possession of the title.

The gaunt forms of this female caryatid mark an assertive departure from the seemingly timeless female images of other Luba arts. Whether this artistic choice reflects changes and transformations within the artist's culture at the time, or whether it is a personal pathos that his works project, this stool is a constant reminder of the artistic greatness of this historic central African kingdom.

Mary Nooter Roberts
Fowler Museum of Cultural History
University of California
Los Angeles
USA

BIBLIOGRAPHY

Neyt, F., 1994, *Luba: to the Sources of the Zaire*, Paris: Éditions Dapper

Roberts, M. N., 1999, 'The naming game: ideologies of Luba artistic identity', *African Arts*, vol. XXXI, 4: 56–73, 92–3

Roberts, M. N. and Roberts, A. F., 1996, *Memory: Luba Art and the Making of History*, New York: Prestel and The Museum for African Art

Vogel, S. M., 1980, 'The Buli Master and other hands', *Art in America* (May)

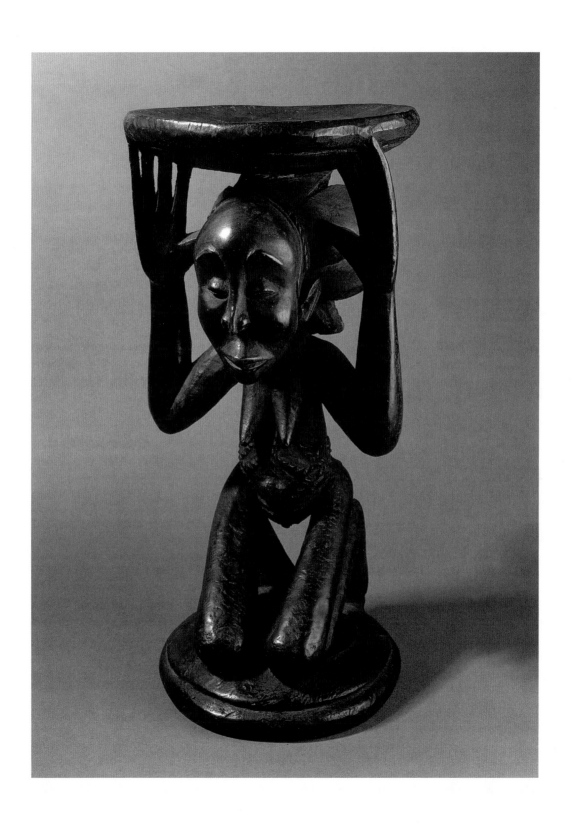

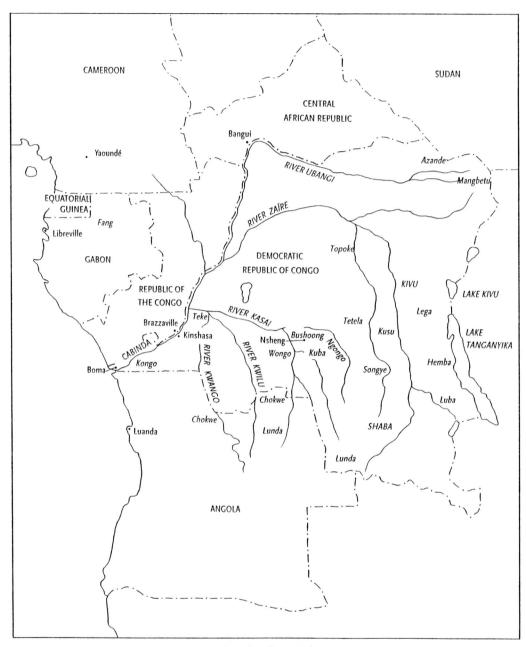

Map showing countries, regions and peoples of central Africa.

Belgian Congo were becoming known (no. 31). Many were heavily oiled, witness to a deliberate ritual process of rubbing with palm oil, akin in the Western mind to veneration. By 1910 three highly representational king figures and a whole range of impressively decorative

objects from the sumptuous kingdom of the Kuba on the southern fringes of the Equatorial forest had been shipped back to London with the apparent agreement of the Kuba royalty and court (no. 33). The intention was that they should be used to show the grandeur of pre-colonial African kingdoms, for the Kuba had no recorded contact with Westerners prior to the 1890s, though the Luba had been in contact with the Arab–Swahili slave and ivory traders traversing Africa from its eastern seaboard during the nineteenth century. Like the Olokun head referred to above, the sophisticated naturalism of these works posed problems to European perception but they could not be disposed of in quite the same fashion. The Greek settlement of ancient Atlantis or the Christian kingdom of Prester John could hardly be asserted to explain away portraits of what were clearly African rulers, let alone relocating their influence to the depths of the Equatorial forest.

Even island populations in the Pacific, let alone peoples on the intensely travelled riverine network of a rainforest, are incorrectly portrayed as isolated pristine cultures developing in abject ignorance of wider cultural influence. Yet in the opening decades of the twentieth century these objects – Kuba, Luba, Hemba and indeed Fang figures from Gabon – posed a puzzle that eventually called into question many European preconceptions. For if, as it seemed at the time, European influence was unequivocally a good thing, how could it be that what to European eyes were among the most sublime of sculptural achievements could have developed quite outside of Western missionizing and civilizing agendas (no. 32). The undoubtedly African cultural achievement of the forest kingdoms sent Western commentators spinning off to search beyond the continent for comparisons – the ornate character of Celtic art was one of the most immediate references; Buddhist figures seem to have been another.

Such figurative sculpture is often grouped together under the term 'ancestor figures' and is usually contrasted with so-called 'fetishes'. The latter are objects to which a range of empowering substances have cumulatively been added – nails, sacks of medicine, claws, torn bits of cloth. It often seems that the classification ancestor figure or fetish is little more than an extension of a Western aesthetic which acknowledges the quality of a polished surface and separates it from one which is the subject of an ill-understood 'magical' process. One, it is suggested,

33 Royal statue (ndop)

Wood, camwood
Kuba-Bushoong, Democratic Republic of Congo
Early 17th or late 18th century
Ht. 55cm, W. 22cm, Dp. 22cm
Given by Emil Torday
Ethno 1909, 12-10. 1

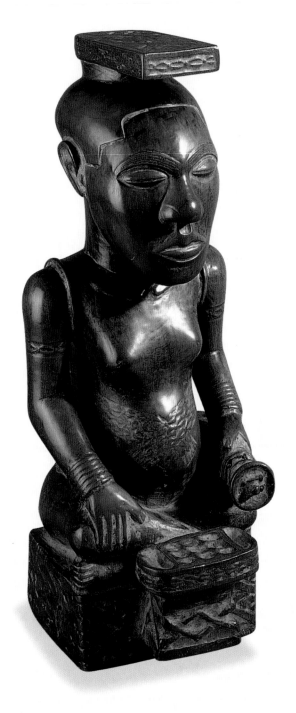

The royal figurative statues known as *ndop*
are uniquely objects of the Kuba royal court.
They are exclusively fashioned within the
court itself, to serve the needs of the court, and
created by professional carvers who are them-
selves courtiers. They are carved from a
tropical wood (*Crossopterix febrifuga*, or in local
language *illwoonci*). The image presents a king
(*nyim*) seated cross-legged on a plinth with
various royal insignia such as the emblem (*ibol*)
associated with the reign of the sovereign
represented. For the Kuba the *ndop* is a
commemorative image, a work of historical
reference; yet it also has an incubatory role,
instilling in successive kings the vital force
deriving from their predecessors. The objects
thus play a pivotal role in the relations of the
living to the dead. The image here, which is
associated with Nyim Shyaam, ranks without
doubt as one of the major works of art and
history from sub-Saharan Africa.

In the history of the Kuba dynasty no king
has a more prestigious place than Shyaam-a-
Mbul Ngwoong, who is rightly entitled *Ngol
ba Nyim*, the eldest of the kings. Before him
the kingdom was unorganized and succession
within the ruling family itself deeply problem-
atical. Nyim Shyaam acceded to power by
force of arms and brought into being great

cultural and political achievements: the use of raphia (as in the cloth also shown here, fig. 62) which he learnt about during a period of exile in Bandundu province; the introduction of an administrative and political structure which continues to the present day; the integration of the different ethnicities which comprise the Kuba kingdom around the 'mother group' of the Bushoong; and the layout of N'sheng, the capital of the kingdom.

In the Kuba court it is understood that, in order to perpetuate his reign, it was Shyaam himself who instituted the practice of carving *ndop*, as a sign of the superiority of the Mat-woon clan. It is believed that, unlike the other *ndop*, that of Nyim Shyaam is a portrait done from life, as indeed was faithfully reported by the collector of the statue, the ethnographer Emil Torday. This view is at odds with much opinion advanced by art historians elsewhere who see it as a retrospective carving dating from the late eighteenth century rather than the early seventeenth when Nyim Shyaam ruled. For us, however, it is the first *ndop*, a concrete representation of the source and authenticity of royal power. It has vitality, brought to life by the realism of the carving, the symmetry of the portrayal and the colour of the flesh.

The figure has a number of identifiable elements. Round the waist is a belt (*mwandaan*) with two knots which confers on the wearer supreme legislator of the kingdom; round the stomach are two belts (*yiem*) which form part of the royal costume. In the left hand is a ceremonial knife (*ilwoon*), whilst the right hand is posed in a gesture which indicates that the king is attentive to his people. The bracelets, armlets and hat are exclusively royal. On the front of the plinth is carved the game *lyeel*, a version of mancala, which symbolizes the reign of Nyim Shyaam. The reference is to Nyim Shyaam's victory over his competitors to the kingdom and the rights thus conferred on him by having won.

In brief the *ndop* of King Shyaam is a work that overshadows the others by the virtuosity of its carving. It belongs with the sacred in its personification of a king who ruled by divine right.

Benjamin Shamashang
Member of the Kuba royal court

BIBLIOGRAPHY

Cornet, J., 1982, *Art Royal Kuba*, Milan: Edizioni Sipiel

Mack, J., 1990, *Emil Torday and the Art of the Congo, 1900–1909*, London: BMP

Vansina, J., 1978, *The Children of Woot: a History of the Kuba Peoples*, Madison: University of Wisconsin Press

34 Commemorative statuette

Wood
Chokwe, Angola
19th or early 20th century
Ht. 35cm, W. 9cm, Dp. 10cm
Ethno 1969, AF9.5

This is a commemorative statuette depicting
the hunter and civilizing hero Chibinda
Ilunga. Reports from the first half of the
twentieth century describe the presence of
several statuettes at ceremonies and other
activities of the Chokwe court.

The Chokwe belong to the important
Lunda group and they occupy the land
between the Kwilu and Kasai rivers, all the
way down through the Muzamba plateau
around the sources of the Lwena and the
Kwanza rivers. The Chokwe have been a
presence in Angola since the sixteenth century
and the Muzumba plateau was their homeland
until their expansion in the middle of the
nineteeenth century.

According to oral tradition the Luba prince
Chibinda Ilunga was an expert hunter who
came into Lunda country during one of his
long hunting expeditions. He married the
Lunda female chief Lueji and improved the
Lunda techniques of hunting, introducing
new weapons and various hunting charms. He
is also commemorated as the civilizing hero
who introduced the concept of divine and
sovereign authority and taught good manners
to the Lunda court. The Chokwe were tribu-
taries of the Lunda for three centuries and

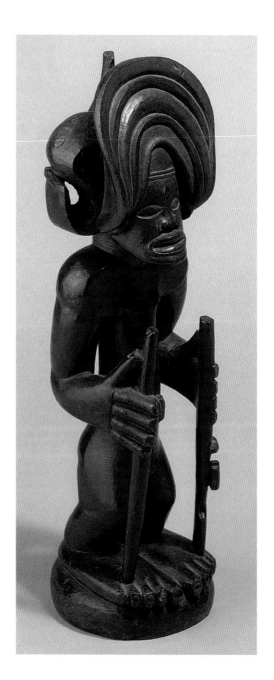

learned from them the moral wisdom associated with Chibinda Ilunga. The Chokwe are known to their neighbours as excellent hunters, and also for their political organization and their court art.

This statuette is a classic court piece. Typically it carries in the left hand the *uta wa mbanze*, a flintlock gun, that was introduced into Angola in the eighteenth century; being such an efficient hunting instrument, it has been depicted in Chibinda Ilunga statues ever since. The right hand holds the *cisokolu* staff with the hook where the *mukata* hangs during rest periods. The *mukata* is a container with hunting charms that can be carried suspended from a strap across the chest or at the hunter's waist. Although it is not present in the British Museum piece, it is often represented by a strap across the chest. Other charm containers that can be seen in Chibinda Ilunga statuettes include *mbinga ya kai* (an antelope horn containing charms to protect the hunter) and the *kafulu* (a tortoise shell where magic medicine is kept). Other pieces of equipment depicted are the hunter's belt from which the *ngonga* box hangs and where the hunter keeps his ammunition, and the *musase wa fundanga*, a small calabash containing gunpowder. The *kasau*, a small machete with a triangular blade, is also carried on the belt.

Chibinda Ilunga is also portrayed in these statues as a Chokwe *mwanangana* (lord of the land) through headdresses and head ornaments. This piece shows the *mutwe wa kayanda* style of headdress which is characterized by having the lateral wings turned upwards, and not backwards, like the *cipenya mutwe* style. The head ornament in this piece is the *kaponde*, a narrow headband used across the forehead which can be single or double and is sometimes ornamented with beads.

Américo António Cuononoca
National Museum of Anthropology
Luanda
Angola

with editorial contributions by:
Maria Magro
School of Oriental and African Studies
London
UK

BIBLIOGRAPHY

Bastin, M.-L., 1978, *Statuettes Tshokwe du héros civilisateur Tshibinda Ilunga*, Arnouville: Arts d'Afrique Noire, vol. 19 (supplement)

Bastin, M.-L., 1982, *La sculpture Tshokwe*, Meudon: Alain and Françoise Chaffin

Oliveira, E. V. *et al.*, 1985, *Escultura africana em Portugal*, Lisbon: Instituto de Investigação Científica Tropical, Museu de Etnologia

is the outcome of a deliberate artistic and religious act; the other merely a record of haphazard, impulsive treatment.

To start with ancestor figures, it is the case that some found across Central Africa are associated with individual named people. The Kuba king figures (*ndop*) are perhaps the most complete example. Here individual kings are recorded in sculptures which show them in regalia, seated on a plinth with a small identifying image at the front. The image recalls an innovation associated with the reign of a particular ruler. In the commentary here (no. 33), by a member of the Kuba royal court, the view is offered that the objects are actual portraits carved from life, which is also the view of the current king (*nyim*), Kot a-Mbweeky III, and is the opinion recorded by the major benefactor of the British Museum, Emil Torday, in 1908. Art historians, however, see many of them, and especially that of the founder of the Kuba dynasty, Shyaam-a-Mbul Ngwoong, as retrospective. Shyaam ruled in the opening decades of the seventeenth century, yet his portrait statue seems to have been carved at the end of the eighteenth century. The local insistence

Fig. 56: LEFT Distinctive layered coiffure characterizes this fine headrest. It is probable that the most prominent carver in the so-called 'Shankadi' style, the Master of the Cascade, was responsible for this piece. The Luba are renowned for their elaborate coiffures, which indicate social and ethnic status.
DR Congo.
Ethno 1949 AF46.481

Fig. 57: OPPOSITE Finely patinated wooden guardian figure used in the initiation rituals of the *byeri* cult among the Fang in Gabon and southern Cameroon.
Given by Mrs Webster Plass
Ethno 1956, AF27.246

that they are portraits carved from life indicates how inseparably the figures are linked to individual named kings.

The status of figures as actual portraits is also an issue elsewhere. Thus there is some suggestion that Hemba ancestor representations were also portraits carved either from memory or by imitating a living person who looked most like the deceased. In addition to the well-known figures of the Chokwe culture-hero Chibinda Ilunga (no. 34), Chokwe ancestor figures sometimes show a degree of individuation which has suggested that some may also be 'portraits'. In general, however, the association of figures with individuals who are often invoked in initiation or installation rites is less a question of actual appearance than of a conceptual link. Thus, the Fang guardian figures from Gabon and southern Cameroon were placed in boxes or baskets with the remains of deceased ancestors (fig. 57). They were brought out to be invoked and reanimated during the initiation of young men into the *byeri* cult. It is the figures rather than the actual bones or skulls that are thus treated. Their individuation is by association with an ancestral spirit rather than physical identity with a person as in life.

Masks and masquerade pose a similar range of problems. Many are associated with the spirit world and often with named spirits, though not necessarily ancestral ones. In this guise they perform at initiation or circumcision, may play a role in anti-sorcery ritual and assist at funerary ceremonies (fig. 58). Yet in performance they may sometimes by gesture and mimicry poke fun at, and in that sense impersonate, living people, as occurs amongst the Pende in the DR Congo (fig. 59).

The so-called 'fetish' offers a stark contrast. The most striking examples are those of the Kongo and related peoples in northern Angola, and both the current Congos, which go by the generic term *nkisi* (plural *minkisi*). *Minkisi* come in a wide variety of forms (no. 35 and fig. 60). They may be human or animal (dogs or monkeys), or they may simply be containers of various sorts (gourds, shells, bags, bottles, bark boxes, cloth). They are often heavily encrusted with a plethora of blades or nails drilled in and with hooks, chains, and rope hanging from them. They may also have packs of substances stuck to the abdomen – white

35 *Nkisi* figure (Kozo)

Wood, metal, resin, fibre, horn, bone
Kongo, Democratic Republic of Congo
Late 19th/early 20th century
L. 64cm, W. 25cm, Ht. 28cm
Ethno 1905, 5-25.6

In the coastal zones of what are now the
Republic of the Congo, Cabinda, the Demo-
cratic Republic of Congo, and northern
Angola, the people speak KiKongo and are
known as BaKongo. At the end of the nine-
teenth century the BaKongo made and used,
as to a considerable extent they still do, objects
called *minkisi* (sing. *nkisi*) which were central
to complex rituals intended to right wrongs,
cure ills and procure benefits for individuals
and groups by influencing occult forces from
the land of the dead. On the coast one of the
best known *minkisi* was Kozo.

The European travellers who collected
artefacts such as Kozo were little interested in
the meaning and function attributed to them
by BaKongo. From the few indications they
left, we can conclude that Kozo was paired
with a large anthropomorphic figure called
Mangaaka; Mangaaka was said to be the fetish
for men, Kozo for women. Mangaaka's
masculine concerns were related to the
punishment of serious crimes; Kozo was
probably used, also by men, to control the
sexuality of women. We learn more about the
figure and what it meant by deduction from
what we know about better-documented
minkisi from further inland.

For the BaKongo, as for other Central
Africans, the universe is divided into the
worlds of the living and the dead. Whereas
the living inhabit villages, the dead live in the
forest with the wild animals that are their
livestock, where in fact cemeteries are usually
located. Witches are people who know how
to use powers from the land of the dead for
their personal good, at the expense of their
neighbours. Qualified experts (*nganga*) can use
similar powers, available through the ritual
manipulation of *minkisi*, to discover, hunt
down and punish witches and other male
factors. The metaphors that go into the
composition of *minkisi* often draw upon
hunting practices; for example, by incorporat-
ing nets. Dogs, used for hunting in the forest,
are animals, but are also like human beings in
that they live with their masters in the village;
they are thought of as mediators between the
living and the dead and are said to have four
eyes, for the seen and the unseen. In this
example, this Janus-theme is replicated in
the two heads of the figure.

The wooden figure itself was only a carving
until it was empowered by adding to it
vegetable and mineral materials known as
'medicines' which expressed by visual and
verbal puns the capacities attributed to it. In
this example, the medicines are sealed in a
pack on the back of the figure; there is no way
of knowing what they include, although
certainly there must be white clay, associated
with the dead. To instruct the *nkisi* in the task
entrusted to it and direct it towards the partic-
ular wrongdoer it was to hunt down, the
nganga drove one or more nails or other iron
into the figure, with an accompanying invoca-
tion. This action both aroused the *nkisi* and
mimed the violence it was to inflict on the
target. Often, though not in this example of

Kozo, bits of cloth or other items associated with the crime in question were attached to the nails to identify it specifically. Alternatively, and perhaps in this instance, the *nganga* or his client might lick the nail for the same purpose.

Wyatt MacGaffey
Haverford College
Haverford, Pennsylvania
USA

BIBLIOGRAPHY

MacGaffey, W., 1993, 'The eyes of understanding: Kongo minkisi', in MacGaffey, W. and Harris, M. D. (eds), *Astonishment and Power*, Washington, DC, and London: Smithsonian Institution Press

Mack, J., 1995, 'Fetish? Magic figures in Central Africa', in Shelton A. (ed.), *Fetishism: Visualising Power and Desire*, London: Lund Humphries

36 Sceptre

Wood
Chokwe, Angola
19th or early 20th century
L. 42cm, W. 10cm, Dp. 8cm
Ethno 1944, AF3.3

This piece is the sceptre of a chief of the land (*mwanangana*) which is displayed during public appearances, by the ruler, as a symbol of his power. It is a good example of court art. Amongst the Chokwe the aristocracy encouraged the professional carvers (*songi*) in artistic creativity. The sceptre is made of hardwood and is covered with black patina. The figure is standing with flexed knees but the legs are shortened where they blend with the staff itself.

The Chokwe are politically organized in independent chieftaincies, with a lord of the land at the head of each. They do not have an overall chief like the Lunda; instead each ruler governs his vassals and the heads of the families receive their farmlands and hunting area from the ruler of their chieftaincy. The Chokwe ruler inherits the right to power through the matrilineal line; on succession he takes the name of his predecessor and becomes divine ruler of the people and the land over which he has supernatural powers passed down by the ancestors.

At the enthronement ceremony the newly appointed chief is given the insignia of power to legitimate and represent his position. He receives the *lukano*, royal bracelet, made from the tendons of sacrificed people, covered with red and blue cloth and sometimes decorated with cowries; he also receives the double-bladed sword (*mukwale*), which serves as an executioner's knife. During the ceremony he wears the *cikungu* mask that symbolizes the chief's ancestors, the pendant (*cimba*), symbolizing the moon, and the headdress that only the *mwanangana* can wear. The effigy of a chief that surmounts this sceptre wears the *cipenya mutwe* headdress, with the wings turned towards the back, like the one seen in a photograph taken by Fonseca Cardoso in 1903 of the Chokwe chief Chauto.

Other insignia that legitimate the *mwanangana* power are the chair or stool, represented in various statuettes of the seated chief, and the sceptre that is used as a symbol of authority during public activities, playing an important part when settling disputes. Some sceptres are surmounted by a lance or a snuff-box on top of a carved figure of a chief. Ceremonial objects such as pipes, snuff-boxes, fly-whisks and the double cup are part of the chief's regalia and that of his entourage.

Américo António Cuononoca
National Museum of Anthropology
Luanda
Angola

with editorial contributions by:
Maria Magro
School of Oriental and African Studies
London
UK

BIBLIOGRAPHY

Bastin, M.-L., 1961, *Art décoratif Tshokwe*, Lisbon: Museo do Dundo

Bastin, M.-L., 1982, *La sculpture Tshokwe*, Meudon: Alain and Françoise Chaffin

Beumers, E. and Koloss, H., 1992, *Kings of Africa: Art and Authority in Central Africa*, Berlin: Collection Museum für Völkerkunde; Maastricht: Foundation Kings of Africa

37 Divination instrument
(itwoom-i-bukaang)

Bone, wood, glass, shell, fibre
Kuba-Bushoong, Democratic Republic of Congo
19th century
L. 39cm, W. 13cm, Dp. 7cm
Ethno 1909, 5-13.316a-b

The Kuba peoples share a belief in the influence for both good and ill of supernatural forces associated with the spirit world. Many such spirits (*ngeesh*) are associated with natural phenomena which animate the flora and fauna of Kuba territory with supernatural significance. This implement of divination (*itwoom-i-bukaang*) is especially empowered in using an actual bone taken from a real crocodile – rather than, as is more familiar, an image in wood carved in the form of an appropriate animal – to act as the vehicle of spirit mediumship. The animals with a particular spirit association are often those which live in the deep forest, especially in distant bogs and pools, and those which reproduce prolifically.

The art of divination using implements such as these is associated in Kuba history with the founder of the Kuba ruling dynasty Nyim Shyaam-a-Mbul Ngwoong (see no. 33). Anxious to maintain social order, Nyim Shyaam sought to reinforce the traditional system of justice of which he, in his person, was the pinnacle, by establishing the authority of recourse to divination using the *itwoom* system to resolve issues that involved discovering the cause of illness, bad luck, theft, sorcery and other misfortune. By virtue of his divine status, Nyim Shyaam – like his successors – was also in one guise a *ngeesh* himself. His control over the process of insight associated with the spirit world and the regulatory functions of society was thus complete.

The diviner himself, though he need not have a specific courtly status, is someone with a special affinity to the world of the spirits. Events in their own life establish their credentials – perhaps a disposition towards exceptional visions or dreams that indicate encounters with spirits. The method of divination is essentially oracular. The diviner poses a series of questions to the *itwoom*. A small disc is rubbed along the upper surface of the divination object and it 'speaks' when the disc stops and will not move further. The implement thus reveals hidden things: truths that have been concealed, circumstances that have been ignored, or events that are yet to happen. *Itwoom* assume an important social and regulatory function across the Kuba kingdom.

Benjamin Shamashang
Member of the Kuba royal court

BIBLIOGRAPHY

Mack, J., 1981, 'Animal representations in Kuba art: an anthropological interpretation of sculpture', *The Oxford Art Journal*, Oxford: Oxford Microform Publications (November): 50–6

Neyt, F., 1981, *Arts traditionnels et histoire au Zaire: cultures forestières et royaumes de la savane*, Louvain-le-Neuve

Thomas, M.-T., 1960, 'Les Itombwa, objets divinatoires sculptés conservés au Musée royal du Congo', *Congo-Tervuren*, vol. 6: 78–83

chalk, kaolin, charcoal, seeds, earth from graves – perhaps with a mirror or large cowrie shell embedded in the middle. Without these elements the object would be unspecific and neutral; with them individual objects might acquire a considerable reputation for a range of powers and capacities.

Despite their thoroughly divergent appearances, there is a connection between the ideas that underlie both ancestor figures, fetishes and many other kinds of object. All these objects are in some sense empowered, dynamic. They are all conceived as containing an inherent animated force. Their diverse appearances are the outcome of the ways in which the objects, of whatever sort, have been manipulated or treated to turn their contained dynamism to appropriate human ends. Kuba *ndop* embody the spirit of kingship. They are rubbed in order to release this essence. Thus when a new king is installed he sleeps in a room with

the figures of his predecessors to incubate in him the spirit of kingship – the king himself is regarded as being a spirit with the extra-human capacities implied. When the king is absent from the capital, the *ndop* may be rubbed to assure the continuance of kingly powers despite the physical absence of the living incumbent. Rubbing releases powers, a technique which is also evident in divinatory implements which are massaged in order to activate their forensic capacity (no. 37).

In the case of *minkisi* it was the addition of the medicinal and magical substances which empowered the object. They had a range of application. *Minkisi* could be used to deflect sorcerous intent, protect against misfortune and illness, regulate disputes, create treaties or swear oaths. In the case of the last, for instance, an oath could be sworn by

Fig. 58: FAR LEFT Striated wooden mask with fur horns and integral fibre costume. Although initially attributed to the Tetela by its collector, Emil Torday, its stylistic associations are rather with the Songye peoples of the DR Congo.
Ethno 1979, AF1.2397

Fig. 59: LEFT Among the Pende peoples of the DR Congo *mbuya* masks are used during circumcision rites. This mask, probably called *tundu*, is viewed as playful; it mingles with spectators and mimics other masks.
Ethno 1910, 4–20.478

Fig. 60: RIGHT A *nkisi nkondi* which has been partially covered with iron blades. The bundle on top of its head contains empowering substances. Kongo, DR Congo.
Ethno 1905, 5–25.3

driving a nail or blade into the *nkisi* with some identifying mark to tie the oath to the oath-taker – a strip of cloth or saliva (fig. 60). To break the oath would be to risk retribution from the forces inherent in the object. To undo it, the correct nail would need to be withdrawn from the *nkisi*; were the wrong one to be pulled out in error this would be to risk uncontrolled and unpredictable results (no. 35). The Western habit of classifying by appearance thus obscures an underlying conceptual level at which the two types of object are ultimately connected.

Initiation

From the above it will also be apparent that initiation is a major occasion for the deployment of art-works and material culture. Across the region the periodic initiation of groups of boys and young men is common and obligatory; female initiation somewhat less so. In the past the process was prolonged, involving the endurance of considerable hardship, separation from the community and often the learning of esoteric knowledge. Often the initiates left their communities in the company of a masked figure, their seclusion was assured by maskers and their eventual return was announced by masked performance, notably amongst the peoples of the Kwango-Kwilu River area, and in northern Angola. To all non-initiates, knowledge of the human agency that articulates masquerade was precluded – indeed knowledge of masquerade was one of the main lessons of the initiation school. The ease of the newly initiated in the company of formerly frightening maskers represents for those who may not have seen their sons or brothers for a period of six months or so, a most marked behavioural change. This may be articulated through an idiom of death and rebirth. Amongst the Kuba the candidates disappear for initiation by passing through the legs of a heavily skirted masker. There they fall into a tunnel and pass a concealed musician playing a friction drum to replicate the growl of a leopard, before re-emerging in the cover of the bush beyond.

Secret things are revealed in initiation. In some places this is taken further and initiation is less about securing entry into a fixed state of manhood than about gaining admittance to a succession of grades within a hierarchy comprising a secret society. The *mani* society of the Azande in the southern Sudan and related areas of the northern DR Congo, and the Central African Republic, or the *bwami* society of the

38 Power figure (nkishi)

Wood, metal, skin, glass, fibre, tooth, seed pod,
animal horn
Songye, Democratic Republic of Congo
19th/early 20th century
Ht. 102cm, W. 36cm, Dp. 22cm
Ethno 1949, AF46. 492

The Songye, a linguistically and culturally
related cluster of chiefdoms, concentrated in
the eastern Kasai with extensions in Kivu and
Shaba provinces of the Democratic Republic
of Congo, have attained a far-flung reputation
at home and abroad for their magical figures,
mankishi (sing. *nkishi*). The generic term
'power figure', used nowadays in the specialist
literature for this typological genre, applies
aptly in several ways to this large-scale model
with its heavily set, starkly defined geometric
volumes, characteristic of the central Songye
region. Its visual impact of male strength and
potency, immediately striking to any viewer,
coincides in this case with Songye intentional-
ity and expectations. As they say themselves:
'the *nkishi* should portray all the physical
attributes of a man who can hold a weapon
and defend himself'. But, beyond this primary
reading, its attributes are culturally specific and
not easily discernible by the non-informed
Western viewer. The blue beads, like skin and
feather headdresses and raphia skirts often
found on such large figures, relate to chiefship.
Reptile belts tightened round the torso are
associated with ministers. Iron blades recall the
role of the smith, a culture bearer, celebrated
in oral tradition for his transformative powers.

Apart from these multiple devices associ-
ated with leadership, authority and ancestral
heritage, other features such as the metal tacks
and appliqué on the face, as well as the horn
pegged into the head, allude more specifically
to superhuman and bestial qualities. For the
nkishi is not merely a visual and metaphoric
representation. It is above all a receptacle for
magical medicines (*bishimba*) and, as such, an
instrument of change and stabilization used by
a community to counteract illness, sterility,
famine and other misfortunes caused by evil
spirits and especially by sorcerers. The magical
ingredients, placed most often in the horn or
simply in a cavity in the head and the abdomi-
nal protrusion, consist of a wide variety of
animal, vegetal, mineral and human substances
that activate and bring into play benevolent
ancestral spirits. These elements are selected
and ritually introduced into the figure by the
nganga, a magical specialist, according to what
people believe to be his personal and secret
formula. Symbolically they define the dual
functioning of the *nkishi*. There are those that
metaphorically provide the aggressive content
such as bits of the claws of a leopard, the scales
of a dangerous snake, the sexual organs of a
crocodile or the bones and flesh of someone
who committed suicide. In opposition to this
category, clippings of hair and nails of the
villagers are added so as to channel the desired
beneficial effect towards them.

Apart from certain conventions in form,
external papraphernalia and even magical
ingredients which constitute the defining
cultural core of the object type, the creation of
a community *nkishi* also incoporates individual
aspects of temporal concern and personaliza-
tion. To begin with it is transformed from a
carved piece of wood into a specifically
expressive, named and coded magical mecha-
nism by the *nganga*. It therefore becomes a
unique creation and an extension of his indi-
vidual artistry rather than that of the sculptor
who simply fashioned its human-shaped shell,
though with required and recognized skill.
Furthermore, it is contextualized into action

according to the needs of a specific client-group, often housed in its private enclosure like a sacred ruler, and subject to a particular ritual prescription of use and exposure assigned by the *nganga*. Being linked to a specific communal crisis, it is also an entity timed into an historical framework. Although its existence is subject to circumstantial change, it is remembered and its personal name evoked in reference to a period of the past with which it was associated. Generations of children born at the time of a *nkishi* were assigned its name and continued to propagate recollections of its feats and accomplishments.

Although community figures reflect a concern with a more public, official status of magico-religious practices, echoing ritual aspects of sacrality as among Luba neighbours, a vast array of small *mankishi*, both figurative and non-figurative, was used by individuals throughout the Songye country to resolve intimate ills and tensions. These personal, magical objects that interact with familiar spirits express the immediate, very specific and more short-term crises. They are a part of an innovative folk culture of healing and believing that remains for the large part private and anonymous.

Dunja Hersak
Université Libre de Bruxelles
Belgium

BIBLIOGRAPHY

Hersak, D., 1986, *Songye Masks and Figure Sculpture*, London: Ethnographica

Van Overbergh, C., 1908, *Les Basonge* (Collection de monographies ethnographiques, vol. III), Brussels: Albert de Wit

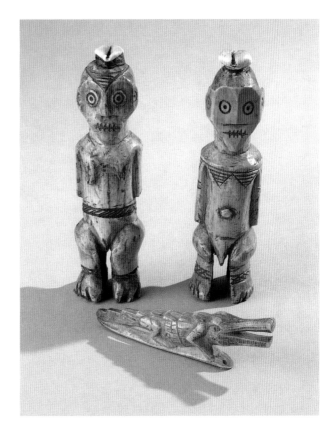

Fig. 61: Two stylized ivory human figures and a naturalistic crocodile figure. These carvings were individually owned by high-ranking *bwami* initiates and have multiple, sometimes overlapping meanings. They may be used as prestige items, as emblems of rank or as mnemonic devices associated with names or wise sayings. Lega, DR Congo.
Ethno 1975, AF14.1–3

Lega in eastern DR Congo are two of the better-documented examples. In both societies material objects had a central role. In *mani* rituals the objects were used to further the aim of gaining advantage for its members, whether by ensuring a successful hunt, by promoting fertility, or by rendering its initiates immune to evil magic. In the *bwami* society the interpretation of objects, often by reference to an aphorism or other verbal formulae, is one of the most significant elements of the secret knowledge appropriate to particular grades. Sculpted art-works of different kinds perform this role (fig. 61). Yet in neither case is the range of appropriate objects restricted. For the Azande *yanda* figures were supplemented by clay images, twisted roots and other natural products. In Lega culture the range was bewildering: in addition to art-work, it extended from a vast variety of leaves and fruits to skulls, teeth, hooves, horns and shells, to assemblages of manufactured objects made of basketry, rope, wood, pottery, metal, leather, even foreign objects such as

lightbulbs, perfume bottles, madonnas and china plates, and much else besides.

Textiles

Eclecticism is less of a feature in Central African textile traditions. For one thing, only one fibre dominates the repertoire of weavers and embroiderers. This is raphia, the stripped membrane of the leaves of the raphia palm. This gives a strip which is little more than a metre in length and thus the woven cloth is only about a metre square. To produce larger cloths, the squares need to be sewn together selvedge to selvedge. In the past, some Kongo weavers seem to have used pineapple fibre as a raw material (as also occurs in Madagascar), but even this produces a cloth which is like a very fine raphia textile. Also, only one type of loom is

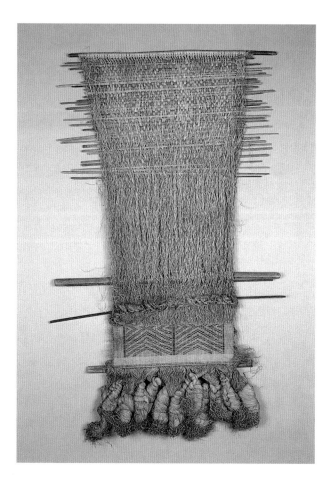

Fig. 62: LEFT Single-heddle raphia loom, Tetela, DR Congo. The complex geometric patterns are formed with the aid of thirty-six supplementary shed sticks which act as a mnemonic device.
Ethno 1909, Ty.822

Fig. 63: OPPOSITE TOP Wooden backrest decorated with interlocking geometric patterns and surmounted by a carved ram's head. It was acquired at the Kuba capital, Nsheng, and is closely associated with kingship in both form (the king must never come directly in contact with the earth) and imagery (the ram expresses the king's ideal relationship to his people: power, dominance and fertility).
Ethno 1909, 5–13.9

Fig. 64: OPPOSITE An Art Deco sofa recently auctioned in London . It has mahogany trim and is upholstered in fabric inspired by patterned cut-pile raphia cloths of the Kuba, DR Congo.
Photo: C. Spring, 1999

used – an upright or angled single-heddle loom – and weaving is the province of men. Women's involvement in the process is limited to the decoration of woven cloth. Despite the simplicity of the raw material, some of the decorative effects produced can be extraordinarily rich. Indeed, rather than external design traditions affecting local production, the reverse has occurred. Woven patterns are often subtle, being an application of float weaves in plain tones. Some weavers used coloured fibres to produce intricate and complex designs – such as those executed by the Kusu, and especially the Tetela (fig. 62). However, most design is added to the finished cloth rather than being achieved during the process of weaving, and it is some of these that have gained a wider international currency.

The founding collections of the British Museum included an example from the Kongo peoples of a type of embroidered textile. Examples are also found in other early European collections, and all appear to be of types shown in the first illustrations of the Kongo rulers and their courts. Nowadays textiles of this general sort, though not employing an identical technique of production, are identified closely with the Shoowa, a northern sub-group of the Kuba kingdom. Other Kuba groups produce textiles in a similar style, though with a lesser density of pattern and less complexity. These are known generically as 'Kasai velvets', after the area in which they are produced and their finished quality which defies the origin of the fibre from which they are made: a stripped palm leaf (fig. 52). Historically, similar cloth was also found among some of the peoples intermediate between the Kongo peoples dominating the coastal areas and the immediate hinterland of central Africa's Atlantic coast and the Kuba in south central DR Congo. Thus, examples from the opening decades of the twentieth century were collected by Torday amongst the Pende. A northern origin of the Kuba

amongst Mongo peoples is convincingly argued by at least one leading historian on the basis of linguistic and other cultural and oral-historical evidence. Yet, there is also a notable affinity to be accounted for between the art and material culture of the historical Kongo and peoples across the southern stretches of the Equatorial forest at least as far as the Kasai.

Technically, the 'velvets' are in fact examples of cut-pile embroidery. Their characteristic design is an exploration of interlocking geometric motifs providing subtle variations of pattern across the surface of a textile. In fact Kuba art as a whole is distinguished by the application of pattern to a whole range of surfaces from carved wood and ivory or basketry wall panels to human skin (figs. 63, 65). In Shoowa textiles these motifs are picked out in a variety of colours with the contrasting of yellow and black the dominant feature. Such textiles have been marketed extensively to the Western world for at least the last decade. Nowadays cut-pile panels are put in frames and hung on fashionable walls (as in fact they were in the 1920s to judge from an illustration of a sophisticated American home in an issue of *Women's Wear Daily*). They are used as cushion covers and furnishing fabric, and the designs are copied on to cotton cloth to make up other kinds of garment (fig. 64). Where *kente* cloth from Ghana has obtained an international status as an expression of Black and African or African-American identity, Kuba cut-pile has emerged as a ubiquitous icon of fashionable modern design. The textiles are now produced in quantity and haste, often leading to crude results. What was in the past women's work is now done by either men or women. Traditionally, it would take upwards of a month to produce a single square, with women of the same matrilineal segment working on the same cloth. The finished product was not destined for export; it was used sometimes as the fringe of a garment or as a funerary cloth.

A similar fate has overtaken Kuba appliquéd cloths. These are very long wraparound skirts made from a large number of squares being sewn together. The skirts are kept for use at periodic ceremonies. Those seen today are densely covered with irregularly shaped patches of plain raffia sewn over the base cloth, the edges of the overlain strips often outlined with black stitching. Complete skirts are of a dimension that make them less practical for display. Vendors in the West often stress their

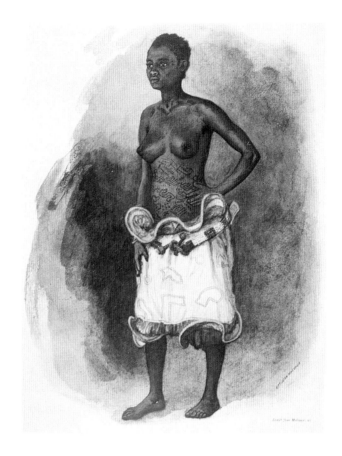

Fig. 65: A high-ranking Kuba-Ngongo woman wearing an appliquéd raphia skirt. The geometric scarification marks on her abdomen are similar to patterns seen on a whole range of artefacts. *Painted by Norman Hardy*

historical origins. Yet this is like saying that the houses we live in are old, when the windows, doors and fireplaces, let alone the furniture, probably date from a range of periods that may be quite different from the date at which the house was originally built. Many of the older examples of this kind of appliqué work point to an intention of covering up holes in the base cloth rather than a deliberate aesthetic choice – indeed the irregularity of the appliqué patches is at odds with the rectilinear geometry otherwise characteristic of Kuba design (fig. 65). The older cloths also lack the intense density of pattern which characterizes those seen today. Such textiles are in fact the product of a constant process of repair and evolution, the patching of one area leading sometimes to the addition of other strips of appliqué to produce a balanced design. They are both old and new.

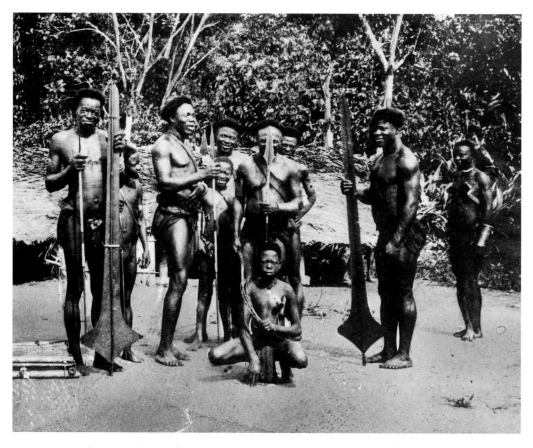

Fig. 66: Topoke men of southern DR Congo carrying enormous iron currency blades which echo the form of the conventional spear blades held by the men in the centre of the photograph.
Photo: Trustees of the British Museum

Metalworking

Evidence of metalworking in Central Africa is less complete than that for West Africa. It suggests traditions of lesser antiquity and sophistication. Indeed trade, and with it the need for currency, provides a leading context for metalworking technology – rather than ritual activity, the production of objects for shrines or for display. Almost all metallurgy in Central Africa is directed to the production of non-figurative objects, a rare exception being some sand-cast figures produced by the Teke of Congo, who also make ornate brass collarets which are worn as chiefly insignia. Otherwise a series of diverse shapes and sizes of objects are

produced for the purposes of exchange. The most straightforward are the cast coppers also known as 'Katanga crosses' after the province of the DR Congo now known as Shaba. This lies at the northern extension of the Zambian copper belt. Katanga crosses are of manageable dimensions. The same cannot be said of some of the huge iron blades associated with the Mongo (fig. 66). Part of the purpose of such large currency pieces is that they might be reused for making weapons or other metal tools, and indeed their shapes often recall those of the weaponry of Central Africa. Collections of weapons, especially from the northernmost reaches of the River Congo, and all dating from the late nineteenth or early twentieth centuries, are common in European collections. They are associated with the collecting habits of a large band of international employees of the Belgian authorities acting in the name of King Leopold who brought colonial government and exploitation to the Congo State by way of the river.

Another kind of metal object associated with Central Africa is a cast metal version of *nkisi*, with the empowering medicinal substances scraped off. They were made not in Africa but in the British Midlands, where in the 1920s or 1930s a series of identical objects were cast from a single Kongo wood model. Examples of the cast versions together with what is thought to be the original Kongo figure from which the mould was taken are both in the British Museum. Similarly in the 1960s a cocktail bar chain, Trader Vic Inc., 'copyrighted' a ceramic mug which they produced in quantity to serve customers with exotic drinks. The model is clearly a wood cup of Lele or Wongo origin similar to the double-headed version from the British Museum collections (no. 39).

Central Africa has, then, had a subtle, though rarely acknowledged, impact on Western popular culture and design beyond the better-documented interests of the Western Primitivist artists. As elsewhere on the continent, objects created for local African purposes have been reinterpreted and readapted to Western functions quite different from the intent of their original creators. This arms-length adaptation of African models is also matched by local production serving the known tastes of exotic foreigners. In the case of the Mangbetu in the far north-east of the DR Congo, what was at first merely a practical response to witchcraft re-emerged as an aesthetic preference. The Mangbetu, like their near neighbours the Azande, have a practice of binding the heads of

39 Double cup

Wood
Lele/Wongo, Democratic Republic of Congo
19th century
Ht. 15.5cm, W. 14.5cm, Dp. 8cm
Ethno 1910, 4-20.11

This is a fine example of the double cups produced by the Lele (Leele) or neighbouring Wongo who live in the Kasai district of the Democratic Republic of Congo. They both have a fine tradition of craftwork in wood-carving, as well as in raphia weaving and embroidery. Among the Lele, carvers were initiated into artists' guilds. Each village has only one official carver, who is expected to

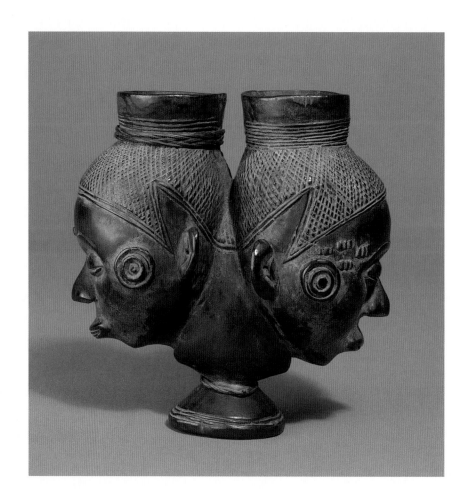

retire when his apprentice takes over. The initiation into carving is long, and includes religious consecration as well as artistic training. Typically the carvers use knives and gouges of soft iron which would not be sharp or strong enough to cut hard wood. The carved objects are blackened by hanging in the smoke of the rafters to preserve them and to give a patina. Wood-carvers make and decorate drums (big and small), bows, bellows and bowls as well as cups. Some of the cups have anthropomorphic heads, some of which, but not necessarily all, are portraits of actual people, commemorative of loved ones. Some sculptors are renowned for being able to 'throw' a good likeness on to the wood, but it would be unusual to find a free-standing portrait bust such as made by the neighbouring Kuba-Bushoong.

The double cup is a highly esteemed object in the Lele repertoire. Some are plain, with geometric patterning, some are sculpted as heads – male or female. This cup is a good example of head sculpture, with strong modelling of physical features. We know that it is a woman's head, because of the symmetrical tattoo marks on her cheeks. Since the two images are symmetrical it seems likely that it does not represent two women, and is possibly not a portrait but an idealized female head. The cross-hatching on the head represents hair, and she has beautifully carved eyes, nose and mouth; the carefully executed tattooing on her face is like 'beauty spots'. All Lele women born before about 1940 had tattoos on several parts of their bodies: chest and stomach, as well as cheeks. This double cup, collected in 1908–9, is of that earlier period.

To this day the double cup is used by Lele for palm wine. Men tend to meet together on the outskirts of the village in the evening to drink palm wine and discuss the events of the day. Each man or head of the household would bring his own personal cup, using the handle to tie it through the belt of his raphia loincloth for easy carrying. Lele hold that palm wine drunk from a wooden vessel tastes better than from a plastic, china or tin cup.

Only a skilled carver can make this double cup form out of a single block of wood, so that the liquid flows between the two heads. Cups of bronze or pottery similar in style are to be seen in the Villa Julia in Rome, dated to fifth-century Greece. For the Lele the double cup that allows the liquid to be communicated between two heads symbolizes the key role of women within the village and of womanhood as a fundamental principle of social life. A cup neither talks nor thinks, but its artistic features enable members of the community to recall facts and people of the past.

Guillaume M. Iyenda
University of Surrey
UK

BIBLIOGRAPHY

Douglas, M., 1977, The *Lele of the Kasai*, London: International African Institute

Mack, J., 1990, *Emil Torday and the Art of the Congo, 1900–1909*, London: BMP

Torday, E. and Joyce, T. A., 1910, *Notes ethnographiques sur les peuples communément appelés Bakuba ainsi que sur les peuplades apparentées: Les Bushongo*, Brussels: Musée du Congo Belge

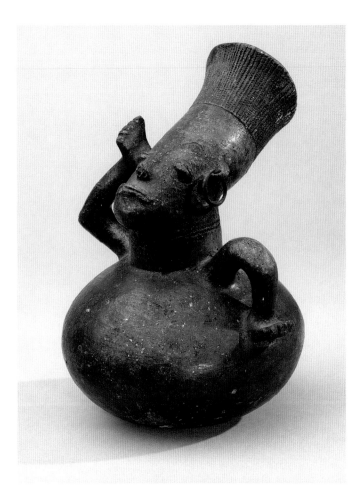

Fig. 67: LEFT Pottery vessel with top in the form of a human head associated with the Mangbetu, northern DR Congo.
Ethno 1971, AF12.1

Fig. 68: OPPOSITE Ivory tusk carved with caricatures of Europeans, a Black Venus and a White Venus. The Loango coast of Central Africa was renowned for the production of relief carving on ivory, typically showing chains of figures twining up the tusk. This, in its turn, led to a practice of figurative ivory carving in Belgium at the end of the nineteenth century. Given by the Wellcome Historical Medical Museum
Ethno 1954, AF23.1691

children. This is intended to prevent witchcraft, which is conceived as entering through the top of the skull. It has, however, the effect of elongating the back of the head in adulthood. This has then fed into a sculptural idiom which is deployed on standing figures, on the tops of musical instruments and in scenes depicted on ivories and elsewhere, all of which emphasize the cranial deformation (fig. 67). Europeans working in the area in the early twentieth century had their own portraits carved by local craftsmen, emphasizing what was interpreted as an artistic response to an aesthetic choice rather than the outcome of pragmatism.

Finally, equivalent developments to those that led to the creation of the Afro-Portuguese ivories in West Africa in the fifteenth and sixteenth

centuries also occurred at a later date in Central Africa. Carvers along the Loango coast united in single objects the two historic motivations of European and Arab–Swahili interests in the continent's Equatorial region: ivory and slaves. Many ships returning to Europe carried with them souvenirs in the form of carved ivories showing in relief slaves chained together in a train which spiralled right round the length of the tusk. Curiously, these objects of 'airport art' then found their way into the eclectic national shrine of the Kalabari of southern Nigeria (above) where they are described by nineteenth-century European visitors. A remarkable example of the art is two large ivories in the British Museum carved not with local historical scenes but with an imitation of a Belgian cartoon from the turn of the twentieth century. In addition to a Black Venus and a White Venus it shows European society caricatures, complete with the original captions in French carved in relief on the surface (fig. 68). At the start of the twentieth century a craze for chryselephantine developed in Belgium. These tusks fit well with that fashion but the evidence appears to be that they were, in fact, carved by Central African rather than Belgian artists and so they recall, in a much more complex medium, the reproductions for tourists by contemporary Senegalese glass painters of scenes from the work of another Belgian cartoonist of a later generation, Hergé, creator of Tintin.

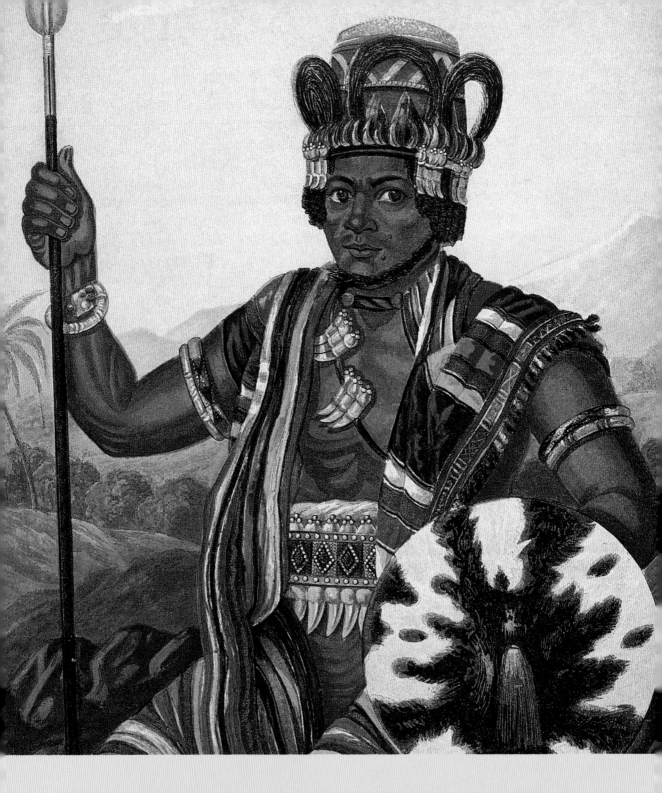

Fig. 69: Portrait of Rafaralahy, the Merina governor of one of the forts on Madagascar's east coast. He wears an elaborately patterned cloth and the regalia of a high-ranking officer. *From W. Ellis*, History of Madagascar, *vol. 1, London, 1838*

E ast and Southern Africa is the most diverse cultural region to be considered in this book. We take the area as being defined by the northern borders of Kenya, Uganda, and adjacent parts of southern Sudan and Ethiopia; on the west it is bounded by Lake Tanganyika; it includes southern Angola and territories southwards (no. 40). Looking beyond the eastern continental fringes, we consider also the islands of the western Indian Ocean. The area saw the first evidence of human activity anywhere – the skeletal remains of 'Lucy' (named after another claimant to global outreach, the Beatles song 'Lucy in the Sky with Diamonds') having been found in the Rift Valley in Ethiopia. This earliest human evidence is reflected in the collections of the British Museum by a small representative collection of material from Olduvai Gorge in what is now Tanzania and dates from about two million years ago. It is, of course, the oldest material from anywhere in the Museum.

Language and interaction

Language is always a useful place to start in identifying the different historical strands which comprise a heterogeneous area. The area is dominated by two separate language groups – Bantu-speakers and Nilotic-speakers. Broadly, the Nilotic populations (that is those with a common derivation in the Nile Valley) comprise an eastern group including the pastoralists (cattle or camel herders) living in northern Kenya and Uganda and including the Maasai of Kenya and adjacent parts of Tanzania; a separate, or western, Nilotic group includes peoples in western Kenya and related regions. They are all ultimately related to the Nilotic peoples of the southern Sudan and south-eastern Ethiopia (fig. 79).

Elsewhere Bantu peoples predominate, successors of a large-scale migration which, in contradiction to early colonial dogma, saw an occupation of the southern parts of the continent about the end of the first century AD (no. 41). Bantu-speakers were the creators of the terracottas known as the Lydenburg heads (found in eastern Transvaal and dating

East and Southern Africa

40 Mask (*muti wa lipiko*)

Wood, human hair, wax, pigment
Makonde, Mozambique
Probably early 20th century
Ht. 28cm, W. 21cm, Dp. 30cm
Ethno 1958, AF12. 1

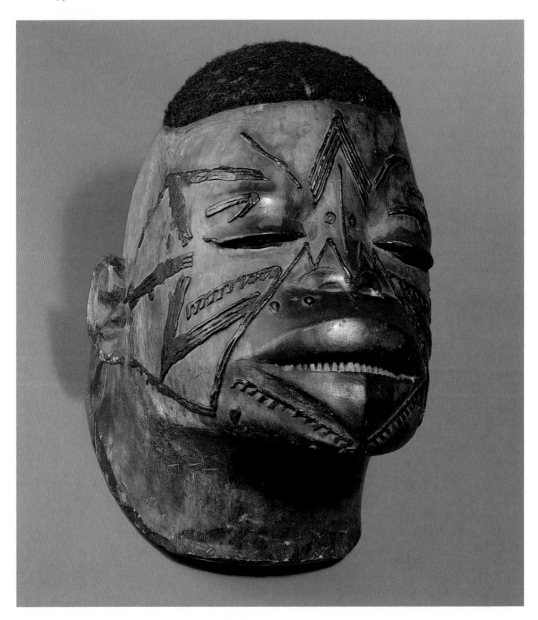

The Makonde are a matrilineal people who are located on both sides of the Ruvuma River which forms the border between Tanzania and Mozambique. Although there are substantial cultural and linguistic overlaps between the two groups of Makonde, and in the twentieth century labour migration brought numbers of Mozambiquan Makonde to Tanzania, there are also differences. These arise largely as a result of the relative isolation of the southernmost Makonde. Living on a high plateau, the Makonde in Mozambique acquired a reputation for unfriendliness and a related name – the Mahwia, or 'angry ones'. One outcome of this relative remoteness is that the mask-types of Tanzania are more eclectic and have a greater range than those produced by the Makonde of Mozambique. In Tanzania masks usually cover only the face whilst in Mozambique they are often in the form of a helmet worn completely over the head.

Masking is associated in Makonde society with male initiation. Initiation (*likumbi*) is largely a feature of the dry season, both a period of less agricultural work and also symbolically the appropriate time for boys to be withdrawn from society before their rebirth as adults with the approach of the wet season. Initiation involves seclusion, circumcision, tattooing, the filing of teeth and the acquisition of knowledge that is otherwise secret. The return to society is marked by the performance of masquerade, knowledge of which is amongst the understanding acquired in the initiation 'school'.

The masks themselves are often realistically carved, with human details accentuated. Thus real hair is often implanted in the mask, rather than it being painted on; wax is applied to the face in relief duplicating the tattooing of adults; teeth are shown as filed; and, in the case of female masks, characteristic lip plugs are faithfully rendered. The implication is that the masks represent members of human society. Yet the term for mask, *muti wa lipiko*, means 'the head of a *lipiko*'. The mask in effect is a representation from the spirit and not from the human world. The authority of the initiation process and the status of the newly initiated are emphasized by the inter-mediation of the supernatural.

Maria Magro
School of Oriental and African Studies
London
UK

BIBLIOGRAPHY

Association Française d'Action Artistique et Musée des Arts Africains et Océaniens, 1989, *Art Makonde: tradition et modernité*, Paris: Ministère des Affaires Étrangères

Dias, A. J. and Dias, M., 1970, *Os Macondes de Moçambique, vida social e ritual*, vol. III, Lisbon: Junta de Investigações do Ultramar, Centro de Estudos Antropogia Cultural

Wembah-Rashid, J. A. R., 1975, *The Ethno-history of the Matrilineal Peoples of Southeast Tanzania*, Acta Ethnologica et Linguistica, 32, Vienna: Universität Wien, Institut für Völkerkunde

41 Dance shield (ndomi)

Wood, pigment, hide, metal
Kikuyu, Kenya
Late 19th century
L. 58cm, W. 25cm, Dp. 12cm
Given by W. Scoresby Routledge
Ethno 1910, 6-4.70

Dance shield (ndomi)

Wood, pigment, fibre, hide
Kikuyu, Kenya
Late 19th century
L. 52.5cm, W. 35.5cm, Dp. 9cm
Given by W. Scoresby Routledge
Ethno 1910, 6-4.72

Dance shield (ndomi)

Wood, pigment, metal, shell, glass
Kikuyu, Kenya
Late 19th century
L. 53cm, W. 32cm, Dp. 12cm
Ethno 1903, 5-18.15

Among the Kikuyu of Kenya boys about to be initiated into adulthood (through circumcision) wear wooden dance shields (*ndomi*) on their upper arms. The dance shields are mainly oval-shaped and are made from light wood. They are curved with a hollow part at the lower end where the initiates slip in their arms. Often the shields are decorated with zigzag patterns. These patterns resemble continuous triangles and are filled in with white pigment. The unpainted part of the shield provides a black or dark brown background to the white decorations. The initiate similarly has his body decorated with white pigment and the same zigzag-like patterns that were used on the *ndomi* shields. As with the oval shields, the unpainted part of the initiate's body offers a dark or black background for the white pigment or patterns.

Together with these the initiate wears a cape of Colobus monkey, a long strap over the chest and a belt of cowrie shells. Another strip of cowrie shells could be worn on the thighs and leg-bells under the knee and on the ankles. The skin of a wild cat is used to cover the private parts of the body and the initiate holds a long stick on the left hand and a dancing club on the right hand. The head is clean-shaven and painted, repeating the same patterns as on the body and shield. Having dressed in this manner the boys form a circle and dance in a certain style. The song and dance performed during the ceremony are a celebration of the 'integration' of the boys into adulthood and in essence into the Kikuyu ethnic group.

Although the wooden shields obviously serve as part of the initiation apparatus, among the Kikuyu they may also bear wider symbolic meanings. The colour contrast and the zigzag patterns are important in order to understand the role of the *ndomi* shield. It is possible to speculate that the 'rugged' or zigzag pattern represents the 'rugged' snow-capped top of Mount Kenya or Kirinyaga as the Kikuyu refer to it. The black and white contrast is symbolic

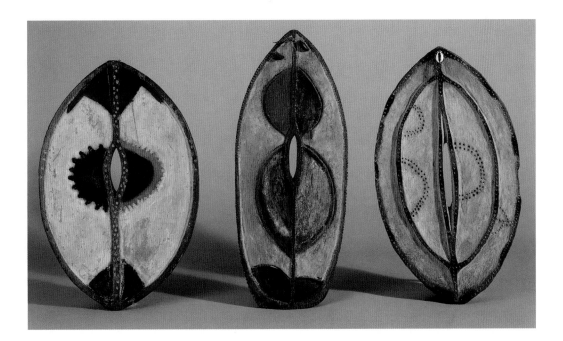

of the white snow against the black background of the mountain. Mount Kenya is a central feature in Kikuyu cosmology. As Jomo Kenyatta himself documented, since time immemorial the Agikuyu prayed facing Mount Kenya. Displaying artefacts that bear patterns that symbolize this central cosmological and mythological feature is thus potentially pivotal to the entire ritual or initation process.

The costume of the initiate gives further meaning to the initiation process. The initiate is depicted as coming from the 'other' space, or wilderness, before he is adorned at the end of the initiation process with the ornaments and clothing of 'normal' society. Instead of the spears the boys carry sticks which in such a setting imply 'femininity' or the 'inability' to fight. Therefore, before they are allowed to carry the respected and revered buffalo hide shields and spears of adulthood, the boys must undergo the pain of circumcision and other rituals.

Their liminal status in initiation is emphasized by the use of a wooden shield rather than the hide shield of warriorhood, a standing to which they aspire. The Kikuyu dance shields are therefore displayed both as visually powerful in their own right and also as objects laden with metaphoric symbols. The dance shield of the Kikuyu, then, can be viewed as part of a complex, intertwined cultural system. The initiates display wooden versions of an object that visually symbolizes manhood, identity, being Kikuyu and being brave.

Hassan G. Wario Arero
National Museums of Kenya
Kenya

BIBLIOGRAPHY

Hobley, C. W., 1938, *Bantu Beliefs and Magic*, London: H. F. & G. Witherby Ltd

Kenyatta, J., 1938, *Facing Mount Kenya: the Tribal Life of the Gikuyu*, London: Secker and Warburg

Routledge, W. S., 1910, *With a Prehistoric People: the Akikuyu of British East Africa*, London: Edward Arnold

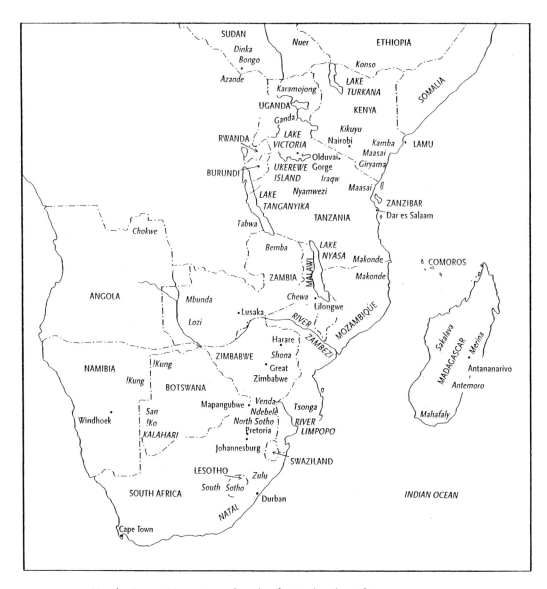

Map showing countries, regions and peoples of east and southern Africa.

from AD 500–700), of the kingdoms centred on Mapangubwe on the Limpopo (1100) and its successor the Shona kingdom whose capital was at the impressive architectural site of Great Zimbabwe (rising to power about 1200) (fig. 71, no. 42). Later developments included the rise of a series of expansionist chiefdoms, notably of the Zulu in the early nineteenth century, with dramatic effect on surrounding peoples. Mixed in

amongst these Bantu-speakers are representatives of populations of older establishment, the Khoisan in southern Africa (that is the people known in colonial literature as the Hottentot and the Bushmen) or the Hadza and Iraqw in Tanzania.

The coastal and island areas have a more complex history of external interactions. Swahili is the language of the East African littoral, though a version of it is now spoken throughout much of East Africa. It is classed as Bantu. However, it includes a significant percentage of loan words from Arabic, indicative of the intermixture that has taken place. Coastal Swahili peoples are Islamic. The first mosques were set up towards the end of the first millennium when trade links with the Arabian Sea, India and ultimately China escalated. Chinese ceramics have been found not only on beaches right along the coast, but at Mapangubwe in what is

Fig. 70: ABOVE Wooden male and female figures from the Azande, southern Sudan. The origin of these carvings remains uncertain. However, it seems possible that they were made as presentation pieces by Belanda craftsmen who acted as royal carvers in the court of the Zande king Gbudwe at Yambio.
Ethno 1949, AF46.522–3

Fig. 71: RIGHT View of the Conical Tower in the Elliptical Building at the site of Great Zimbabwe.
Photo: Trustees of the British Museum

42 Anthropomorphic figure

Soapstone
Great Zimbabwe, Zimbabwe
Date uncertain
L. 42cm, W. 6cm, Dp. 10cm
Ethno 1923, 6-20.1

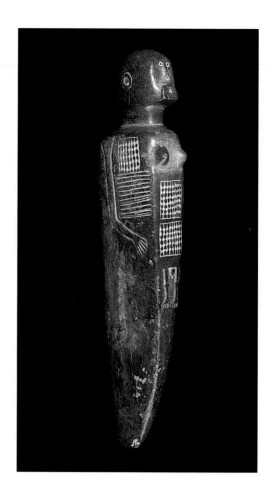

The provenance of this object, carved in soapstone, is believed to be the archaeological site of Great Zimbabwe, a twelfth- to thirteenth-century royal settlement dominated by stone wall enclosures and terrace platforms occupying a granite hill and an adjacent valley. Great Zimbabwe, now a world heritage site, is the largest precolonial settlement in southern Africa and indisputably ranks first as the most celebrated pre-European achievement of black Africa. The circumstances of the removal of this object from Great Zimbabwe are not known. Indeed, this is not surprising since, for example, the lower half of one of the much better-known soapstone Zimbabwe bird carvings, also removed from the same site, mysteriously travelled to Germany before 1906 and was deposited at the Völkerkunde Museum, while to confirm its provenance the upper half was found and has remained at the Great Zimbabwe site. To our knowledge, this figurine was first officially mentioned in a brochure detailing the list of exhibits from Great Zimbabwe and other ancient sites in southern Rhodesia which were displayed at the British Museum in 1930. This figurine was described as follows: 'the head is markedly negroid; the body tapers away below . . .

From the "main ruin", Zimbabwe: purchased 1923'. It cannot, however, be ascertained what was meant by the "main ruin", presumably the Great Enclosure, the main building situated below the granite hill at Great Zimbabwe, previously referred to as the Elliptical Temple.

This object is a figurine which may at least be described as anthropomorphic. It is quite sophisticated in the design of the head, palpably depicting a human head (note the eyes and nose). But blended in very subtly are some animal features. The head surmounts a trunk which is rectangular but tapers to the bottom end, indicating that it was embedded in the ground or on top of stone walls. This posture

of exhibition is suggested in a Rhodesian school textbook illustration published in 1968. A pair of breasts were clearly sculpted but arms and legs were excised on the trunk in very low relief. The trunk has square panels with rows of repeated diamond patterns and lines. Note that more or less similar geometric patterns occur on a soapstone plinth, 52cm long, found at the Zimbabwe site of Danamombe (Dhlodhlo).

A similar figurine also presumed to have originated at Great Zimbabwe is in the Tishman Collection, now owned by the Disney Corporation. Tens of objects of similar material (soapstone) and design (unnaturalistic) have been found at this and other sites in the country. Such objects have been interpreted variously as votive offerings, symbols of a fertility complex or royal regalia.

The object indeed depicts a human figure but transformed into the realm of the imaginary. Although the object belonged to a pre-literate civilization which has been called the Zimbabwe Culture, we are informed by reliable ethno-archaeological research that the culture was rich in expressive art. For instance the monumental stone-walled enclosures themselves expressed the wealth, power and prestige of the rulers. The eight soapstone bird carvings perching on top of columns 1.5m long represented a bateleur eagle (*Terathopius ecuadorus*), a bird universally respected by the inhabitants of Zimbabwe as an intercessor between them and the high god, Mwari. Concerning the anthropomorphic figure, it may be noticed that the breasts are given prominent relief compared to other organs, e.g. the arms and legs, which are presented in very low relief. It is the view of the author that this and other related objects express a fertility complex. This complex is manifest in several media and even today it forms a unique component of the praise poetry and totemic recitations of the descendants of the inhabitants of Great Zimbabwe, the Shona.

Edward Matenga
*Great Zimbabwe National Monument
Zimbabwe*

BIBLIOGRAPHY

Bent, J. T., 1892, *The Ruined Cities of Mashonaland*, London: Longmans and Green

British Museum, 1930, *Loan Exhibition of Antiquities from Zimbabwe and Other Ancient Sites in Southern Rhodesia*, London

Garlake, P. S., 1973, *Great Zimbabwe*, London: Thames and Hudson

Hall, R. N., 1905, *Great Zimbabwe*, London: Methuen

MacIver, D. R., *Medieval Rhodesia*, London: Macmillan

Matenga, E., 1993, *Archaeological Figurines from Zimbabwe*, Uppsala: Societas Archaeologica Upsaliensis

Matenga, E., 1997, 'Images of a fertility complex: Iron Age figurines from Zimbabwe', in Dewey, W. J. and de Palmanaer, E. (eds), *Legacies of Stone: Zimbabwe Past and Present*, vol.1, Tervuren: Royal Museum for Central Africa

Matenga, E., 1998, *The Soapstone Birds of Great Zimbabwe: Symbols of a Nation*, Harare: African Publishing Group

Walton, J., 1995, 'The soapstone birds of Zimbabwe', *South African Archaeological Bulletin*, vol. 10, 39: 78–84

43 Headrest (isigqiki)

Wood
KwaZulu-Natal, South Africa
Late 19th/early 20th century
L. 32cm, Ht. 15.5cm, Dp.10.5
Given by Dowager Viscountess Wolseley
Ethno 1917, 11-3.1

Headrest (isigqiki)

Wood
KwaZulu-Natal, South Africa
Late 19th/early 20th century
L. 45cm, Ht. 16.5cm, Dp. 8cm
Given by Dowager Viscountess Wolseley
Ethno 1917, 11-3.3

A number of different groups from the south-east African region produced headrests at least until the mid twentieth century. Among Swazi- and Zulu-speaking communities, these headrests generally formed part of a woman's dowry. In most cases, two headrests were commissioned by brides (or their fathers), one for the new wife herself, the other for her future husband. Because these brides grew elaborate hairstyles as a sign of respect to their new in-laws (and to their husbands' ancestors), many headrests fulfilled an important practical function: placed under the neck, rather than under the head, they protected the women's stiffly coiffed hair from possible damage. The fact that women from the south-east African region gradually abandoned the practice of styling their hair with mud and ochre in the course of the twentieth century helps to explain why it has become increasingly uncommon for these headrests to be produced. But it also tends to mask the fact that those produced in the course of the nineteenth and early twentieth centuries attest to the communication of important religious and political values.

In the past, headrests were generally afforded the status (and power) ascribed to other ancestral relics like spoons and meat plates, which were usually preserved unless their owners expressed a desire to be buried with them. Like these artefacts, they were protected from possible attack by insects through constant exposure to smoke in the rafters of the cooking area of a homestead. Infused with the body dirt of their former owners, they afforded the living an important, but by no means unique, opportunity to communicate with the ancestors. Communications

of this kind were achieved also through specially designated cattle in the homestead's cattle byre, which is where homestead heads were invariably buried.

In contrast to headrests from present-day Swaziland, which almost invariably have two fluted, bifurcated legs, those from the region formerly dominated by the Zulu kingdom and the Colony of Natal are remarkably diverse in style. But the raised *amasumpa* motif (sometimes translated as 'warts') – see here in 1917,11–3.1 – was restricted to the area controlled by successive nineteenth-century Zulu kings prior to the destruction of the kingdom by British forces in the Anglo-Zulu war of 1879. There is considerable evidence to suggest that this motif, which is also found on the large brass armbands (*izingxotha*) issued by the king to his royal entourage and close political allies, was reserved for the Zulu leader's immediate family, and for the collateral groups through which he sought to extend his political power.

Other headrest styles – see here 1917, 11–3.3 – appear to have been associated with groups to the south of the Zulu kingdom, where a British colony was established in the 1840s. In most cases, these groups had been actively excluded from the benefits of the Delagoa Bay trade by the first Zulu king, Shaka, who was assassinated in 1828. Treated as lowly menials by their neighbours from the Zulu kingdom, they were forced to pay tribute in the form of cattle, furs and feathers to Shaka and his immediate successor, Dingane.

Despite differences in the styles of headrests produced by Zulu-speakers from the Zulu kingdom and the Colony of Natal, many of the headrests collected in this region allude to cattle (and therefore to the idea of the ancestors) in covert and sometimes explicit ways. Some have split legs, tails and even abstractly rendered bellies. It is important to remember, however, that, since cattle were a major source of wealth, headrests with numerous pairs of legs were probably also intended to invoke the idea of large herds of cattle.

Sandra Klopper
University of Cape Town
South Africa

BIBLIOGRAPHY

Klopper, S., 1991, '"Zulu" headrests and figurative carvings', in *Art and Ambiguity: Perspectives on the Brenthurst Collection of Southern African Art*, Johannesburg: Johannesburg Art Gallery

Nettleton, A., 1990, '"Dream machines": Southern African headrests', *South African Journal of Art and Architectural History*, vol. 1, 4: 147–54

now northern Transvaal and at cattle-keepers' camps in the centre of southern Madagascar at early dates. Zanzibar had significant links with Omani allies from the end of the seventeenth century, and a sultanate of Omani origin established its capital there in the mid nineteenth century (fig. 72). It was home to the notorious slave dealer Tipu Tip. In discussing Central Africa reference has been made to the incursions of Arab slavers from the east of the continent across Lake Victoria and into the present-day Democratic Republic of Congo. Simultaneously slave and ivory traders from the northern Sudan, the 'Khartoumers', had penetrated deep into southern Sudan and southwards into Uganda.

The documentary sources on external influence tend to be more substantial than those on the strengths of indigenous cultures and thus skew the historical record. However, local cultures have clearly been far from blank pages on which external influence is inevitably and overwhelmingly inscribed. In most instances internal relations were more important than external factors. Indeed, trade with the wider Indian Ocean network was largely controlled by inland African rulers in southern Africa, and Islam had no significant impact; transcontinental trade initiated from eastern Africa was ultimately in the control of coastal Muslim traders, but beyond the littoral it none the less frequently worked through established local authority.

The islands off the East African coast – Lamu, Manda, Pate, Pemba, Kilwa and the Comoros – were all, like Zanzibar, Swahili-speaking, Islamic and with tangible links to peoples deriving from the Arabian Sea and beyond. Much of the material culture reflects over a millennium of a distinctive history. Ornate chip-carved doors, boxes and high-backed chairs, silver-working or weaponry are all distinctive of participation in an Indian Ocean network of trade, influence and settlement (fig. 73).

However, the largest island of all, Madagascar, is a significant exception. Linguistically it is quite distinct: the dominant language of the vast island is Malagasy, a complex of mutually comprehensible dialects of Austronesian origin. Muslim calls to prayer summon not the longer-established population but more recent migrants from the Indian subcontinent. The Arabic script is used by the Antemoro and

Fig. 72: OPPOSITE Pair of finely worked silver anklets with hinged opening fastened by a pin. The sultanate of Zanzibar is of Omani origin, explaining the coincidence with Omani examples in form, decoration and technique.
Ethno 1948, AF5.1a-b

Fig. 73: RIGHT Modern example of the *kita cha enzi* (literally 'chair of power') which was popular in wealthy households on the islands of Zanzibar and Lamu off the East African coast. It is distinguished by its angular form, ebony frame, elaborate string panels and ivory or bone inlays.
Given by Mrs Cave
Ethno 1962, AF3.1

others in south-eastern Madagascar but to record astrological events rather than Qur'anic text. The mosques at Mahilaka on the north of the island are in ruins whilst the domed buildings of the Antemoro are ancestral tombs, shrines of a different denomination (fig. 74). It is rather the church bells that call Madagascar's faithful to prayer, testament to the influence of Christian missions since the beginning of the nineteenth

Fig. 74: LEFT Open-sided structure with domed roof reminiscent of the form of Muslim shrines (*kabba*) used by the Antemoro of south-eastern Madagascar as shelters for ancestral tombs which are set into the floor. The building's completion date is inscribed in both Arabic and Roman scripts.
Photo: J. Mack, 1985

Fig. 75: RIGHT Wooden female figure which was in the possession of Kabaka (King) Sana of Buganda before collection by a long-term missionary resident. It seems likely that this piece was given to Sana as a diplomatic gift by the Kerebe (Tanzania) King Machunda. This figure seems to have been originally carved by Nyamwezi sculptors accompanying trading expeditions to Bukerebe island.
Given by the Reverend J. Roscoe
Ethno 1909–40

Fig. 76: FAR RIGHT The Wiko of Zambia use masquerades during the period of initiation rites. Their form, character and name (*makisi*) recall Wiko origin in northern Angola.
Ethno 1949, AF35.2

century. Yet, even Christianity has a distinctive Malagasy twist for it is integrated with Malagasy belief in the ancestors (*razana*) as an ultimate source of human vitality. Putting the dates together with the oddity of Madagascar's cultural and linguistic heritage leads to the possibility that the ancestors of the Malagasy were displaced from historic bases on the East African coast by the arrival of Arab–Swahili traders about the eighth century AD, the late date at which Madagascar appears to have been significantly occupied.

The result of the internal upheavals of the eighteenth and nine-teenth centuries across eastern and southern Africa are still evident in art and material culture (no. 43). Ethnicity was set on a confused course by the Swahili–Arab slave trade, by internal upheavals such as the expansion of the Zulu kingdom under Shaka in the early nineteenth century, or that of the Merina in Madagascar under Andrianampoinimerina and his successor Radama I in the late eighteenth and early nineteenth centuries. The slave routes produced a mobile population, not just of slaves but also of intermediaries, craftsmen and others trading in ivory and

other items. The Nyamwezi based round Tabora in modern Tanzania made alliances with the slavers and willingly entered into the trade. Nyamwezi were eventually established as far afield as the south-eastern Congo, Zambia, and Ukerewe island in Lake Victoria, where, as the creators of figurative carving, they produced works for the host communities in which they had come to reside. A number of large Nyamwezi figures from the Lake Victoria area, one of which is in the British Museum, are good examples (fig. 75). These appear to have been admired as exercises in skill but otherwise seem to have had little local significance. As a result they were passed on as diplomatic gifts. One ended up in Uganda given to the Kabaka of the Buganda, who also have no tradition of figurative carving and no established context for its interpretation. It was passed on to the missionary-anthropologist the Reverend John Roscoe, who ultimately gave it to the Museum.

Similar migrations have brought Chokwe to southern Zambia (where they are known as the Wiko) and where they produce figures and especially masking that recall their Angolan ancestry (fig. 76).

44 Lidded bowl

Wood
Lozi (Barotse), Zambia
Probably 20th century
L. 43cm, W. 20cm, Dp. 15cm
Given by Mrs Webster Plass
Ethno 1956, AF27.279a-b

The Lozi people live in and around the flood plain of the Zambezi River in the Western Province of Zambia. Since the eighteenth century, they have assimilated elements of many neighbouring ethnic groups, including the Ndundulu, Kwangwa, Mbunda, Ila, Tonga, Lunda and Chokwe. The term 'Barotse' gained currency through usage by the Paris Evangelical Mission, and has been used to refer to the whole kingdom, of which the Lozi are the dominant group. In 1890 and 1900 a British Protectorate was established over Barotseland under treaties with the British South Africa Company which to a large extent endorsed the powers of the Lozi king. Even after the Independence of Zambia, the political power of the Lozi king over the area has been substantially retained.

Although the Lozi are noted for their fine basketry, they do not normally work in wood, except for dug-out canoes. It is the carvers from several subjugated groups like Kwangwa

and Mbunda who meet the demand for wooden objects at the Lozi court. Among the best-known objects are the lidded bowls used for meat and vegetables. The surface of the bowls is usually smooth, and the top knobs or handles of the lids form the main decorative element. In many examples the handles are modelled into highly stylized figures such as birds, antelope, elephants, lions and humans. It is worth noting that the figures are not only stylized or simplified but arranged in conformity with the shape of the bowls. In this case, the oval shape of the bowl is repeated in the form of the ducks.

Kenji Yoshida
National Museum of Ethnology
Osaka
Japan

BIBLIOGRAPHY

Leuzinger, E., 1960, *Africa: the Art of the Negro Peoples*, London: Methuen

Leuzinger, E., 1972, *The Art of Black Africa*, London: Studio Vista

Museum Rietberg, 1978, *Afrikanische Skulpturen*, Zürich: Museum Rietberg

Schmalenbach, W., 1953, *Die Kunst Afrikas*, Basel: Holbein-Verlag

Sydow, E. von, 1932, *Kunst und Religion der Naturvölker*, Berlin: B. Cassirer

Lozi lidded bowls with human or bird imagery are in fact the work of distant Mbunda (no. 44). Tsonga from Mozambique provided sculpted staffs as tribute to the powerful Zulu chiefs. They also moved in significant numbers into South Africa, where they were the authors of male and female figures used in initiation by both Venda and northern Sotho to illustrate social and sexual lessons. In many parts of northern Uganda, southern Sudan and related areas iron-working is often identified as a skill of immigrants. In Madagascar the expansion of the Merina, together with subsequent labour migration, has disrupted the obligation placed on the living to return now dispersed relatives for burial in a common tomb in the midst of the ancestral rice fields. Arrangements to return bodies to the appropriate tomb can often not be made until long after death; this is partly responsible for the evolution of elaborate second burial ceremonies (*famadihana*) with its associated escalation in the production of woven burial shrouds (*lamba mena*).

Rock art and animal imagery

Of course Museum collections can only partially represent such a rich and complex history, even as so briefly described here. Most objects are of nineteenth- and twentieth-century origin. For many commentaries the starting point for any discussion of the region is very much older than we have been discussing here – its heritage of rock art, something which is largely in place where it was originally created. There is limited overlap between the images found on rock surfaces and those inscribed on more portable objects such as the gourds, and especially the ostrich shells (no. 45), that are found in Museum holdings – but none of itself conveys the rich symbolic significance of the rock imagery (fig. 77).

The paintings are widely distributed across rock shelter sites in South Africa, Zimbabwe, Botswana and Namibia, and, in eastern Africa, in Tanzania. The oldest dated paintings so far identified in Africa as a whole are from the so-called Apollo II shelter in southern Namibia and date from approximately 27,500 years ago. Sites, of course, were not painted all at once and many are the result of what has clearly been an on-going process of creation. Images of armed colonists with their wagon trains, and even Queen Victoria, appear on some of the later

45 Water bottle

Ostrich eggshell
San, southern Africa
Late 19th/early 20th century
Ht. 15cm, W. 11cm
Ethno 1910-363

The ostrich eggshell water bottle was, until recently, the most widely used water container among the nomadic !Kung of the Kalahari and among all San groups living in Botswana and Namibia. Each shell holds approximately one litre of water. The bottles are bulky and heavy because an empty shell weighs 225–285g and takes up a space the size of a large cantaloup melon.

It takes a woman about an hour to prepare a water bottle for use. She drills the hole, which is about 13–20cm in diameter, shakes out the contents, rinses and deodorizes the interior with aromatic herbs, and makes a small grass stopper. Although the eggshell does not leak it breathes slightly and, through the evaporation of small quantities, it keeps the water cold. Each married woman owns a stock of five to ten eggshell water bottles. The shells are thick and not easily broken so that they may have a life of several years. The shells are sometimes buried in areas where water is scarce and then dug up when water is required. A cache of fifteen eggshell containers was excavated at Vaalbos in the northern Cape and the excavator suggests that the bottles are likely to be less than 150 years old.

The eggshells are occasionally decorated with incised designs but the decorated bottles are unusual. The designs are said by some ethnographers to be put on the bottles to make

the shells identifiable to their owners. Meiring notes that on a photograph in the F. S. Malan Museum thirteen shells are visible as Masarwa women fill them with water, and only four of the shells show signs of decorations (geometric designs).

Not only the !Kung, but also the !Ko, who live in the south-western part of Botswana, decorate their eggshells. Today a knife is used for the engraving and the incisions are rubbed with black ash or charcoal. Decorations in the Ghanzi District of Botswana appear to have fat mixed with the charcoal, and this helps to bind the colouring material into the incisions.

The practice of making eggshell water bottles and decorating them is of great antiquity, and the custom was once far more widespread than it is today. The site of Boomplaas in the southern Cape, South Africa, has fragments of eggshell, decorated with geometric designs, that date to more than twelve thousand years ago, and similar examples have been found as far afield as Wonderwerk Cave in the northern Cape and Kruger Cave in the Magaliesberg of Northern Province. Most of the decorated eggshell fragments have only geometric designs, but sites dated to the last few hundred years contain a few examples of representational engravings of animals and even humans.

Although it is accepted that the eggshell bottles were primarily for storing and transporting water, some eggshell bottles have been found to contain colouring materials such as specularite or red ochre, food or even eggshell fragments that were presumably kept for the manufacture of beads. Ostrich eggshell bottles were also sometimes buried with the dead.

There seem, then, to be at least three known uses for ostrich eggshell water bottles: first, they are used for transporting and storing water or specularite, ochre, food or fragments of shell; second, they are used for the storage of colouring material; and, third, they are used as grave goods. All three practices have great antiquity: water bottles date to at least fifteen thousand years ago at Boomplaas Cave, southern Cape and they become common in Later Stone age sites after about ten thousand years ago. The burial of bottles with the dead seems more recent, with the earliest burials dating to the beginning of the Holocene.

Lyn Wadley
University of the Witwatersrand
Johannesburg
South Africa

BIBLIOGRAPHY

Humphreys, A. J. B. and Thackeray, A. I., 1983, *Ghaap and Gariep: Later Stone Age Studies in the Northern Cape*, South African Archaeological Society Monograph Series 2

Lee, R. B., 1979, *The !Kung San: Men, Women and Work in a Foraging Society*, Cambridge: Cambridge University Press

Marshall, L., 1976, *The !Kung of Nyae Nyae*, Cambridge, Massachusetts: Harvard University Press

Meiring, A. J. D., 1945, 'The significance of the engravings of masarwa egg-shells', *Fort Hare Papers*, vol. 1, 1: 3–8

Morris, D., 1994, 'An ostrich eggshell cache from the Vaalbos National Park, Northern Cape', *Southern African Field Archaeology*, vol. 3: 55–8

Sandelowsky, B. H., 1971, 'Ostrich eggshell caches from South West Africa', *South African Archaeological Bulletin*, vol. 26: 153

paintings. However, this should not be taken to imply that the wealth of other imagery was a literal depiction of everyday life. It has been noted that the eland, a large gazelle, is a constant theme of southern African paintings, yet the eland has not been a significant part of the hunting and gathering economy of the San, the authors of many of the sites (no. 46). Their significance resides rather in the identification of various animals and plants as sources of powerful energy that can be redirected in ritual to serve human ends. The scenes are now thought to record the visions experienced by healers when in trance, and their cumulative depiction itself imbues the shelters with a potency that lends them a ritual rather than a passing residential significance. In an area that is associated historically with a more limited range of representational imagery than is found in West or Central Africa, those subjects chosen for representation are unlikely to have merely prosaic significance.

The eland reappears in the masking practice of the Chewa in Zambia and adjacent areas of Malawi; the *nyau maliro*, a large antelope-shaped mask, is one of the main subjects of an eclectic series of mask forms seen as appropriate vehicles in which to embody the spirit of a deceased person (fig. 78). At the site of Great Zimbabwe a series of eight polar sculptures in soapstone are topped with images of birds that appear to be eagles imbued with human features. Great Zimbabwe came to pre-eminence in the mid thirteenth century as the centre of a vast kingdom controlled by the rulers of the Shona peoples. Birds are regarded as emissaries, and the eagle in particular is associated with ancestral spirits. As each of the sculpted birds is different, it is assumed that they recall specific rulers, both male and female, whose sacred status permits them an important intercessionary role between the spirit and human worlds.

Crocodiles are everywhere feared and rarely without some potent symbolic resonance, whether verbal, mythic or material. In Madagascar crocodiles (or caymans) are the only serious predators, the island lacking the elephant, lion and leopard which are the ubiquitous metaphor of royal or chiefly power in continental Africa. In some places people falling inadvertently into crocodile rivers may be left to find their own way to safety as it might be regarded as ancestral will that they should fall foul of crocodiles. In western Madagascar crocodiles' teeth are extracted to be incorporated into powerful charms, whilst in the nineteenth century the Merina developed large box-like charms worn by

the nobility and incorporating silver- or gold-plated representations of crocodile teeth both to mark their own authority and to assert a spiritual protection (no. 47). Among the Venda in South Africa the crocodile is associated both with chieftaincy and with wisdom. Divination bowls, of which one exists in the British Museum collections, have crocodiles represented in the base (no. 48). Such bowls were used at chiefly courts to determine the sources of witchcraft. In use the bowl is filled with water covering the crocodile which recalls the Venda founder-hero, a ruler who is said to have descended into a local lake where he continues to rule with his court. A maize kernel is floated on the top and the bowl rocked to and fro; where it touches the sides (or 'land') indicates the home and ultimately the identity of witches.

Amongst pastoralists in the north of the region cattle are something of an obsession. This is more ideological than economic, for, despite the dominant place of their herds in the pastoralist life, many of the basic, though unheralded, subsistence activities are undertaken by older men and women at semi-permanent villages removed from the seasonal

Fig. 77: ABOVE The San are a semi-nomadic hunting and gathering group who now inhabit the arid Kalahari Desert. This gourd, with its fibre carrying net, was presumably used as a water container. Small isolated human and animal figures inscribed on its surface recall the traditions of rock painting associated with the San.
Ethno 1976, AF5.2

Fig. 78: RIGHT Most Chewa men and boys are initiated into the *nyau* society, one of whose functions is to perform masquerades at funerary rituals. Large basketry structures called *nyau yolemba* represent wild animals; this example, the *kasiya maliro*, takes the form of an eland and is believed to capture the spirit of the deceased.
Photo: K.Yoshida, 1984

46 Shield

Bamboo, ostrich feathers, iron
Sotho, Lesotho
19th century
L. 146cm, W. 100cm
Given by Miss Powles
Ethno 6095

There are three shields in the National Cultural History Museum in Pretoria which were collected by Dr W. T. M. Beukes in the 1930s in Lesotho and are similar in style to this nineteenth-century example from the British Museum. They average 63cm high and are cut from a piece of cow hide. At the back, there is a handle made of cow hide, as well as a number of loops through which a stick, topped with ostrich feathers, is attached. This stick is called *sefoka* and serves largely as a 'banner'. It is not necessarily associated with shields, but can be used separately for other ceremonial activities. Shields (known as *thebe* (pl. *dithebe*) in Sesotho) were made by specialists and were bartered for other produce.

Tylden undertook a comparative study of shield forms and came to the following conclusions, which are supported by general ethnography and my own observations. The Nguni-speaking people preferred large, oval-shaped shields whereas the Sotho/Tswana-speaking people used various shapes of shields, but showed a preference for hour-glass forms. The Venda- and Ndebele-speaking people had circular shields, while the Tsonga, because of the Nguni influence, had an oval shape. The Basotho (i.e. the people of Lesotho, or ethnographically referred to as the South Sotho) shields have projecting 'wings' which, Tylden maintains, replaced an earlier more rounded form.

Contemporary drawings from the nineteenth century by Charles Davidson Bell in Andrew Smith's journal confirmed the size and shape of the Basotho shield. This conforms with the one in the collections of the British Museum and the Pretoria Museum. The Tswana, on the other hand, used a more hour-glass-shaped shield.

The rationale behind the various-shaped shields can be related to a need to declare identity. They are not big enough to hide behind effectively, and as defensive weapons they are not very efficient. Warfare, in the past, consisted of people facing each other over a distance, throwing a number of light-weight spears that could easily be dodged or deflected. In a period of large-scale social upheaval and displacement, the shield might rather have served as a badge to identify particular groups.

Shields are depicted in the San rock art in Lesotho and eastern Free State Province of South Africa, as well as in engravings more to the north-west. Loubser and Laurens argue that these shields were painted by the San rather than the Tswana-speakers. San people are reported to have used shields obtained from the Sotho-Tswana in a symbolic way, possibly to generate potency during rain-making and curing sessions. There are also reported finds of fragmentary pieces of small clay figurines in the shape of shields. These are less than one cm in thickness, perhaps 4–5cm in maximum length.

All these depictions, in rock art and clay figurines, tend to favour the 'Tswana' form. I would argue that this is a more original form, based on the wider distribution, and that it only later took on the 'Basotho' form to distinguish them from the 'other' as the South Sotho polity grew up around the activities of Moshoeshoe I in the early nineteenth century. Whether this was a conscious development is arguable.

J. van Schalkwyk
National Cultural History Museum
Pretoria
South Africa

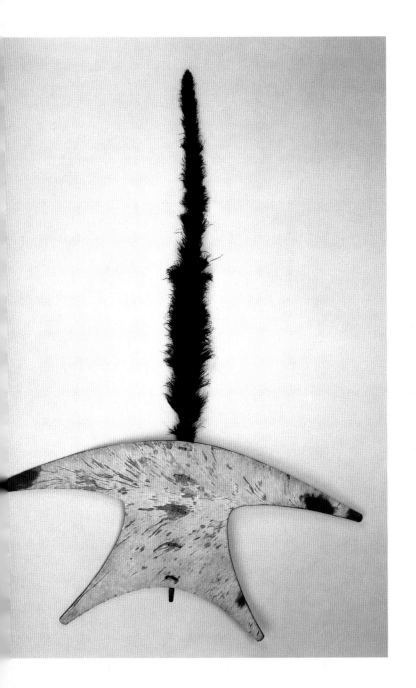

BIBLIOGRAPHY

Bosko, D., 1981, 'Why Basotho wear blankets', *African Studies*, vol. 40, 1: 23–32

Loubser, J. and Laurens, G., 1994, 'Depictions of domestic ungulates and shields: hunter/gatherers as agro-pastoralists in the Caledon River valley area', in Dowson, T. A. and Lewis-Williams, D. (eds), *Contested Images: Diversity in Southern African Rock Art Research*, Johannesburg: Witwatersrand University Press

Lye, W. F., 1975, *Andrew Smith's Journal of his Expedition into the Interior of South Africa 1834–36*, Cape Town: A. A. Balkan

Maggs, T. M. O'C., 1976, *Iron Age Communities of the Southern Highveld*, Occasional Publications of the Natal Museum, no.2, Pietermaritzburg: Natal Museum

Steel, R. H., 1988, *Late Iron Age Rock Engravings of Settlement Plans, Shields, Goats and Human Figurines*, Occasional Paper 19, Archaeological Research Unit, Johannesburg: University of the Witwatersrand

Tylden, G., 1946, 'Bantu shields', *South African Archaeological Bulletin*, vol. 1, 2: 33–7

47 Charm (*mohara*)

Gold, gemstones, silk
Merina, Madagascar
Said to date from the 1820s
L. 65cm, W. 20cm, Dp. 7cm
Ethno 1900, 5-24. 34

Malagasy, the generic name for all the peoples of Madagascar, experience unity through diversity. This is partly due to the method of population by which successive waves of migrants reached the large island and established themselves. There is also a common language and a technical or ritual vocabulary which is widely understood, even where it varies.

The object shown here is specific to the Merina aristocracy of the centre of the island who established a large kingdom in the nineteenth century. It was worn on ritual occasions such as circumcision and an example is shown being worn round the waist by the Merina governor of a distant coastal fort in a painting published in 1838 (fig. 69). Here it has assumed some of the attributes of costume jewellery, but its significance goes much wider than ornamentation.

In form this example coheres with a type of ritual object known elsewhere in Madagascar as *mohara*. *Mohara* is a term from the provinces. It refers to a kind of box often made from zebu horn (the horn of the humped cattle of Madagascar) or hollowed out from wood. The box is typically decorated with coloured beads and contains such objects as a pair of scissors, an imitation axe, nails, coins, a fishing hook, snake bones, crocodile teeth, leaves crushed with honey and white earth, slivers of wood, beads etc. In this example the curving gold projections at the bottom recall the crocodile teeth which are inserted in the base of *mohara* elsewhere, notably amongst the Sakalava in western Madagascar.

Mohara can be owned by groups or families or might be held by individuals. Not everyone in Malagasy society knows how to manipulate *mohara*, and there are risks and dangers involved in their use. Knowledge of them is transmitted down the generations within families, making possible contact with ancestors (*razana*) and with invisible spirits. The power of *mohara* is magical rather than therapeutic.

Ramilisonina
Musée d'Art et d'Archéologie
Antananarivo
Madagascar

BIBLIOGRAPHY

Bernard-Thierry, S., 1959, 'Les perles magiques à Madagascar', *Bulletin de la Société des Africanistes*: 33–90

Mack, J., 1986, *Madagascar, Island of the Ancestors*, London: BMP

Vig, L.,1969, *Charmes: spécimens de magie malgache*, Oslo: Universitetsforlaget

48 Divining bowl (ndilo)

Wood, bone, fibre, glass, cowrie shell
Venda, South Africa
19th or early 20th century
Diam. 33cm, Ht. 10cm
Ethno 1946, AF4. 1

The Venda-speaking peoples of the Northern Province in South Africa had, up to the end of the nineteenth century, two distinct methods of divination. In one, a set of four bone tablets, called *dzithangu*, was used by ordinary diviner-healers (*nganga*) to divine the cause of a wide variety of illnesses and misfortune, as well as to give prognostic evaluations of endeavours such as hunting. The other, using carved divining bowls of the type illustrated here, was employed only by the most powerful diviners (*mungoma*), at the capital of the *kosi* (kings) of the Singo lineage, and only in cases of witchcraft. Only ten of these bowls have survived to the present, all of which were collected prior to the 1930s, by which date they were no longer in use.

Very little is known of the collection circumstances of the bowl illustrated here, but it conforms in all important respects to examples which are better documented. The bowls all have a relatively wide rim surrounding the hollowed-out central section, and on the underside they all have between one and three bosses which allow the bowl to be tipped. The relief decoration on the rims, bed and underside are all significant within the divination procedure, referring to Venda cosmological concepts. When in use the bowls were filled with water so that they resembled a pool or lake with a crocodile (*ngwena*) on its bed. There is only one natural lake in VhaVenda, Lake Fundudzi, which is said to be the home of the culture hero of the ruling Singo group, Thoho ya Ndou, who disappeared into the lake to set up a capital (*musanda*) there. This is represented in the bottom of the bowl, with the crocodile referring to the king – one of the honorifics of the king is 'the great crocodile'. The central mound containing magical substances is the *musanda*, and the motifs around it refer to his cattle, wives, ancestral relics and hearth-stones, as well as to lightning and the lightning bird.

The images on the rim of the bowl refer to the king's constituency, through animals which are the emblems (*mitupo*) of lineages and sibs, through objects such as grinding stones, combs and spears which indicate gender, and shapes which refer to the four divining tablets representing senior man and woman, and junior man and woman. One section of the rim is left plain; this is the 'gate' over which the water is poured to fill the bowl: it is both the entrance to the *musanda*, and the inlet to the lake (*tivha*). Once the bowl was full, maize kernels were floated on its surface, and the bowl was tipped, the diviner noting at which points the kernels touched the rim and the base. From this he was able to establish the identity of witches who had caused others harm, and the king was then able to take appropriate action against the wrongdoers.

The decoration of the undersides of the bowl is also notably intricate and signifies further aspects of Venda cosmology, the most significant of which is the zigzag around the

perimeter which refers to the python which thus metaphorically encircles the lake.

Anitra Nettleton
University of the Witwatersrand
South Africa

BIBLIOGRAPHY

Bartels, W., 1896, 'Zwei Zauber Hölster der BaVenda im Transvaal', *Berlin: Berliner Gesellschaft für Ethnologie*: 109–10

Giesseke, E. D., 1930, 'Wahrsagerei bei den BaVenda', *Zeitschrift für Eingeborenensprache*, vol. 21, I: 257–310

Nettleton, A., 1984, *The Figurative Woodcarving of the Shona and Venda*, unpublished PhD thesis, Johannesburg: University of the Witwatersrand

Nettleton, A.,1989, 'The Crocodile does not leave the pool: Venda court arts', in Nettleton, A. and Hammond-Tooke, W. D., *African Art in Southern Africa: From Tradition to Township*, Johannesburg: A. D. Donker

Stayt, H., 1931, *The BaVenda*, Oxford: Oxford University Press

Van Warmelo, N. J.,1932, *Contributions Towards Venda History, Religion and Tribal Ritual*, Pretoria: Government Ethnological Publications, no. 52

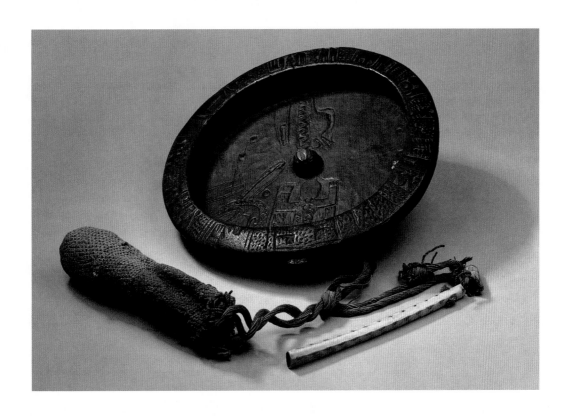

cattle-camps. There is little representational art in the region, though the common humped cattle are often modelled in clay and used by young children in imaginative play about the large herds which they aspire to assemble in adulthood. Yet, beyond that, the cattle themselves are often decorated, whether with tassels attached to the tips of their horns, or with bone and ivory ornaments hung on their foreheads; their horns are twisted and tied together so they grow into particular shapes; and an extensive 'aesthetic' vocabulary exists to describe the combinations of colours on their hides (fig. 79). Men in societies such as the Nuer and the Dinka adopt 'ox-names', sing songs in praise of their favourite animal, raise their arms in dance to mimic the horn shape of their favoured beast, and may even fight in defence of their animal's qualities should these be challenged.

Art of the body and textiles

The so-called arts of the body are also associated by many commentators with Nilotic pastoralists, as if – it is implied – the absence of representations of the human form in other media has redoubled attention to the body itself. Elaborately beaded garments are worn by Dinka men and women as corsets round the upper body, and by most Nilotic women as aprons (fig. 81). In addition, women often mass necklaces of coloured beads round the neck, sometimes with sixty or more strings

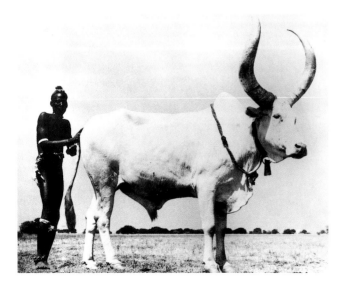

Fig. 79: Cattle-keeping peoples such as the Nuer and Dinka of southern Sudan concentrate their aesthetic interests upon the colours and forms of specific animals whose horns are trained into particular shapes.
Photo: J. Bloss, Trustees of the British Museum

which completely envelop the chin, neck and upper shoulders. Men may emphasize the head with painted mud-packs in vivid colours, often with feathers implanted along the top. The arms are encased in cylinders of ivory, coiled metal armlets and bracelets.

While much attention is, thus, paid to personal adornment, it may be that this is not simply viewed as the result of a deliberate aesthetic choice. These are areas with a marginal and unpredictable climate, where large and valuable herds of cattle (or camels) have to be moved from place to place in search of limited pasture and water. Temporary failure of the seasonal rains can leave transhumant pastoralists stranded with their cattle at distant water sources obliged to create alliances possibly with erstwhile enemies to survive; changes in the level of Lake Turkana can flood large areas and force groups of people into each others' territory. Few substantive centralized social or political structures have arisen to exert control, and conflict within and between different groups of cattle-keepers has been common. Pastoralists also carry much of their material culture with them – headrests can be carried on the arm with a thong and used as both pillow and stool (sometimes with chewing tobacco incorporated into the base), circular wrist knives can be used to cut up meat as well as for protection, spears and throwing sticks are available to hunt or to fight (fig. 82). The forms of each of these assert identity, an identity moreover which is not fixed and immutable but which may change as circumstances change. Most Nilotic groups have clan names which translate as 'foreigner', an ambiguous status that underlines the mobility of pastoralist identity – and of the means to express it.

A comparable but somewhat divergent situation obtains in South Africa. Here colourful beadwork is a feature of contemporary life (no. 49). Different combinations are characteristic of different regions but sufficiently formulaic that they are expressive of common upbringing. The same systematicity has been applied to hairstyles, such that Zulu women, for example, have a series of local styles. Earplugs are similarly nuanced (no. 50). This is an old tradition, first elaborated with the use of plastic overlays on the circular disks in the 1920s, and which later made use of vinyl flooring materials when these were introduced (fig. 80). Among the most prolific of modern decorative arts is that which has developed among the Ndebele, especially the Ndzundza Ndebele. With

49 Frontal apron

Cotton, glass
Zulu, Msinga district, Natal, South Africa
20th century
L. 51cm, W. 66.5cm
Ethno 1997, AF6. 227

A frontal apron worn over the *isidwaba* (pleated leather skirt) is traditionally part of a married woman's costume in the Msinga district of Natal, south of the Tugela River. The two coloured panels of beadwork are in the most complex of the old Msinga colour schemes, which was called *isishunka*, and was in fashion between the 1920s and 1960s. The seven colours used form a developed colour sequence in which white, light blue, dark green, pale yellow, pink, red and black follow one another in an instantly recognizable manner. Here the coloured diamonds are set against a white ground, which is unusual. This apron was made between 1930 and 1940; it is worn by twisting the flimsy black fabric over a cord or strip of cloth which is then tied round the waist so that the beadwork strip is at the desired level, a few inches above the knee.

Margret Carey
Formerly of the British Museum
London
UK

BIBLIOGRAPHY

Jolles, F., 1993, 'Traditional Zulu beadwork of the Msinga area', *African Arts*, vol. XXVI, 1: 42–53, 101–2

Jolles, F., 1994, 'Messages in fixed colour sequences', in Sienaert, E. R. *et al.* (eds), *Oral Tradition and its Transmission*, Durban: Natal University

Morris, J. and Preston-Whyte, E., 1994, *Speaking with Beads*, London: Thames and Hudson

50 Earplugs

Wood, paint, vinyl asbestos, perspex, metal, rubber
Zulu, Natal, South Africa
20th century
Diam. 7.2cm (max.), Diam. 3.8cm (min.)
Ethno 1999, AF5. 1-7

The *Qhumbuza* ('opening of the ears') ceremony associated with ear-piercing used to mark a child's coming of age, though it lost its ritual significance by the 1950s. Before the 1920s, men wore plain earplugs as a status marker; later on, between the 1930s and 1980s, women also wore earplugs, which were made of softwood, variously decorated with designs in oil paint, vinyl asbestos ('Marley Tiles') secured with old gramophone needles, thicker plastic and metal studs. The earliest earplugs were made of ivory, bone or horn, often conical on one side, while reed snuff-boxes might also be worn as earplugs.

The oldest pair of earplugs (top row, left) was made before 1930 out of polished hardwood from the red ivory tree, one of the woods reserved for making artefacts associated with the Zulu kings. One earplug (middle row, left) is medium-sized and split, with the two halves secured by a strip of inner tubing, enabling it to be worn as a clip-on earring. These came in after the 1980s, when extended ear lobes became unpopular. Other earplugs (all rows, right) show how the pattern was arranged in three bands, and in geometric designs such as the rising sun motif (middle row, right), which is said to derive from the trademark of Sunbeam Polish – 'Shines brighter, lasts longer'. The colour convention, while still connected to the Msinga area, was a more recent one which came in from about 1965, called *umzansi*, usually consisting of four colours in repeated strips: red, dark blue or black, red, white and green in that order.

Although women invariably made beadwork for themselves and their families, or for cash sale, earplugs were made by men, and frequently offered for sale in Mai-Mai, the main Zulu market in Johannesburg. Men coming home from work in the mines might bring a pair of earplugs as a present for the wife or fiancée at home.

Dr Frank Jolles, who collected these earplugs, came to South Africa in 1987, as Head of the German Department in the University of Pietermaritzburg. His ongoing research into Zulu culture has established him as a leading authority in this field, with a special interest in the study of beadwork and earplugs.

Margret Carey
Formerly of the British Museum
London
UK

BIBLIOGRAPHY

Jolles, F., 1994, 'Messages in fixed colour sequences', in Sienaert, E. R. *et al.* (eds), *Oral Tradition and its Transmission*, Durban: Natal University

Jolles, F., 1997, 'Zulu earplugs: a study in transformation', *African Arts*, vol. XXX, 2: 46–59, 94

the advent of white domination they came to live in dispersed settlements on white-owned farms, with inevitable consequences for Ndebele identity. However, rather than submit to an acculturated future, the Ndebele have tenaciously sought to revive threatened social institutions and develop new ways of asserting a distinctive cultural individuality. Amongst women, the evolution of beadwork and mural art are the most dramatic examples – indeed to the point that some Ndebele women have transferred their works to canvas and been included in international exhibitions of contemporary art.

The arts of personal adornment throughout the area depend to a very limited extent on locally produced cloth. There was a historic tradition of weaving simple cotton cloth in southern Africa – examples have been found in archaeological excavation at Great Zimbabwe and in historical collections formed in South Africa. Otherwise textiles are largely imported or made by industrialized means in local factories. The printed cloth of the Swahili (*kanga*) derives ultimately from India. A similar cloth printed locally is also found in Madagascar (and known as *lamba hony*) where it is distinguished by the addition of a proverbial saying along the lower fringe. Madagascar is also the home of the most complex and diverse of historical weaving traditions. The most elaborate and colourful of all are the *lamba akotofahana* produced in the nineteenth century by Merina weavers. These were mostly used as shawls by the nobility (fig. 69). The 'tradition' has recently been revived by a group of weavers from the area of Arivonimamo, a centre of weaving. The

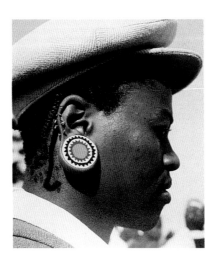

British Museum collections include both nineteenth-century examples and ones produced within the last few years (no. 51). The techniques are technically exacting, and the revival is possible only because, throughout the twentieth century, the patterns were maintained in weaving on hand looms but as white patterning on a white ground. The older richly coloured cloth ceased to be produced with the advent of colonialism, the exile of the monarch and the

Fig. 81: ABOVE Beaded corset with hide 'spinal column' worn by Dinka girls in Sudan who are eligible for marriage. The beads are provided by the girl's family; cowrie shells are attached to promote fertility.
Ethno 1989, AF9.1

Fig. 82: RIGHT Wrist and finger knives with protective hide sheaths and an iron finger hook. In addition to its possible use as a weapon, the hook was also used as an aid to eating. Karamojong, Uganda. Given by the Reverend H. Paget-Williams
Ethno 1934, 4–10.15–17

Fig. 80: OPPOSITE Young Zulu man, wearing decorative earplugs, attending the July Festival at the Nazareth Baptist Church in Ekuphakameni near Durban, South Africa, 1959.
Photo: Trustees of the British Museum

51 Textile *(lamba akotofahana)*

Silk
Merina, Madagascar
20th century
Ethno 1993, AF14.1

The most elaborate of cloths known from
Madagascar – an African island with a rich
tradition of diverse textile production – are the
silk weavings produced in the nineteenth
century in central Madagascar for the aristoc-
racy of the Merina. They are distinguished by
having a series of detailed designs picked out
in a wide variety of contrasting colours. Such
cloths are known as *lamba akotofahana*.

The term *lamba* refers in Malagasy to a
woven cloth; *akotofahana* designates in the first
instance a technical process of float weaves
which produces the elaborately brocaded
surfaces that characterize these textiles. This
is a technique which is found exclusively in
Imerina (the nineteenth-century kingdom in
the centre of the island). It is associated partic-
ularly with the Andriandrando, one of the
noble clans of Imerina who held the privilege
and right to produce and use such cloth.
Amongst the Merina such cloth was essentially
reserved for use on grand occasions, though it
could also be brought into use as a burial
shroud – and some of the red/purple brocad-
ing is still produced as appropriate to a *lamba
mena* (burial cloth).

Weaving was a female preoccupation.
Many different designs were recognised. At
the highest level a distinction was made
between *amboradara lehibe* (the great brocade)
and *amboradara kely* (the small brocade). There
were once silver brocades (*amboradara volafotsy*)
and gold brocades (*amboradara volamena*). Their
prestige was derived both from their aesthetic
qualities and from the acknowledged difficul-
ties attending their production. A detailed
vocabulary of pattern existed to describe a
series of vertical and horizontal patterning
and combinations of the two. Amongst the
commonest are *lavo-bokotra* (button-hole
motif), *ravim-pibasy* (a leaf image), *rantsam-
pihogo* (tooth-combs), *bepoaka* (exploding or
bursting but leaving a hollow within), *kintana*
(star) or *vato peratra* (stone shapes arranged
as a diamond).

Weaving in this manner continues to the
present day though with colonialism designs in
colourful contrasts transmuted into a more
subtle white-on-white textile worn as a shawl
or sometimes as a burial shroud. The more
ancient form of weaving in coloured brocaded
motifs has recently been revived in Imerina
essentially for an export market.

Clarisse Rasoamampionona
Musée Faniahy
Fianarantsoa
Madagascar

BIBLIOGRAPHY

Mack, J., 1989, *Malagasy Textiles*, Aylesbury: Shire
Publications Ltd

52 Spoon

Wood, glass
Sakalava?, Madagascar
Probably 19th century
L. 17cm, W. 6.5cm, Dp. 6cm
Ethno 1947, AF18. 103

The spoon is much more than an unremarked
adjunct to domestic life throughout Madagas-
car. One indication is that spoons are often
kept in the north-east corner of a house, the
corner reserved to ancestral things. It is also
the basis of a large number of proverbial
references or of metaphoric speech,
another sure index of wider significance.
Although Malagasy is the common
language of the island there are also a
wide range of words that translate as
'spoon' – *sotro, koera, ondroka, sadroa, saoko,*
indicating both dialect variation and an
extensive exploitation of the possibili-
ties of shape, form and function.
Spoons, in short, serve a wide range
of purposes from the mundane
through to the sacred. The Malagasy
phrase '*tsy sotro, tsy fihatsaka*' (literally,
to have neither spoon nor knife) is one
of the ultimate expressions of disenfranchise-
ment, implying not just a level of poverty that
denies regular and predictable sustenance but
in addition a lack of access to appropriate
participation in ritual process.

Spoons are made from a variety of
materials; few, however, are figurative. Before
the twentieth century, and the advent of
colonization (which in Madagascar began in

1897), figurative sculpture was rarely produced
and then virtually only in ancestral contexts.
Funerary sculpture is the most obvious
example. The creation of such works has been
regarded as a sacred occupation, and specialist
carvers are rare. In style this piece is closest,
perhaps, to that of the Sakalava of western
Madagascar. Spoons with the degree of sculp-
tural elaboration seen here must certainly have
been retained for exclusively ritual purposes,
and probably kept alongside a ritual dish (*lovia,
fandila*) to be used in sacrificial or other
ceremonial contexts. Some healers and their
followers own and guard their own ritual
spoons to the extent that they will never
part from them even when they depart
on *mitrambona* (trips). Although docu-
mentation is lacking for this impressive
example, we can be confident that its
purpose would have involved the stirring,
serving and scattering of medicines and the
preparation of special foods for use on
ritual occasions such as circumcision,
marriage or the building of a grave or
a house: all events that are closely
associated with establishing the crucial
relations between the living and the
ancestors (*razana*) which is pivotal to
ensuring the vitality of Malagasy life.

Ramilisonina
Musée d'Art et d'Archéologie
Antananarivo
Madagascar

BIBLIOGRAPHY

Mack, J., 1986, *Madagascar, Island of the Ancestors*,
London: BMP

disbanding of the royal court. In thecolonial era identity as Merina, or more broadly as Malagasy, took precedence over identity as a descendant of a now challenged and abandoned court system. The modern rediscovery of *lamba akotofanaha* is largely for an export market.

Domestic objects

If figurative sculpture has attracted most attention in West and Central Africa, collections of objects from East and southern Africa, such as those of the British Museum, are dominated by one ubiquitous category of object: domestic utensils, pipes, snuff containers, chairs, stools and headrests (fig. 83). Many of these, however, have more than the merely utilitarian significance which Western perceptions would attribute to them. Some of the forms are highly complex explorations of shape and interior space. The fact that wood

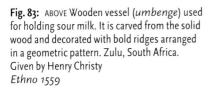

Fig. 83: ABOVE Wooden vessel (*umbenge*) used for holding sour milk. It is carved from the solid wood and decorated with bold ridges arranged in a geometric pattern. Zulu, South Africa. Given by Henry Christy
Ethno 1559

Fig.84: RIGHT Among the Shona, Zimbabwe, headrests are used by mature men who are believed to receive their ancestors in dreams. This headrest with its well-defined breasts and pubic triangle has clear female associations. Shona men traditionally marry outside their clan; the female symbolism on these headrests may be a visual reminder of the importance of a fertile wife to ensure the continuance of the male lineage.
Ethno 1949, AF46.810

objects are, with the exception of coastal Swahili furniture, monoxylous (that is carved from a single block of wood) indicates the degree of attention that is given to the creation of many of them. In the case of Nilotic peoples headrests and stools are often cut directly from the trees, branches cut off close to the trunk to form legs and the top shaped for sitting. Here the artistry is in identifying which configurations of living wood will, when cut, produce a stable seat. The results are often intriguing and complex shapes. Beyond the artistry of the production of such objects, their ownership, use and significance often belie their more immediate functional purposes. In Madagascar elaborate spoons are kept for ritual occasions, and their use implies some level of ancestral transaction (no. 52). Similarly, headrests are often more than simply a form of pillow – one which in supporting the neck prevents an elaborate headdress from being crushed when lying down. Among the Shona it is only mature men who use headrests. These are precious objects which are well cared for and at the death of the owner they may be buried with him or passed on to a male descendant. Ownership remains within the patriclan. Dreams are said to be ancestral visitations (fig. 84).

Pottery is, as in most of sub-Saharan Africa, nearly always a female craft. In place of (or as well as) pottery, gourds are also extensively used as containers. Again a straightforward functional purpose can conceal a wider significance. Thus, the Miji Kenda in Kenya and related peoples in Tanzania use complete gourds as medicine containers. Many of these have human-headed stoppers. The documentation of one example in the British Museum collections suggests that the medicine is said to be ready when the stopper, through the fermentation of the substances within, begins to jump up and down – an ancestral endorsement of the efficacy of the contents (no. 53).

Figurative sculpture

It is, of course, far from true that eastern and southern Africa lack figurative work (no. 54). We have mentioned some significant exceptions already. Perhaps the most prolific of all the types of figurative work produced in the area is that made by Makonde craftsmen principally for use in initiation contexts: masks, figures, drums, dance staffs (fig. 85). In addition to such uses the major context in which sculpture is produced is that of funerary practice. Some sculpture is made to be placed directly

on or around grave sites, or as a cenotaph at some other place to commemorate the dead. Sometimes there is an element of 'portraiture' about the sculptural programme, but this is in the sense of making reference to the deeds and events by which people are remembered rather than in the Western sense of creating a physical likeness to the deceased. Amongst the Konso in southern Ethiopia, a man who has performed heroic acts in hunting or in warfare may be acknowledged by a series of carved figures (*wanga*) erected at his grave that represent both the man himself, his wives, slain enemies and perhaps the animals killed in a prodigious life as a hunter. His wealth is recalled by a series of stones that enumerate the fields he owned. The Bongo in south-western Sudan seem to erect funerary posts with similar intent (fig. 86). In southern Madagascar the sculptor Fesira created a series of pole sculptures in the 1930s as memorials for Antanosy clients which have a secure 'biographical' purpose. His works include a sculpture to a group drowned in a canoe accident and another to a wealthy local man shown seated inside the motor car

Fig. 85: ABOVE Dance stick (*simba*) used by Makonde men or youths in Mozambique during initiation ceremonies. The stick would be suspended over the arm so that the carved head faced outwards.
Given by Mrs Webster Plass
Ethno 1957, AF12.4

Fig. 86: RIGHT Wooden grave figure attributed to the Bongo people, south-west Sudan. Hunter-warriors were honoured after death by the erection of such effigies on their graves; representations of their victims were also produced.
Ethno 1973, AF35.1

53 Medicine flask (kidonga)

Gourd, skin, wood, glass
Giriama, Kenya
Late 19th/early 20th century
Ht. 25cm, Dp. 16cm
Given by A. M. Champion
Ethno 1915, 7-3. 53a-b

The Giriama are part of the nine related clans of the Bantu-speaking Miji Kenda people. They are found along the coastal parts of Kenya and are part of the East Coast Bantu speakers. The Miji Kenda are renowned for their sacred forests, the *kayas*, and their grave-posts (*vigango*).

Medicine and witchcraft are central to the beliefs of the Giriama people in particular and the Miji Kenda in general. The medicine men are important people in Giriama society, and some of the best medicine men are initiated into the highest level of a society of distinguished elders known as the *Gohu* society.

Among the Giriama, as is the case among many other African societies, disease is thought to be caused by evil spirits sent by jealous neighbours, relatives or enemies and at times the gods and the spirits of the departed may show their anger by causing diseases (and other calamities). The medicine man (*mganga*) has a raphia bag (*mkoba*) in which he carries the paraphernalia for treating various illnesses. The *mganga*, or more literally the 'solution-finder', is normally regarded as a person with supernatural powers. It is believed that a *mganga* could capture the evil spirit that was possibly responsible for causing various illnesses.

One of the most important items stored in this bag is the medicine gourd, *kidonga* (pl. *vidonga*). These are small calabashes with carved wooden stoppers. The stoppers are carved in the shape of a female figure sometimes depicted wearing shell ornaments on the neck. The head and the facial features of the *kidonga* are usually more elaborate than those on the *vigango* posts. The upper torso and the belly are also elaborate in most cases. The belly is well pronounced. The interesting feature of the stopper is the pair of eyes: they seem to be gazing downwards into some distant space.

The Giriama also use other types of gourds. The *mganga wa mburuga* is another divining medicine man who uses a thin sausage-shaped gourd (*buruga*), which contains seeds called *semakake* in Kiswahili and *mbathi* in KiGiriama. The seeds are the same as the ones used in the board game *bao*.

The medicine man manipulates the *kidonga* so as to reveal the identity of the disease-causing spirit or individual. The medicine man 'talks' to the *kidonga* using a vocabulary which only he and the *kidonga* 'spirit' can understand. In cases where the calabash contains liquid medicines, the figurative stopper may pop up and down as if a force within the container is pushing it. This adds to the theatrics of the healing ritual by 'qualifying' the *kidonga* as a container of a spirit. The metaphoric or symbolic use of vessels as places where spirits are 'contained' or found is a widespread phenomenon among the Giriama, as it is elsewhere in Africa.

Among the Giriama, containers have both utilitarian and metaphorical significance. The belly as a symbol of fertility and endowment is symbolically emphasized by the calabashes and the gourds. The spells that cause illness are believed to be in the stomach; the animals sacrificed in order to end the spell have their stomachs cut open and the contents of the stomach are used to make a medicinal mixture. Women are important mediators in rituals, medicine and burial ceremonies. The figure on the stopper for the medicine container (*kidonga*) is feminine in shape. Although the *kidonga* is used by a medicine man, he may be consulting a 'female' spirit to assist him in the healing or exorcizing process.

Although we are made to think that the male spirits were more powerful (because in some cases the grave posts had to be erected to appease them), I think it is the female spirit which is the more feared and revered.

The use of a feminine figure on the stopper may symbolize the importance that is given to the female spirits. Although femininity (in many African societies) may socially be depicted as a weakness, we have seen how women play significant roles in ritually important and liminal periods. The gourd also bears features that symbolically portray endowment, pregnancy and fertility, which are important female symbols.

The use of 'maternal' symbols in a healing process or as part of the ritual paraphernalia is a phenomenon practised in many parts of Africa. The 'maternal' figure is used in many liminal, ritual and healing processes to portray kindness, fertility and protection. The Giriama medicine men may have used the *kidonga* figure so as to invoke the maternal spirits to heal the ailing, make fertile the sterile and 'protect' the vulnerable.

Hassan G. Wario Arero
National Museums of Kenya
Kenya

BIBLIOGRAPHY

Champion, A., 1967, *The Agiryama of Kenya*, ed. J. Middleton, Royal Anthropological Institute Occasional Paper, no. 25, London: Royal Anthropological Institute

Parkin, D., 1991, *The Sacred Void: Spatial Images of Work and Ritual Among the Giriama of Kenya*, Cambridge: Cambridge University Press

Spear, T. T., 1978, *The Kaya Complex: a History of the Mijikenda Peoples of the Kenya Coast to 1900*, Nairobi: Kenya Literature Bureau

54 Standing female figure

Wood, glass
Tabwa or Bemba, Zambia
19th century
Ht. 44cm, W. 13.5cm, Dp. 11.5cm
Ethno 1980, AF9.1

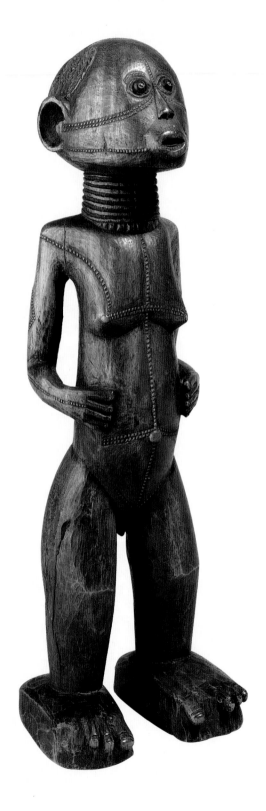

A record tells us that this figure was collected by a German trader in northern Bembaland where present Tanzania, the Democratic Republic of the Congo and Zambia meet. Among the Bemba, figure sculpture seems to have become extinct by the end of the nineteenth century. Though there is a possibility that figure sculpture of this sort had been made among the Bemba people until the end of the century, the style of the present figure strongly suggests a Tabwa origin.

The Tabwa live in the extreme south-east of the Democratic Republic of Congo, on the west coast of Lake Tanganyika. They are a Bantu-speaking people closely related to the Bemba to their south, to the Luba and Hemba to their west, and to the Tumbwe to their north. The Tabwa were known as prolific sculptors, producing various wooden objects such as plates, stools, headrests and staffs, with figurative decorations. Small wooden figures called *mikisi* represent the height of this artistry.

Tabwa *mikisi* figures are characterized by arms carved free of elongated torsos and fingers resting on abdomen, body with intricate scarification, oval face with protruding mouths and elaborate hairstyles. All these features can be found in this example. The figure is particularly noted for its clear-cut scarification.

According to Allen Roberts, who carried out long-term field research among the people in the 1970s, such figures were most frequently said to represent ancestral spirits (*mipasi* or *mizimu*). Lineage elders kept them in shrines within their compounds, where they made frequent offerings for the well-being of the lineage. *Mipasi* ancestral spirits may come to people in dreams, or they are sometimes identified as the source of affliction by a diviner.

Then the person commissions a figure from a known artist or a diviner-healer. In any case, a diviner-healer would be called upon to compose and insert magical medicines into the figures to increase the figure's capacity to protect those who honour them. *Mikisi* were used in a number of contexts. They might be placed near a sick person to keep evil forces away, or at the entrance to the village as a silent sentinel; they might be used in litigation to ensure that a defendant told the truth.

Though small numbers of people still use carved figures in some of the ways mentioned above, Tabwa wooden figures are no longer generally produced. Christian missionaries considered such objects to be heathen, and seized them. Although most of the wooden *mikisi* figures are now kept in Western museums, terracotta versions are still in use amongst some Tabwa elders.

Kenji Yoshida
National Museum of Ethnology
Osaka
Japan

BIBLIOGRAPHY

De Grunne, B., 1985, 'A note on "prime object" and variation in Tabwa figural sculpture', in Maurer, E. M. and Roberts, A. (eds), *Tabwa, the Rising of a New Moon: a Century of Tabwa Art*, Ann Arbor: University of Michigan, Museum of Art

Roberts, A., 1985, 'Social and historical contexts of Tabwa art', in Maurer, E. M. and Roberts, A. (eds), *Tabwa, the Rising of a New Moon: a Century of Tabwa Art*, Ann Arbor: University of Michigan, Museum of Art

Roberts, A., 1996, 'Duality in Tabwa art', *African Arts*, vol. XXIX, 4: 26–35, 86–7

which he introduced into his remote village and a mounted colonial figure recalling his period working for the French authorities (fig. 87).

It is sometimes more difficult to be clear whether the function of such sculptures is only commemoration or whether there is a sense in which they become themselves the abode of the spirit of the deceased. Amongst the Mahafaly of Madagascar funerary sculpture is known as *aloalo*. Typically such sculpture shows a figure surmounted by a succession of circles and crescents and the whole surmounted by either birds or humped cattle. It has often been suggested that the term for the sculpture derives from the word *alo* meaning an emissary or messenger and thus the sculpture is assumed to have the role of acting as a visual go-between connecting the human and the ancestral worlds. Yet *alo* also has a more general usage to describe situations of linkage, in which con-

text it is also used as a weaving term. The likelihood, therefore, is that what is referred to is less the spiritual status of the objects than the pattern of interlocking geometric shapes which form the central element of the sculpture. A contrary position seems to characterize the funerary sculpture of the Giryama in eastern Kenya. Here human-headed funerary posts (*vigango*) may be put up either in proximity to graves or at a distance from them. Their function, however, is not to mark the place of burial but to house the spirit of the deceased.

There is no exact tense available in English for the above descriptions. The most appropriate, if it existed, would probably be best described as the voice of the recent past – rather than the assumption of a historic present in which, for simplicity alone, it has been written. In the southern Sudan and related areas, rifles originally introduced in the 1970s from the wars in Uganda and Ethiopia have transformed historic patterns of cattle-raiding into a more deadly activity, whilst the whole pastoralist way of life has been threatened by the subsequent extended civil war in Sudan. Modern conflicts have seen refugees crossing and recrossing several borders. Postcolonial governments have sometimes

Fig. 87: OPPOSITE The itinerant Malagasy carver Fesira produced funerary sculptures which recalled major events in the lives of those commemorated rather than accurate portraits. This memorial depicts a group of men who drowned nearby in a canoeing accident; southeast Madagascar.
Photo: J. Mack, 1985

Fig. 88: RIGHT Frank McEwen in 1971 at the Musée Rodin, Paris, at the opening of a pioneering exhibition of contemporary sculpture from Zimbabwe. The black serpentine figure at his side, 'Skeletal Baboon', was made by the renowned Shona sculptor John Takawira (1938–89).
Photo: Trustees of the British Museum

55 Sculpture
('Skeletal Baboon Spirit')

Green serpentine
Shona, Nyanga, Zimbabwe
c.1970
Ht. 31cm, W. 9cm, Dp.15.5cm
Made by Sylvester Mubayi
Ethno 1996, AF18.27

Sylvester Mubayi's sculpture 'Skeletal Baboon Spirit' is a good example of the Workshop School sculpture that emanated from the National Gallery of Zimbabwe (then the Rhodes National Gallery, Rhodesia) in the 1960s under the influence of its first Director, Frank McEwen, who in 1962 described the early stone sculpture as having 'a sense of domination. Their rude, heavy grain of stone or timber strikes a vibrant note. Challenging the past, the present and the future.'

It is generally accepted that, prior to the rise of the artists of the Workshop School, there was no discernible indigenous figurative art form in the country among the majority Shona people. Some attempts have been made to link directly the Zimbabwe bird carvings discovered at the site of the Great Zimbabwe ruins to present-day sculpture. These assumptions have never been supported by factual evidence. In a study of archaeological figurines discovered throughout Zimbabwe, Edward Matenga goes only so far as to say, 'It is likely that commercial stone and wood carving which thrives today in Zimbabwe exploited existing artistic experience.'

All appearances suggest that the sculptors of

McEwen's Workshop School emerged from a seeming vacuum of artistic expression; but they came from a cultural heritage rich in spiritual imagery. McEwen encouraged the artists to look to their roots and beliefs for their subject matter and to approach their work through expressive means; he actively decried the mimesis of naturalism. The images that emerged under McEwen's encouragement were a contemporary vision of Shona traditional culture and religion in a manner that McEwen hailed as being a truly contemporary African art form. In his catalogue introduction for the exhibition *Shona Art Today* in Johannesburg in July 1971, McEwen declared: 'The Shona people live on the land and retain their mystical belief; a deep involvement in a magic world of ancestor and tribal spirits . . . Today, astride the two worlds the ancient and the modern, the Shona artist, awakening to a need of self-expression and to mark his presence in a new domain, draws from his rich inheritance of vision.'

Sylvester Mubayi was one of the sculptors whom McEwen especially admired, possibly because Mubayi remained faithful to the spiritual in his art. Mubayi said of his work: 'I try to keep to my traditions. My art comes from these traditions. When I die my sculpture will still be a history for the people.' This 'Skeletal Baboon Spirit' encapsulates Shona ancestral spiritual belief. McEwen described the skeletal form as a representation of the visible sign of death, signifying that the spirit of the departed has temporally incarnated in the form of a baboon in its need to maintain communication with the living. McEwen's understanding of Shona culture and beliefs came directly from his conversations with the

artists, many of whom were close personal friends.

Many of the early Workshop School artists used the skeleton in both human and animal form, but, as the sculpture movement became more commercially focused in the late 1970s, the artists abandoned the skeleton for more marketable and less disturbing imagery.

Pip Curling
National Gallery of Zimbabwe
Harare
Zimbabwe

BIBLIOGRAPHY

McEwen, F., 1971, *Sculpture contemporaine des Shonas d'Afrique*, Paris: Musée Rodin

McEwen, F., 1972, 'Shona art today', *African Arts*, vol. V, 4: 8–11

Matenga, E., 1993, *Archaeological Figurines from Zimbabwe*, Uppsala: Societas Archaeologica Upsaliensis

56 Pottery vessel

Pottery, graphite, plumbago
Ganda, Uganda
Late 19th century
Ht. 30cm, W. 18.5cm
Given by Sir H. H. Johnston
Ethno 1901, 11-13.50

Pottery vessel

Pottery, graphite, plumbago
Ganda, Uganda
Late 19th century
Ht. 21cm, W. 20cm
Given by Sir H. H. Johnston
Ethno 1901, 11-13.51

Pottery vessel

Pottery, graphite
Ganda, Uganda
20th century
Ht. 34cm, W. 20cm
Given by Mrs M. Trowell
Ethno 1971, AF38.2

Ensumbi – black high burnished pots – were made for the Kabaka's (King's) palace among the Baganda. The Bajona, the King's potters, worked under royal patronage in workshops set up within the royal grounds. The potters were accorded royal privilege through land tenancy, and remuneration was made against this tenancy.

Potting skill and knowledge among the Bajona was passed on from father to son. *Ensumbi* pottery was very finely crafted and distinguished from the other commonly available red-oxidized ware used in the rest of Uganda and indeed throughout the whole area around Lake Victoria. To some extent this black ware resembled that found in the Bunyoro area west of Buganda, giving rise to the notion that this technique may have been introduced to the Baganda court potters by Banyoro potters.

The pots were hand-built using thickish coils in what might be termed the overlapping, pinch and pull method. A lump of clay was placed on a shallow low-fired mould and centred before further coils of clay were added. A banana-leaf lining prevented the base from drying too quickly and made for easy release from the mould to complete the work.

It is in the clay preparation, the surface treatment (decoration) and the firing that the black finish of these pots is achieved. Much of the coarse material was removed from the clay by hand, ground, sieved through a fine mesh, then soaked and slackened before grog made from ground sherds was added. The clay was then covered and left outside to settle, age and mature. When the clay was ready for use it had become fine and smooth but lacked plasticity.

Like bone china this clay was more suited to making smaller wares like drinking vessels.

The vessel was finished by first applying cord rouletting to some parts of the neck if this was the desired decoration. Next the rest was scraped to achieve an even surface. A thin graphite-based slip was painted on when the pot was leather-hard and burnished. The pieces were then dried very slowly over several days before firing. The only other decoration after firing would have been the application of kaolin to highlight the rouletted or incised areas.

The firing process was the trademark of this blackware, and it took place in secrecy. It was more complicated than that used for the red wares. To obtain black ware, the pots were fired in a shallow pit tightly packed with reeds and dried grasses. At red heat the pots were encased in dried cow-pats and left to combust slowly over several days, thus creating a reducing atmosphere in the chamber. This method of firing creates an evenly black body that ranges from matt to a shiny lustre – quite unlike the smoked patchy appearance that may occur on pots by accident. *Ensumbi* pottery was thus not mass-produced and became associated with the court and used by wealthier Baganda.

It is likely that the vessel shapes were derived from organic forms like gourds because gourds grew locally and had been adapted as drinking vessels and milk containers and offered an easily-copied form. Because these vessels always had round bases they were stored on beautifully hand-woven grass or raphia bases like those in the picture. However the ring bases in the museum collection would appear to have come from western Uganda, from Bunyoro; and were probably acquired as separate items brought in from the same source. The basketry from Buganda is much bolder.

Magdalene A. Odundo
Contemporary artist
Farnham
UK

BIBLIOGRAPHY

Roscoe, J., 1911, *The Baganda: an Account of their Nature, Customs and Beliefs*, London: Macmillan and Co.

Trowell, M., 1960, *African Designs*, London: Faber and Faber

sought to assert modernity and the viability of the new nation state by attacking local cultural expressions of separate ethnic identity including that conveyed by personal adornment. In post-Apartheid South Africa the status of colonial-period ethnographic museums is ambiguous; but meanwhile contemporary art has emerged with renewed multi-racial vigour.

Contemporary art moves African artists into a wider international context. Others have already taken that route. The best known are the carvers of the 'schools' of the Kamba in Kenya, the Makonde in Tanzania and the Zimababwe stone sculptors. The last come out of an initiative associated with the former Director of the National Art Gallery, Frank McEwen, in what was then Salisbury, Rhodesia (fig. 88). He formed his own collection of the early works of local artists whom, in the late 1950s, he encouraged to find their own forms of expression, mostly in the medium of hard stone. His family have since donated the collection to the British Museum (no. 55).

Modern Makonde and Zimbabwe sculpture often comes with associated narratives which see in them visualizations of 'traditional' perceptions of the world, especially a spirit world. The idea of contemporary artistic expression as a new form of realising some 'primitive' vision is one which contemporary artists would certainly reject. A ceramicist like Magdalene Odundo, who has travelled widely to study pottery practice in her native East Africa and elsewhere on the continent, is by no means limited by the traditions she has researched or by any local expectation of what a pot is for. She does use well-established techniques of hand building rather than the potters' wheel, and burnishes her work before firing, as most African potters do, rather than applying a glaze (no. 56). None the less, her ceramics are explorations of form and not intended to be functional village objects. It is perhaps revealing, and in its way appropriate, that, in researching this book, it came to light that one of her earliest pots turned out to have been acquired by the British Museum – but by a department dealing with modern design rather than specifically with African cultures.

Bibliography

GENERAL WORKS

Arnoldi, M. J. and Kreamer, C. M. (eds), 1995, *Crowning Achievements: African Arts of Dressing the Head*, Los Angeles: Fowler Museum of Cultural History

Appiah, K. A., 1992, *In my father's house: Africa in the philosophy of culture*, Oxford and New York: Oxford University Press

Barley, N., 1994, *Smashing Pots: Feats of Clay from Africa*, London: British Museum Press

Bassani, E. and Fagg, W. B., 1988, *Africa and the Renaissance: Art in Ivory*, New York: Center for African Art, in association with Prestel-Verlag

Blier, S. P.,1998, *Royal Arts of Africa, The Majesty of Form*, London: Laurence King Publishing

Burn, L., 1991, *The British Museum Book of Greek and Roman Art*, London: British Museum Press

Caygill, M., 1981, *The Story of the British Museum*, London: British Museum Press

Cole, H. M., 1989, *Icons: Ideals and Power in the Art of Africa*, Washington, D.C.: National Museum of African Art

Martin, J-H., 1999, *Magiciens de la Terre*, Paris: Éditions du Centre Pompidou

McLeod, M. D., 1993, 'Collecting for the British Museum', *Quaderni Poro*, vol. 8

Mutwa, C. V., 1969, *My People: the incredible writings of Credo Vusa'mazulu Mutwa*, London: Anthony Blond

Nooter, M. H., (ed.), 1993, *Secrecy: African Art that Conceals and Reveals*, New York: The Museum for African Art; Munich: Prestel

Phillips, T. (ed.), 1995, *Africa: The Art of a Continent*, London: Royal Academy of Arts; Munich and New York: Prestel-Verlag

Phillipson, D., 1998, *Ancient Ethiopia, Aksum: its Antecedents and Successors*, London: British Museum Press

Picton, J. and Mack, J., 1989, *African Textiles*, London: British Museum Publications

Ross, D., 1998, *Wrapped in Pride: Ghanaian Kente and African-American Identity*, Los Angeles: Fowler Museum of Cultural History at UCLA

Rubin, A. G., 1974, *African Accumulative Sculpture: Power and Display*, New York: Pace Gallery

Sieber, R., 1980, *African Furniture and Household Objects*, Bloomington: University of Indiana

Sieber, R. and Walker, R. A., 1987, *African Art and the Cycle of Life*, Washington, D.C.: Smithsonian Institution Press

Spring, C., 1993, *African Arms and Armour*, London: British Museum Press

Tempels, P., 1961, *La Philosophie Bantou*, Paris: Présence africaine

Vansina, J., 1984, *Art History in Africa. An Introduction to Method*, London: Longman

Vogel, S. M. (ed.), 1991, *Africa Explores: 20th Century African Art*, New York: Center for African Art; Munich: Prestel-Verlag

Willett, F., 1994 (2nd edn), *African Art*, London: Thames and Hudson

NORTH, NORTH-EAST AFRICA AND THE SAHARA

Abu-Nasr, J. M., 1975 (2nd edn), *A History of the Maghrib*, Cambridge: Cambridge University Press

Balfet, H., 1965, 'Ethnographical Observations in North Africa and the Archaeological Interpretation: The Pottery of the Maghreb', in Matson, F. R. (ed.), *Ceramics and Man*, Chicago: Aldine

Besancenot, J., 1990, *Costumes of Morocco*, London and New York: Kegan Paul International

Bynon, J., 1984, 'Berber Women's Pottery: Is the Decoration Motivated?', in Picton, J. (ed.), *Eathenware in Asia and Africa*, London: Percival David Foundation of Chinese Art

Fakhry, A., 1973, *The Oases of Egypt: Siwa Oasis*, vol. I, Cairo: American University in Cairo Press

Fakhry, A., 1974, *The Oases of Egypt: Bahriyah and Farafra Oases*, vol. II, Cairo: American University in Cairo Press

Gabus, J., 1955-82, *Au Sahara*, 3 vols, Neuchâtel: À la Baconnière

Gargouri-Sethom, S., 1986, *Le bijou traditionnel en Tunisie: femmes parées, femmes enchaînées*, Aix-en-Provence: Édisud

Hopkins, J. F. P. and Levtzion, N., 1981, *Corpus of Early Arabic Sources for West African History,* Cambridge: Cambridge Universtiy Press

Lane, E. W., 1871, *An Account of the Manners and Customs of the Modern Egyptians*, 2 vols, London: John Murray

Lisse, P. and Louis, A., 1956, *Les potiers de Nabeul*, Tunis: Bascone & Muscat

Micaud, E., 1970, 'The Craft Tradition in North Africa', *African Arts*, vol. III, 2:38–43

Pankhurst, R., 1990, *A Social History of Ethiopia*, Addis Adaba: Institute of Ethiopian Studies

Reswick, I., 1985, *Traditional Textiles of Tunisia and Related North African Weavings*, Los Angeles, Craft and Folk Art Museum: University of Washington Press

Rugh, A. B., 1986, *Reveal and Conceal: Dress in Contemporary Egypt*, New York: Syracuse University Press

Smith, R. S., 1989, *Warfare and Diplomacy in Pre-colonial West Africa*, London: James Currey

Spring, C. and Hudson, J., 1995, *North African Textiles*, London: British Museum Press

Stone, C., 1985, *The Embroideries of North Africa*, London: Longman

Vivier, M.-F., 1995, 'Les voiles et les châles', in Musée des Arts d'Afrique et d'Océanie, *Noces tisées, noces brodées: parures et costumes féminins de Tunisie*, Paris: Editions Joël Cuénot

WEST AFRICA

Abiodun, R., Drewal, H. and Pemberton III, J. (eds), 1994, *The Yoruba Artist: New Theoretical Perspectives on African Arts*, Washington, D.C. and London: Smithsonian Institution Press

Ajayi, J. and Crowder, M. (eds), 1971, *History of West Africa*, 2 vols, London: Longman

Barley, N., 1988, *Foreheads of the Dead: An Anthropological View of Kalabari Ancestral Screens*, Washington, D.C. and London: Smithsonian Institution Press

Barnes, S., (ed.), 1989, *Africa's Ogun: Old World and New*, Bloomington and Indianapolis: Indiana University Press

Ben-Amos, P., 1995, *The Art of Benin*, London: British Museum Press

Bravmann, R. A., 1983, *African Islam*, Washington, D.C.: Smithsonian Institution Press; London: Ethnographica

Brincard, M.-T. (ed.), 1982, *The Art of Metal in Africa*, New York: The African American Institute

Frank, B., 1998, *Mande Potters and Leather-workers: Art and Heritage in West Africa*, Washington and London: Smithsonian Institution Press

Herbert, E., 1984, *Red Gold of Africa: Copper in Precolonial History and Culture*, Madison: University of Wisconsin Press

Kramer, F., 1993, *The Red Fez*, London and New York: Verso

Lamb, V., 1975, *West African Weaving*, London: Duckworth

McNaughton, P., 1988, *The Mande Black-smiths: Knowledge, Power and Art in West Africa*, Bloomington and Indianapolis: Indiana University Press

Moughtin, J., 1985, *Hausa Architecture*, London: Ethnographica

Prussin, L., 1986, *Hatumere: Islamic Design in West Africa*, Berkeley, Los Angeles and London: University of California Press

Secretan, T., 1995, *Going into Darkness: Fantastic Coffins from Africa*, London: Thames and Hudson

CENTRAL AFRICA

Bastin, M.-L., 1976, *Statuettes tshokwe*, Arnouville-lès-Gonesse: Arts d'Afrique Noire

Bastin, M.-L., 1982, *La Sculpture tshokwe*, Meudon: Alain & Françoise Chaffin

Bastin, M.-L., 1994, *Sculpture angolaise: memorial de cultures*, Lisbon: Electa

Biebuyck, D., 1974, *Lega Culture, Art, Inititiation and Philosophy among a Central African People*, Los Angeles and Berkeley: University of California Press

Biebuyck, D., 1985, *The Arts of Zaire: South-western Zaire*, Berkeley and Los Angeles: University of California Press

Biebuyck, D., 1986, *The Arts of Zaire: Eastern Zaire, the Ritual and Artistic Context of Voluntary Association*, Berkeley and Los Angeles: University of California Press

Biebuyck, D., 1987, *The Arts of Central Africa: An Annotated Bibliography*, Boston: G. K. Hall

Bourgeois, A., 1984, *Art of the Yaka and Suku*, Meudon: Alain & Françoise Chaffin

Chaffin, A. and Chaffin, F., 1979, *L'art kota: les figures de reliquaire*, Meudon: Alain & Françoise Chaffin

Cornet, J., 1982, *Art Royal Kuba*, Milan: Edizioni Sipiel

Darish, P., 1989, 'Dressing for the Next Life: Raffia Textile Fabrication and Display among the Kuba of south-central Zaire', in Weiner, A. and Schneider, J. (eds), *Cloth and Human Experience*, Washington, D.C. and London: Smithsonian Institution Press

Hersak, D., 1986, *Songye Masks and Figure Sculpture*, London: Ethnographica

Lehuard, R., 1974, *Statuaire du Stanley Pool*, Arnouville-lès-Gonesse: Arts d'Afrique Noire

Lehuard, R., 1976, *Les Phemba du Mayombe*, Arnouville-lès-Gonesse: Arts d'Afrique Noire

MacGaffey, W., 1991, *Art and Healing of the Bakongo Commented by Themselves: Minkisi from the Laman Collection*, Stockholm: Folkens Museum-Ethnografiska

MacGaffey, W. and Harris, M. D., 1993, *Astonishment and Power*, Washington, D.C. and London: Smithsonian Institution Press

Mack, J., 1990, *Emil Torday and the Art of the Congo, 1900–1910*, London: British Museum Publications

Neyt, F., 1993, *Luba, aux sources du Zaire*, Paris: Musée Dapper

Perrois, L., 1972, *La statuaire fan*, Paris: Mémoires Orstom

Perrois, L., 1979, *Arts du Gabon*, Arnouville-lès-Gonesse: Arts d'Afrique Noire

Roberts, A. F. and Roberts, M. N., 1996,

Memory: Luba Art and the Making of History, New York: Prestel and The Museum for African Art

Schildkrout, E. and Keim, C. A., 1990, *African Reflections: Art from Northeastern Zaire*, Seattle and London: University of Washington Press; New York: American Museum of Natural History

Strother, Z. S., 1998, *Inventing Masks: Agency and History in the Art of the Central Pende*, Chicago and London: University of Chicago Press

Thompson, R. F. and Cornet, J., 1981, *The Four Moments of the Sun*, Washington, D.C.: National Gallery of Art

Torday, E. and Joyce, T. A., 1910, *Notes ethnographiques sur les peuples communément appelés Bakuba, ainsi que les peuplades apparentées: les Bushongo*, Brussels: Musée du Congo Belge

Vansina, J., 1978, *The Children of Woot: A History of the Kuba Peoples*, Madison: University of Wisconsin Press

EAST AND SOUTHERN AFRICA

Burt, E. C., 1980, *An Annotated Bibliography of the Visual Arts of East Africa*, Bloomington: Indiana University Press

Carey, M., 1986, *Beads and Beadwork of East and South Africa*, Aylesbury: Shire Publications Ltd

Cory, H., 1956, *African Figurines: Their Ceremonial Use in Puberty Rites in Tanganyika*, London: Faber and Faber

Davison, P. *et al.*, 1991, *Art and Ambiguity: Perspectives on the Brenthurst Collection of Southern African Art*, Johannesburg: Johannesburg Art Gallery

Dewey, W., 1993, *Sleeping Beauties: The Jerome L. Joss Collection of African Headrests at UCLA*, Los Angeles: Fowler Museum of Cultural History

Dias A. J. and Dias, M., 1964–70, *Os Macondes de Moçambique*, 3 vols, Lisbon: Junta de Investigações do Ultramar, Centro de Estudos de Antropologia Cultural

Felix, M. L., 1990, *Mwana Hiti: Life and Art of the Matrilineal Bantu of Tanzania*, Munich: Fred Jahn

Garlake, P., 1973, *Great Zimbabwe*, London: Thames and Hudson

Garlake, P., 1995, *The Hunter's Vision: The Prehistoric Art of Zimbabwe*, London: British Museum Press

Hartwig, G., 1969, 'The Role of Plastic Art Traditions in Tanzania', *Baessler-Archiv*, vol. 17: 25–40

Holy, L., 1967, *The Art of Africa: Masks and Figures from Eastern and Southern Africa*, London: Paul Hamlyn

Lewis-Williams, J. D. and Dowson, T., 1989, *Images of Power: Understanding Bushman Rock Art*, Johannesburg: Southern Book Publishers

Mack, J., 1986, *Madagascar, Island of the Ancestors*, London: British Museum Publications

Mack, J., 1989, *Malagasy Textiles*, Aylesbury: Shire Publications Ltd

Nettleton, A. and Hammond-Tooke, D. (eds), 1989, *Art of Southern Africa: From Tradition to Township*, Johannesburg: A. D. Donker

Trowell, M. and Wachsmann, K. P., 1953, *Tribal Crafts of Uganda*, Oxford: Oxford University Press

Urbain-Faublée, M., 1963, *L'art malgache*, Paris: Presse Universitaire de France

Wolfe, E., Parkin, D. and Sieber, R., 1981, *Vigango: The Commemorative Sculpture of the Mijikenda of Kenya*, Bloomington: University of Indiana

Index

Page numbers in *italics* refer to illustrations and captions